DISCARDED FROM

MW01093032

DEC -- 2015

BRUCE SPRINGSTEEN & THE E STREET BAND

1975

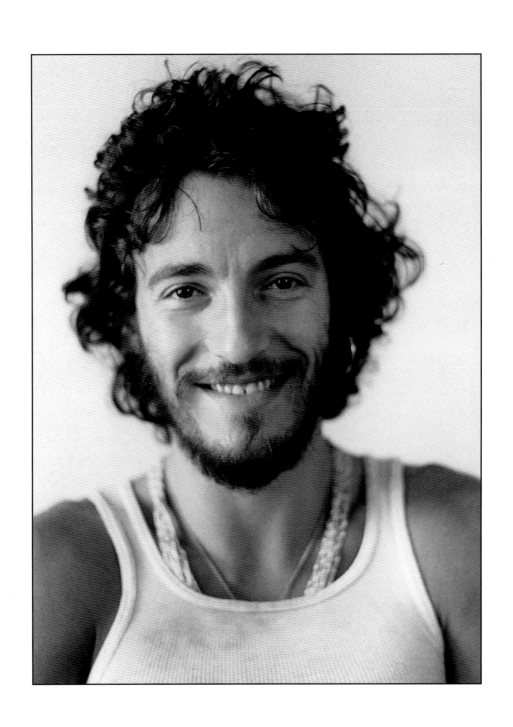

BRUCE SPRINGSTEEN
& THE E STREET BAND

1975

PHOTOGRAPHS
& COMMENTARY BY

BARBARA PYLE

R|A|P

REEL ART PRESS

Caldwell Public Library

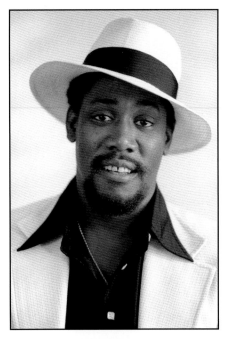
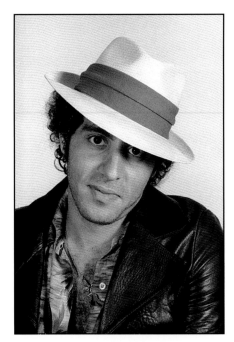
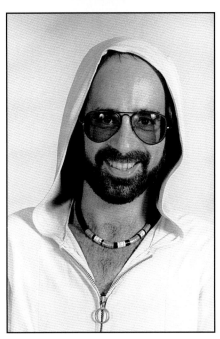
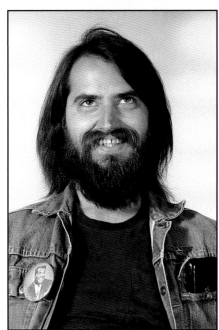
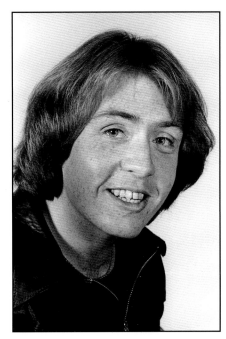
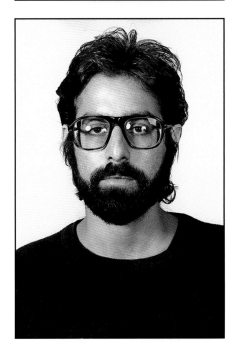

EDITED BY

BARBARA PYLE
TONY NOURMAND
DAGON JAMES

WITH

ERIC MEOLA
PETER DOGGETT
DAVE BROLAN

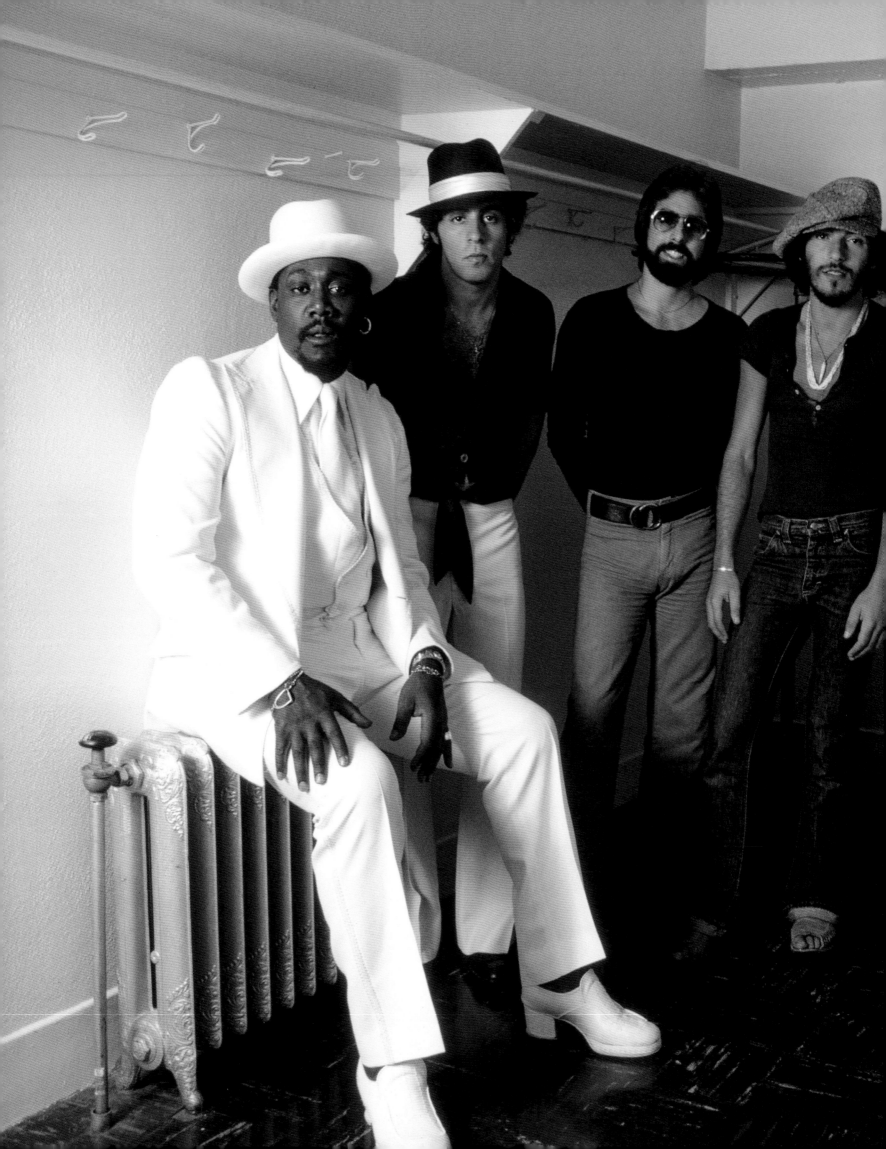

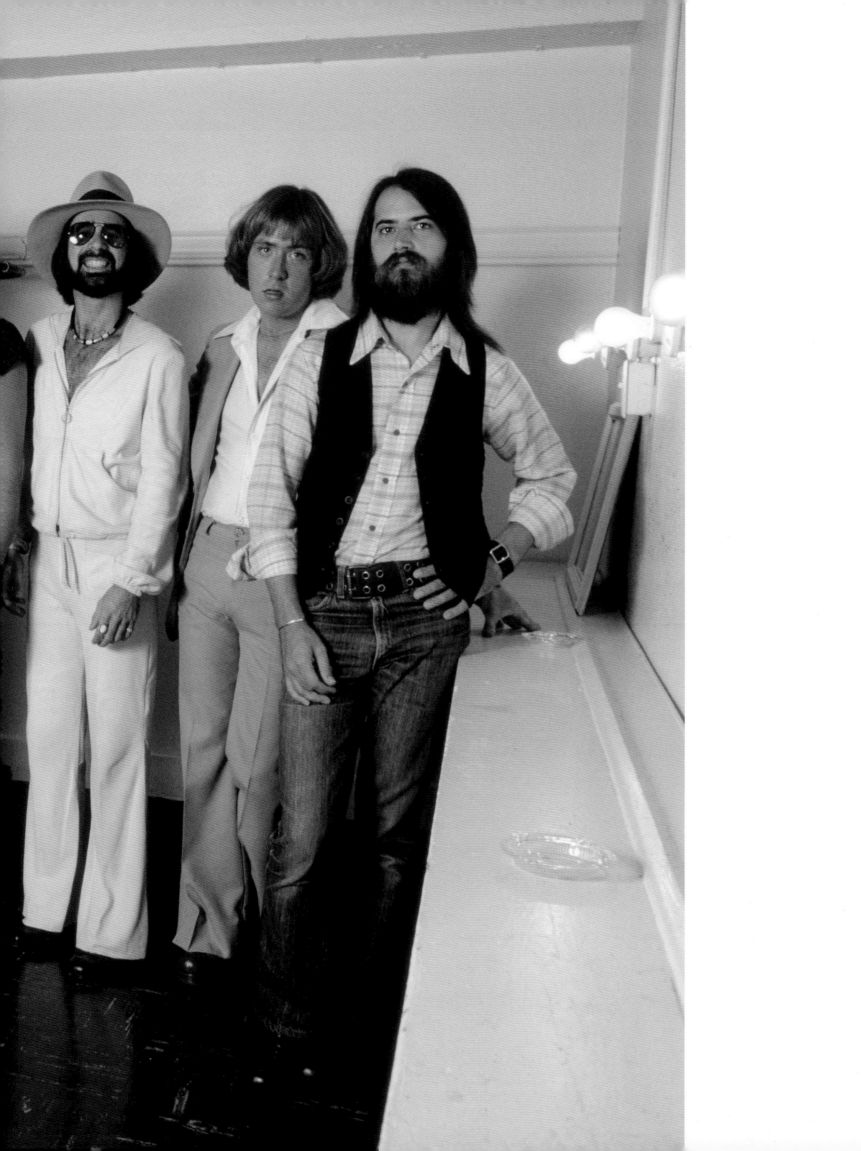

CONTENTS

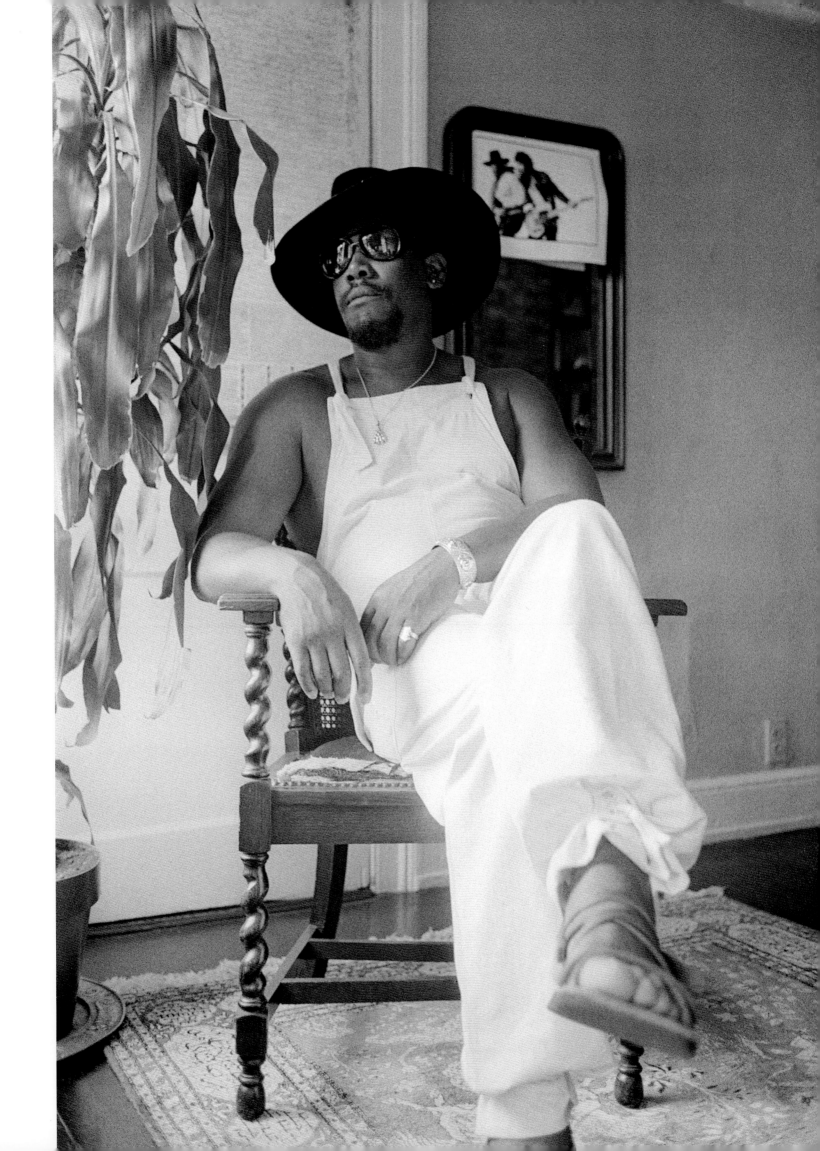

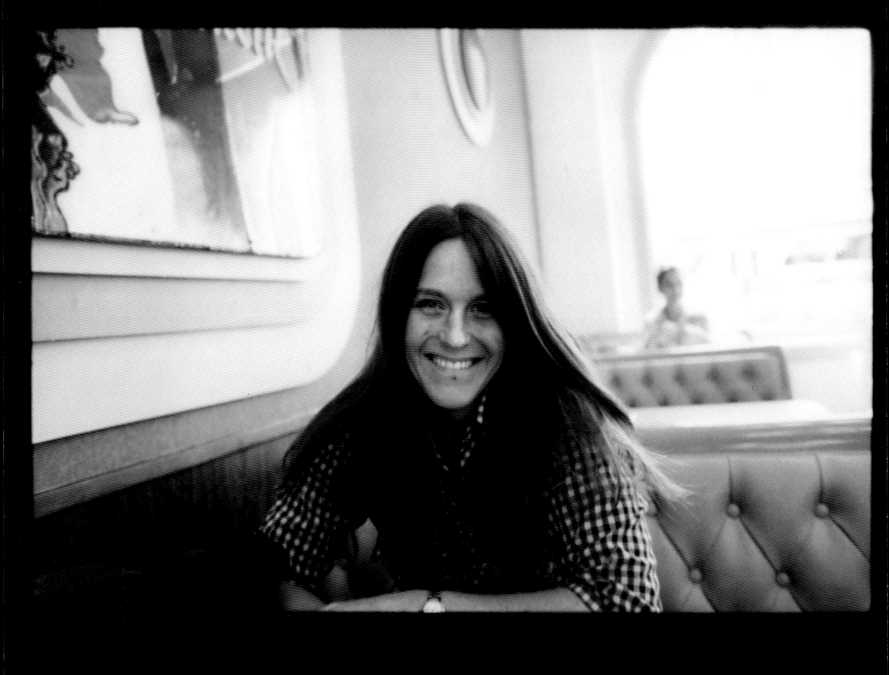

Barbara by Bruce, Bruce by Barbara: McDonalds, Canal Street, New Orleans.

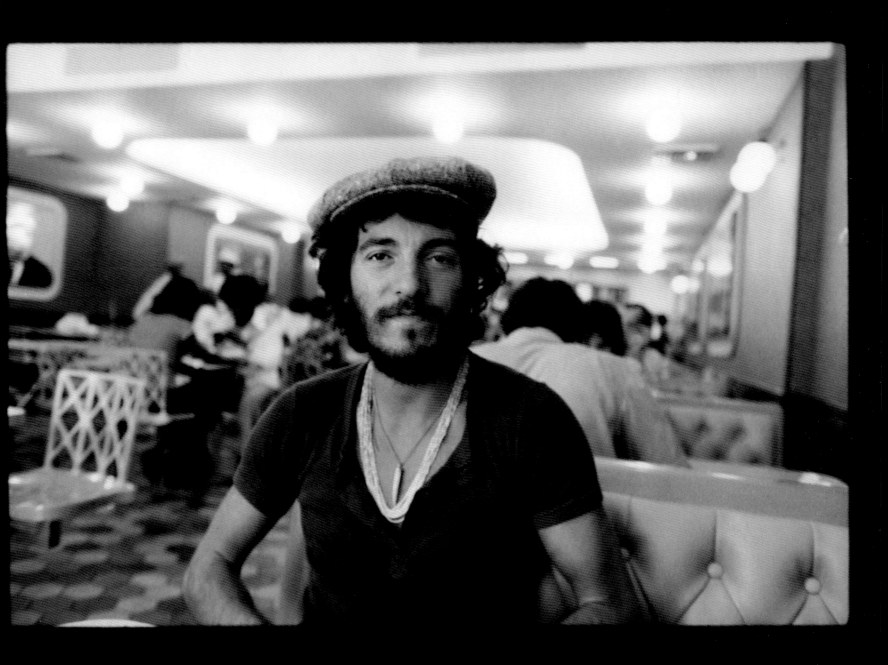

→28 →28A

→22 →22A

SAFETY FILM

After four days trapped within the claustrophobic walls of New York's Record Plant studio in July 1975, time had long since blurred for Bruce Springsteen. An environment that should have symbolized creative freedom had become a prison. Sleep-deprived and driven by perfectionist zeal, he was being pulled between two irreconcilable forces: an album he was simply unable to finish to his own satisfaction, even after over a year of labor and sweat; and the sell-out audience waiting for him that night in Providence, Rhode Island. But, as sound engineer Jimmy Iovine described the tortured creation of *Born to Run*, "he had a picture in his head and as tired as he was, he wouldn't let go of that picture."

Springsteen remembered feeling that last morning as if not only his mind but his body had been broken into fragments: "I was singing 'She's the One' at the same time as I was mixing 'Jungleland' in another studio downstairs. At the same time, I was in another studio rehearsing the band for the gig that night. That's the truth. I almost died." It was a moment so traumatic, he said, that nobody might have believed it was real, were it not for the documentary evidence of a photograph taken by someone Bruce identified only as "this girl Barbara." "It's the scariest thing I've ever seen. You have to see the band. It should be on the cover of that album. You ain't never seen faces like that in your life. We were there for four days, and every single minute is on everybody's face. The light comes through the window, it's like ten in the morning, we've been up for days. We got a gig that night, we're rehearsing, and what's worse is, I can't even sing!"

"This girl Barbara" was Barbara Pyle and the photograph was "Dawn Rehearsal" (see p.64-5). Two months later, Barbara met the E Street Band in New Orleans as they promoted the album that had driven them to the edge and was transforming their lives. She joined the tour and went with them to her native Oklahoma in their bus and took them to her parents' house for home-cooked barbecue. On that very night, the tension finally began to dissolve. The *Born to Run* album, which Bruce had poured his heart and soul into translating musical fantasy into physical sound and fury, had just entered the US Top 10.

"There was an innocence to Bruce's first two albums. They were filled with exuberance and passion," Barbara Pyle reflects today. "*Born to Run* was a different story altogether. For Bruce, this was *the* album. It was his major statement and it needed to be a hit because Columbia Records had really turned up the heat on him to deliver a commercial success. In the studio he became obsessed with detail. He was hands on with everything, every part the band played. They were all great musicians in their own right. Each made their own contribution to the music. He couldn't have done it without them. But Bruce always knew what he wanted to hear."

The record company planned to dump Springsteen if sales of his third album did not match his critical reputation. When *Born to Run* was a hit, they relaxed in the knowledge that they had rock's hottest new property under contract. Yet success would carry its own burden. Springsteen would soon be immersed in a potentially catastrophic legal dispute with his manager. He also discovered that fame could become its own curse; that his responsibilities were no longer to himself and his muse, or even his friends and band mates, but to a worldwide public who imagined that they knew him as a brother or lover. "I felt bad for two, three, maybe four months," he admitted later. "Before that, it had been me and the band and we'd go out and play. We'd sleep where we could and drive to the next show. All of a sudden I became a person who could make money for other people, and that brings new forces and distractions into your life."

That's me, Bruce, Roy and Stevie dancing at a party I threw for the band in New Orleans.
A blast was had by one and all.

Born to Run, as Springsteen has reflected, was the "dividing line" in his career. The album not only transformed him from cult attraction into international superstar but it also symbolized his journey into adulthood. Growing up in New Jersey, rock'n'roll—hearing it, playing it, living within its ecstatic frontiers—offered Springsteen a form of salvation from the petty confines of family life and school assignments. He imbibed its mythologies like nectar and fueled himself on its promise of liberation. At fifteen, Springsteen was in his first band, the Rogues; by sixteen he was gigging regularly with Freehold's local heroes, the Castiles. Over the next few years, he went through a series of different line-ups, realizing that musical creativity and control would follow only if he could dictate his own course. Gradually he assembled a body of like-minded musicians who were sometimes band mates, sometimes rivals, but who shared his belief in the magical power of rock'n'roll. This was the E Street Band, perhaps the only musical amalgam in America equal to the challenge of responding to all of Springsteen's musical inspirations—blues, country, rock, R&B, jazz, folk, pop and soul—and translating them into an utterly distinctive brand of rock'n'roll. By the early seventies, Bruce and his cohorts were delivering incendiary shows in clubs and halls across the nation, rekindling every fantasy that rock had incited in the fifties and sixties. Springsteen himself succeeded in the rare magic act of combining classic rock'n'roll myth-making with personal authenticity, an iconic blend that commanded total belief from everyone who experienced it. As Barbara Pyle reflects today, "Bruce created himself—not in a cynical, manipulative way, but by presenting an image that would be true to himself and also appeal to his fans. He had decided who Bruce Springsteen was going to be and what he would represent. He planned to make it happen and he did."

In August 1974, Springsteen and the E Street Band were back in the familiar surroundings of 914 Sound Studios in Blauvelt, New York. He knew that despite the freewheeling energy of his music, both on stage and on his second album, he had to carry a more profound creative responsibility—musically and lyrically—into the sessions for his next record. "As a songwriter I always felt one of my jobs was to face the questions that evolve out of the music and search for the answers as best as I could," he explained many years later. "The primary questions I'd be writing about for the rest of my work life first took form in the songs on Born to Run ('I want to know if love is real'). It was the album where I left behind my adolescent definitions of love and freedom."

Between sessions, the E Street Band had a steady stream of live performances. On the afternoon of August 3, 1974, they played at the Schaefer Music Festival in Central Park, delivering a set so intense that most of the ecstatic audience left before the headliner could even take the stage. Among the crowd was photographer and music lover Barbara Pyle who was there on a freelance assignment for Schaefer Beer. "That was the first time I'd seen Bruce and the band perform," she remembers today, "and I was completely blown away. I instantly became a huge fan. After the concert, I was raving about the show to photographer Eric Meola. I was working in his studio. Eric already had both the Springsteen albums. A week or so later, we drove to a show in Red Bank at the Carlton Theater and went backstage, which in those days was as easy as walking through the open door. There was no security or mystique. I'd met Bruce's keyboardist Roy Bittan years earlier, long before he joined the E Street Band. He saw me backstage and asked, 'Aren't you Kitty Pyle's sister?' Wow. Small world. I loved the music so much I went to every concert they played within driving distance of Manhattan." Barbara also struck up individual friendships with the band.

I thought it would be fun to illustrate some of the images in Bruce's songs. This photo by the Exxon sign (from "Jungleland") was the only occasion I ever attempted a set-up shot with any of the band. To this day, I still can't believe I convinced Roy and Clarence to do this! I also shot Madame Marie's (from "Sandy," see p.28-9) which is a real place on the boardwalk in Asbury Park. She was a locally-known and beloved clairvoyant.

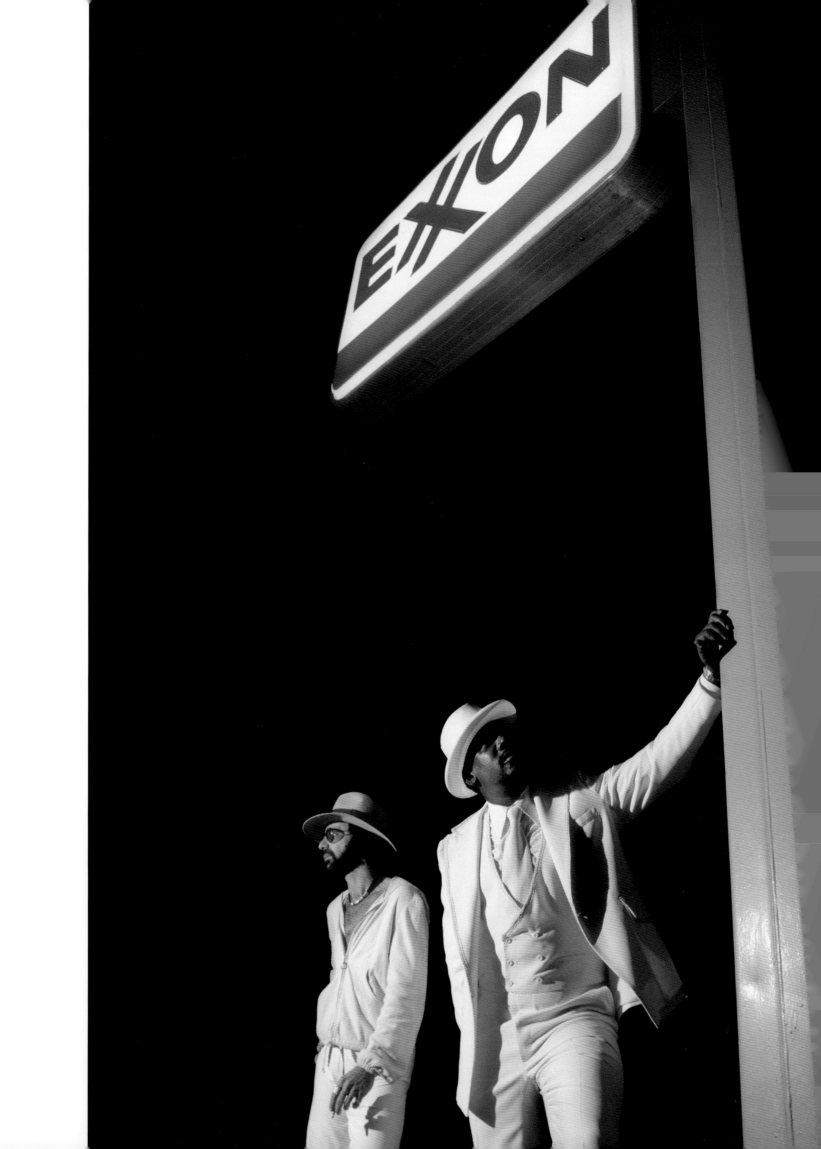

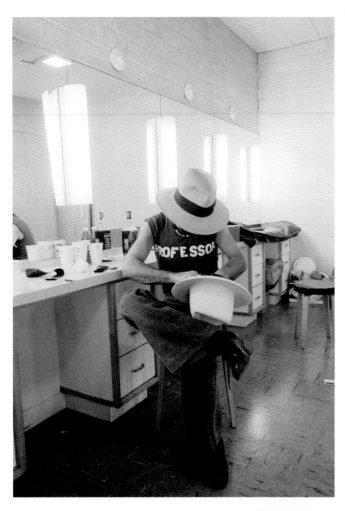
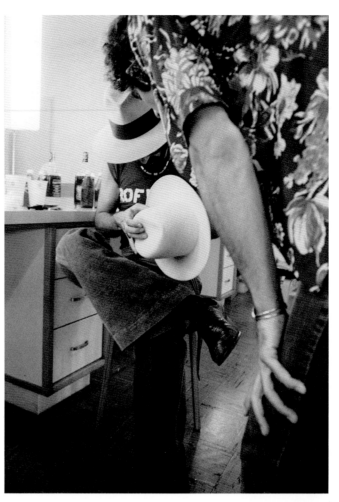
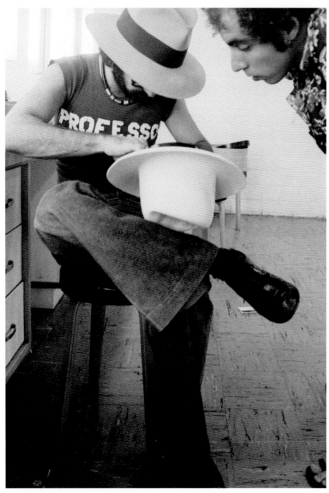
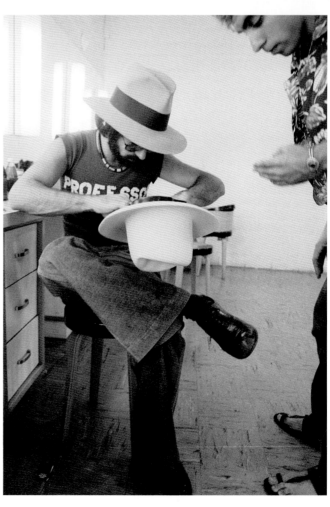

As Springsteen's reputation grew, so the band's touring schedule widened and they spent less time on the East Coast. But by the summer of 1975, their third album was still incomplete and they had moved from 914 to Record Plant on W 44th Street at 8th Avenue near Times Square in New York, a seedy neighborhood populated with characters right out of Bruce's lyrics. The wall of sound Springsteen wanted on the album was challenging for him to reproduce in the studio. The Record Plant sessions were descending into a marathon of repetition and self-doubt. One night, Barbara Pyle dropped by the studio to visit her friends. "Bruce was stuck," she recalls. "When I turned up at Record Plant, something shifted. I was already a full-on studio rat from all the nights I spent at Sea-Saint recording studio in New Orleans. I became sort of a fixture and was expected to be there almost every night. And I was. But I never felt comfortable photographing Bruce in the studio. The stress was palpable. I didn't want to intrude." The *Born to Run* sessions ended in the exhaustion so visible in "Dawn Rehearsal."

Ahead lay some of the most difficult years of Bruce Springsteen's career, as he adjusted to the responsibilities of his fame while being stymied by a bitter legal battle with early manager Mike Appel. Yet the musician and artist who emerged from this trial of endurance was clear-sighted, driven and focused: not just a remarkable songwriter, producer and peerless entertainer, but someone who would later become a political player.

Barbara Pyle had already undergone a similar process of artistic and personal transformation. She forged a stellar career as a filmmaker, environmental activist and photographer. For her body of work and humanitarian efforts, Barbara has received dozens of personal commendations including the world's most prestigious environmental honor for lifetime achievement, the United Nations Environment Program Sasakawa Prize. Usually reserved for scientists, she is the only member of the media to be named a Sasakawa Laureate. In 1997, she created the Barbara Pyle Foundation with the award money; its mission is "to use media in all its forms to make the world a better place and empower people to protect the planet." Producing and directing such groundbreaking TV series as *People Count* and the children's animated eco-toon *Captain Planet and the Planeteers*, as well as documentary films such as *The Day of Five Billion*, *Without Borders* and *One Child – One Voice*, Barbara has done as much as anyone to alert the world to the imminent threat of environmental apocalypse. Her work today centers around the Barbara Pyle Foundation, with a focus on the six hundred thousand-strong global Planeteer Movement. Comprised of young adults who grew up watching Captain Planet, the Planeteers have taken her message of environmental balance and sustainability into their hearts and lives. She has also returned to her former life as a marine photographer, shooting yacht races while at the same time winning them. Her passionate fury about the state of the planet and the intransigence of world governments—along with her ferocious energy—remain undimmed.

So does her affection for the work that emerged from a simpler time, forging a unique bond between photographer and musician. Pyle remembers, "There was an honesty between us that can only come from endless hours locked in the studio, hours that bled into days, weeks, months. It is that honesty you can see in Bruce's face. I respected him and he knew that. So he trusted me."

"I love these pictures," Barbara says today. "There have been a number of runs at making this book over the decades but I would always bail out when I found myself writing endless pages of notes to publishers explaining why the band needed to be included in the story. Then I'd just give up and quit. No other publisher saw the band as critical to the book. Not until Tony Nourmand and Reel Art Press. Tony saw my vision and understood it. Now he has made the book I always wanted. It was worth waiting forty years to find him. Thank you, Tony, for respecting these pictures and the story they tell. They were taken with passion and belief, not for money. In fact, the only time I got paid was for taking the band's passport pictures! Looking back at them now, they're touching—and honest. My gut instinct said there was something important about that unique moment in the lives of Bruce Springsteen and the E Street Band. Photographing them was a hobby but then it became a mission. As a photographer with full access, I considered it my duty to document what was happening. I knew it was big. I am grateful to finally tell that story."

Peter Doggett

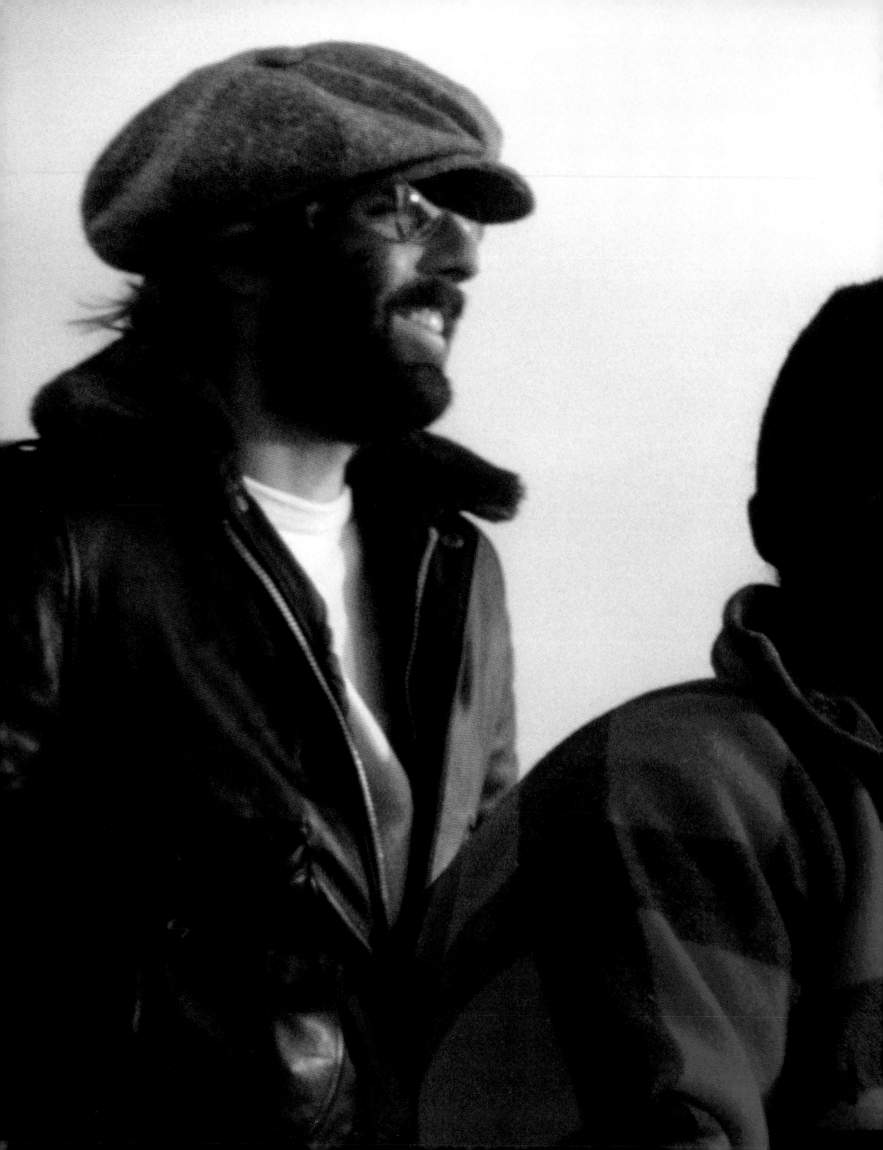

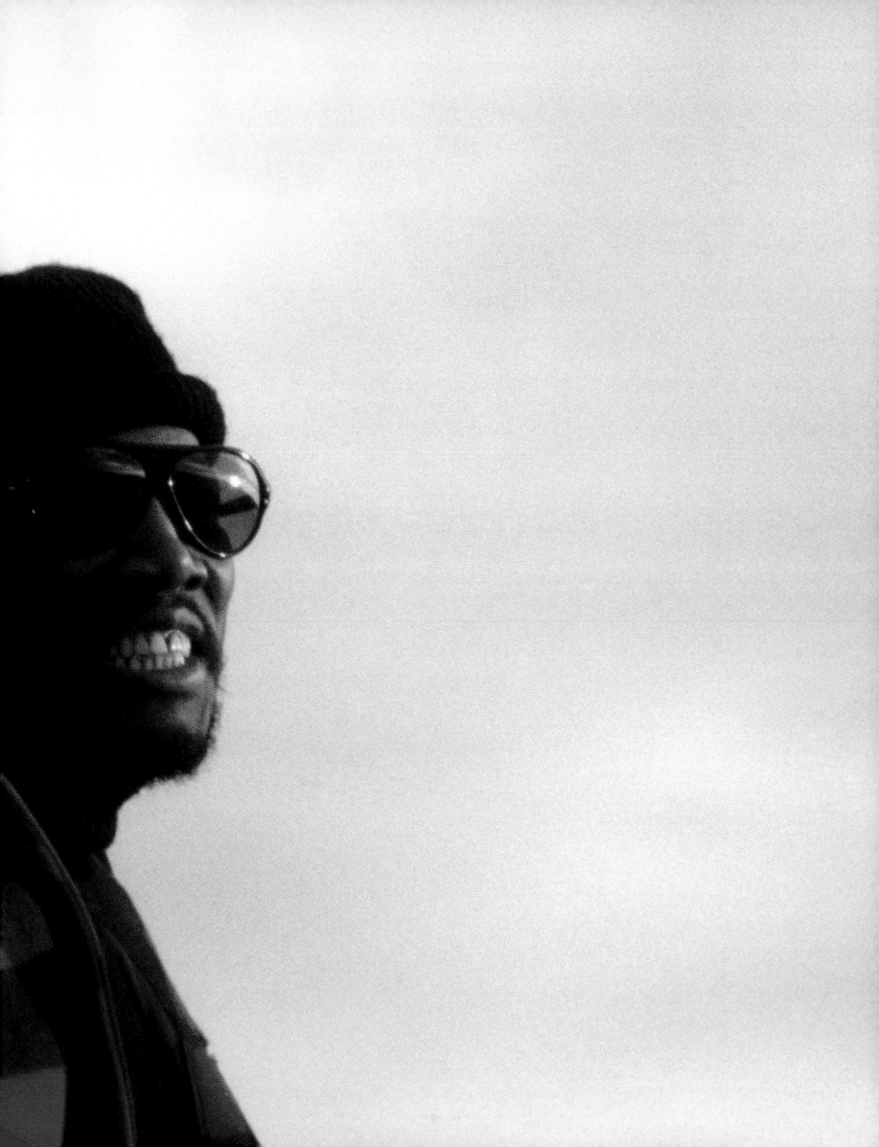

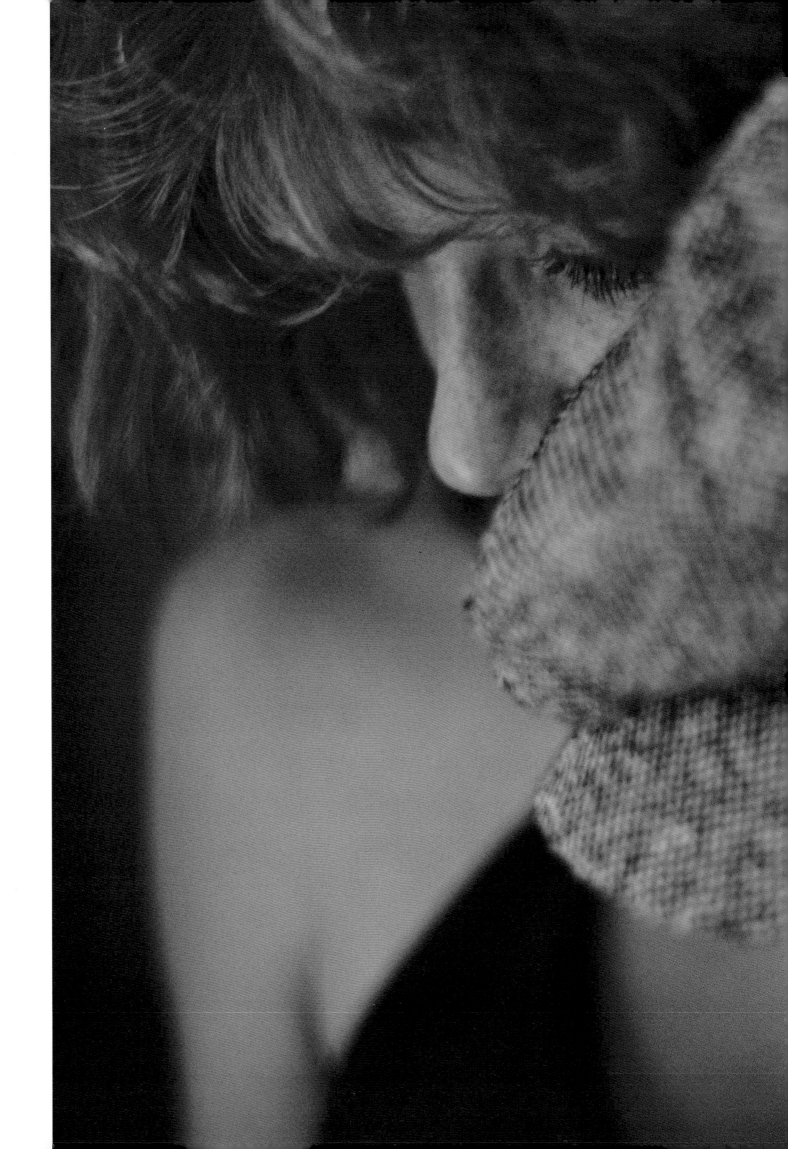

BREAKFAST WITH BARBARA PYLE

Barbara Pyle is as equally fluent in streetwise vernacular as she is in the more refined language required at the highest levels of political diplomacy. This morning I get a mix of both in a strikingly colorful message asking if we can push our breakfast meeting a couple of hours. My long distance, sometimes complex and frustrating telephone and email dealings with Barbara over the years trying to pin her down to talk about her photography suddenly all made sense as our first face-to-face meeting is delayed because of a late-night charity fundraising event! As we walked into the restaurant at The Savoy, London—Barbara's hotel "by the river"—past the sign that says "breakfast until 11 a.m.," she is already greeting and being greeted on first name terms by all the staff and we are shown to a table set for breakfast, standing apart from the rest which are set for lunch. "They know me here."

But as I discover, it's not the late nights that are the issue. Pinning Barbara down has been difficult because she is rarely in the same place for very long and is extraordinarily busy with full-time humanitarian and environmental projects that are extremely urgent. While Barbara is getting her hands dirty making significant changes to our planet, I feel a bit silly pestering her to talk to me about some forty-year-old music pictures. The specific purpose of our meeting is to discuss doing a book of 1975 photographs of Bruce Springsteen and the E Street Band. Most music photographers have shot some non-musical subjects but Barbara is a photographer who happened to shoot some musicians during a long and varied career. This, and the fact that everyone instantly feels comfortable around her, resulted in a unique series of photographs of Bruce and the band at the most crucial point in their career. After two hours of gossip and laughter, Barbara pulls out an envelope with a strip of negatives of Bruce that she has brought over for a master printer in London to work on. Holding them up to the chandelier she says, "These are good! OK, let's do this book."

Barbara does things her own way. At times it is difficult to keep up but it's clear that she never stops working. She works hard, parties hard and takes no shit. She is multi-talented, charming, eloquent, funny, generous and full of surprises. Her story is fascinating and a real revelation. In her own words, "One thing led to another . . ." Barbara effortlessly moves around the world, making films about sustainable development, covering the America's Cup and countless other yacht races. She opened a commercial darkroom in New York, was sent on assignments for NBC that were "too dangerous for cameramen," shot covers for *Time* magazine, won countless awards including a clutch of Emmys, set up environmental awareness projects and filmed many groundbreaking documentaries and TV programs, including the influential *Captain Planet* series. As we talk about last night's soiree and the many other events that Barbara supports, it's clear she puts the fun into fundraising while tackling serious environmental issues.

I introduced Barbara to publisher Tony Nourmand and she agreed to work with Reel Art Press. Tony flew to Atlanta to spend time going through contact sheets and negatives with Barbara, unearthing countless unpublished photos and hearing the stories. We all met again a few months later in New York to review the book layouts that they had pretty much assembled by hand, using scissors, paper and tape. Later, Barbara threw a party. We were entertained with a night of "not to be printed" stories that sounded like the script of a Scorsese movie. Rock stars and world leaders, hustlers and thieves, an assassination, strip clubs, private jets, yachts, tropical islands and a cast of characters along the way with names that could be from a Springsteen song!

And finally this book, just a small part of Barbara's work but a major part of Bruce Springsteen and the E Street Band's legacy. A rare, intimate, honest and fun look at 1975, as Bruce and the band explode from the small US club scene to international fame and recognition. Barbara's is one of the most fascinating books about Bruce Springsteen but I'm pretty sure there is an even more fascinating book to be done about Barbara!

Dave Brolan
Photo Archivist

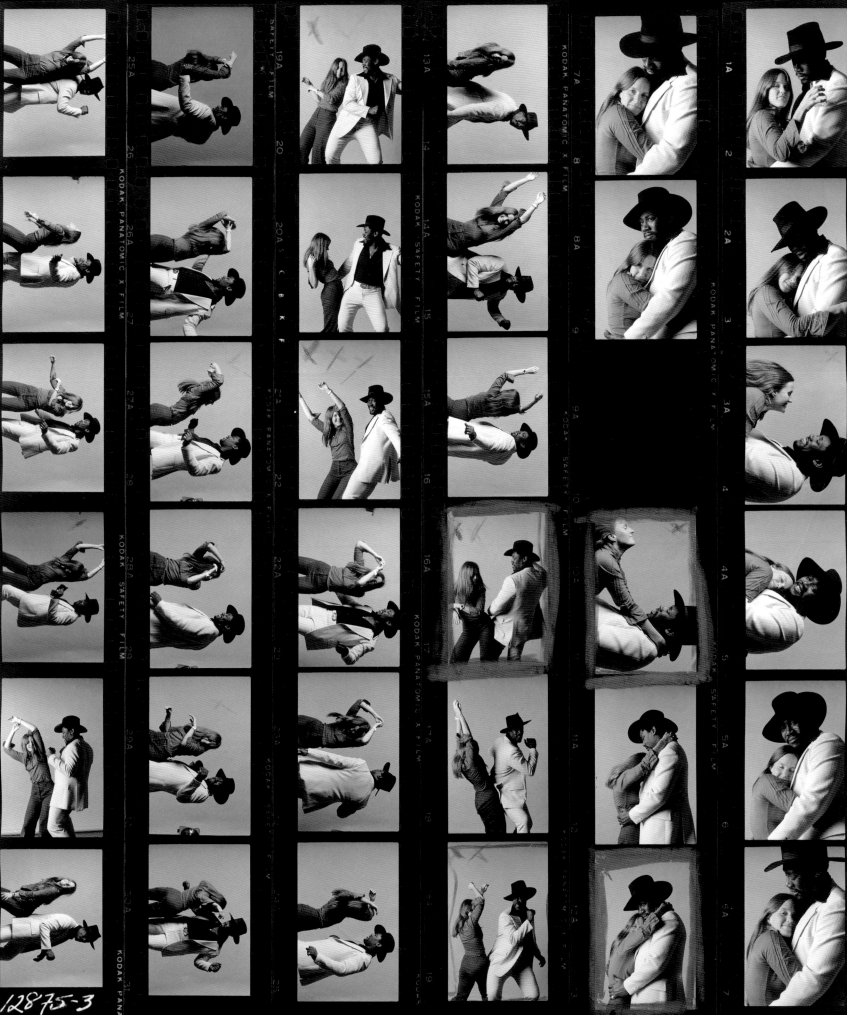

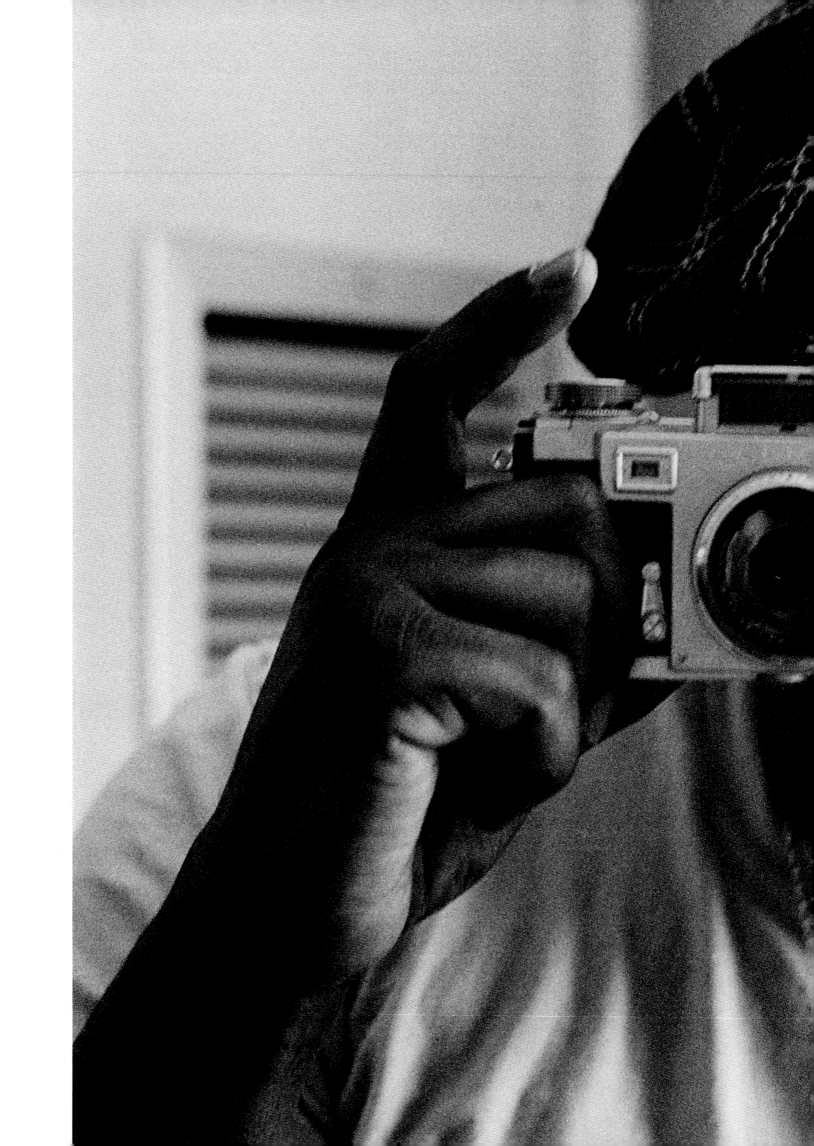

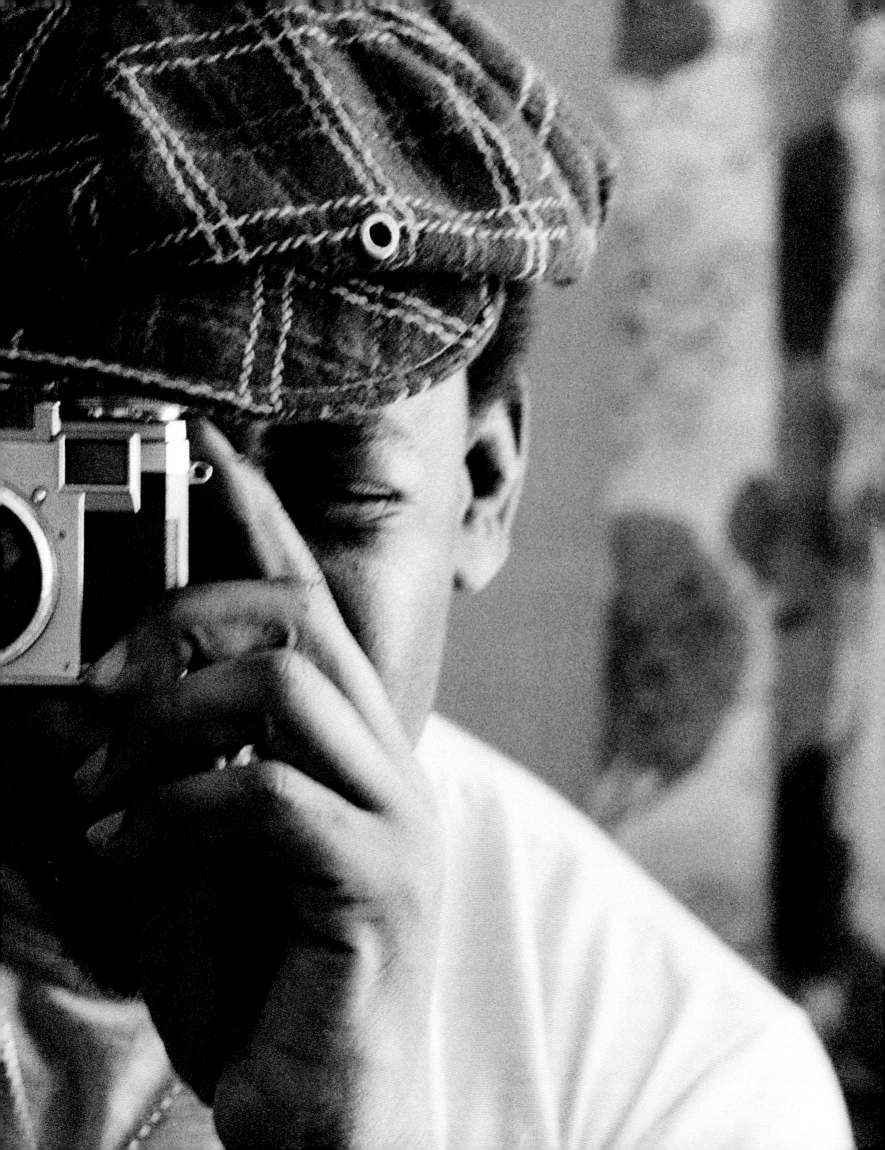

OUT IN THE STREETS

Bruce Springsteen's album *Born to Run* was released in August 1975. Months of meticulous writing and rewriting of music and a grueling schedule at Record Plant recording studio had resulted in a masterpiece.

A mutual friend, Sean Callahan, who was then an editor at *Playboy*, called me in the late summer of 1974 to ask if he could send over a photographer who needed a studio to photograph some models. Barbara Pyle had long brown hair, piercingly hypnotic eyes, had graduated from Tulane and could talk faster than anyone I had ever met. And she had a Leica—several of them. Soon we were driving to all the Springsteen concerts we could see, and in those days we simply walked to the side of the stage and photographed without being stopped. I vividly remember one night at Bryn Mawr College when Bruce sat at the piano to play "For You," and Barbara's Leica barely made a sound as she pressed the shutter. In the absolute silence of the moment it sounded like a gun. Bruce stopped and looked over with a trace of a scowl but then continued. It was the only time I ever saw her doubt herself as a journalist and it lasted all of a second.

Alfred Wertheimer's photographs of Elvis Presley have become the standard by which all rock photographs are judged; and certainly Barbara's work is in that pantheon. These intimate images document the roadhouse, garage band look of Bruce and the E Street Band out in the streets of New Orleans, Barbara's hometown of Pauls Valley, Oklahoma, and in the small venues they played before the era of arena rock. Her photographs of Bruce and the band before, during and after the release of *Born to Run* are a dazzling document of a moment in time that the poet of a generation stood at the edge of glory and grasped it.

Bruce's career is one of the most written about in the history of rock and writers and photographers have documented its every facet. Yet three years after the release of the album, a ticket to a Springsteen concert was still only five dollars and fifty cents. *Born to Run* brought fame yet there was still a long road ahead to fortune, and more importantly the maturity and breadth of a career that would lead one day to the Kennedy Center with Barack Obama stating "I'm the President, but he's *The Boss*." As much as we believed Bruce would one day be famous, we had our own lives to make. We watched from a distance as the kid from New Jersey went from "Bruce *who*?" to one of the most respected and prolific musicians in the history of rock. I followed Barbara's career as she moved from one project to another, always breathless, whether with the Kayapo Indians in the Amazon or accepting the prestigious Sasakawa Award from Kofi Annan at the United Nations. We last met in 2011 in Florida at the funeral for Clarence Clemons, mourning the loss of our dear friend.

These photographs document a band that went on to create music that gave us hope and purpose as the Woodstock Nation grew up. They are a memory bank, a set piece, a wonderful collection of moments that went by all too fast. After photographing the birth of *Born to Run*, Barbara caught her breath and went on to her own quiet glory. The girl with the bare midriff and the short, halter-tops from a small town in Oklahoma, who spoke with such disdain about "hippie chicks," went on to change the world. In the brilliance of these images I see the glimmer in Barbara's eyes that became a life filled with drive, purpose and selfless determination to leave this planet a better place. I see her flashing smile and know how privileged I was to be a small part of it and to have her as a friend.

Eric Meola

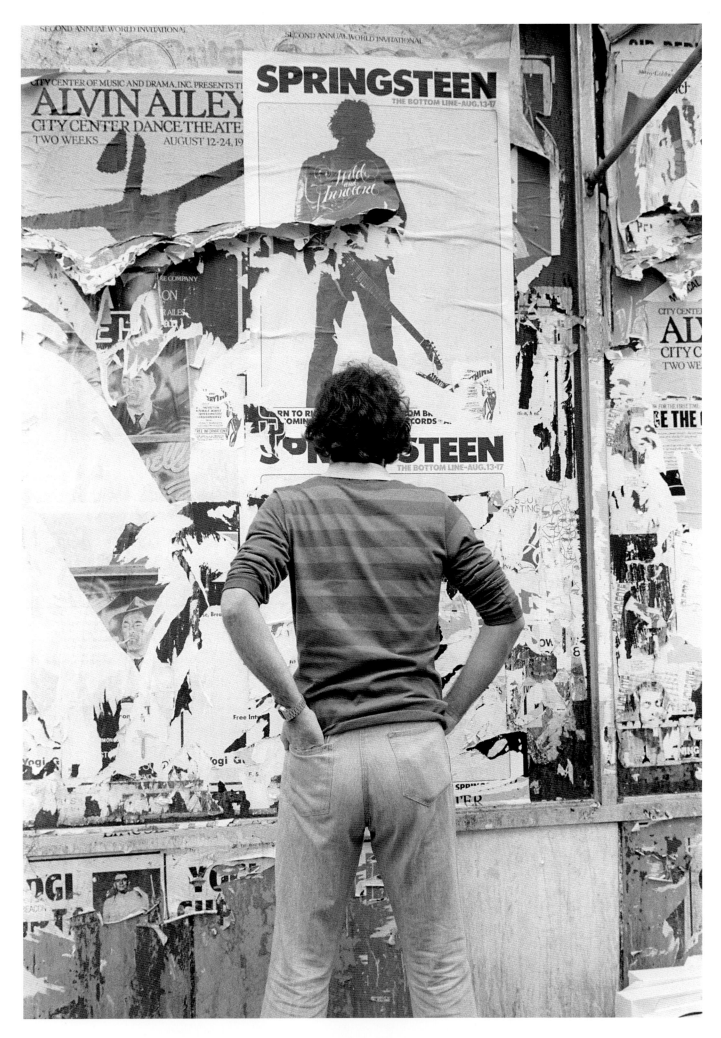

Eric Meola, who shot the iconic *Born to Run* album cover, in front of his poster.

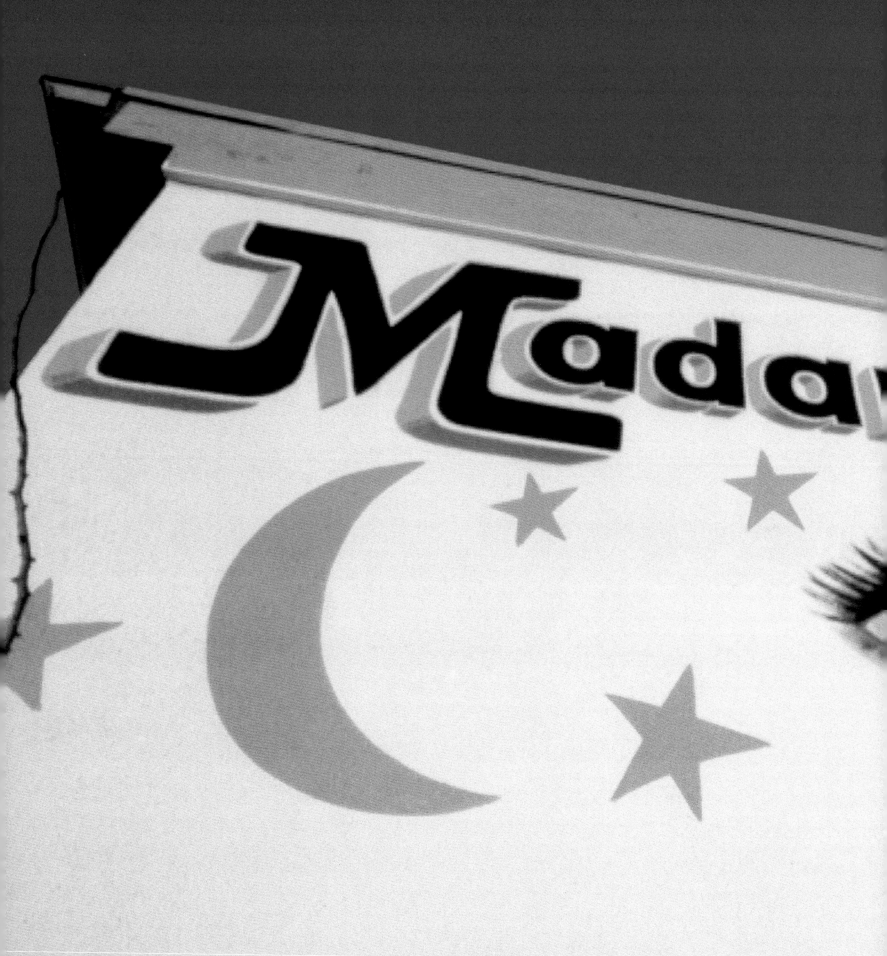

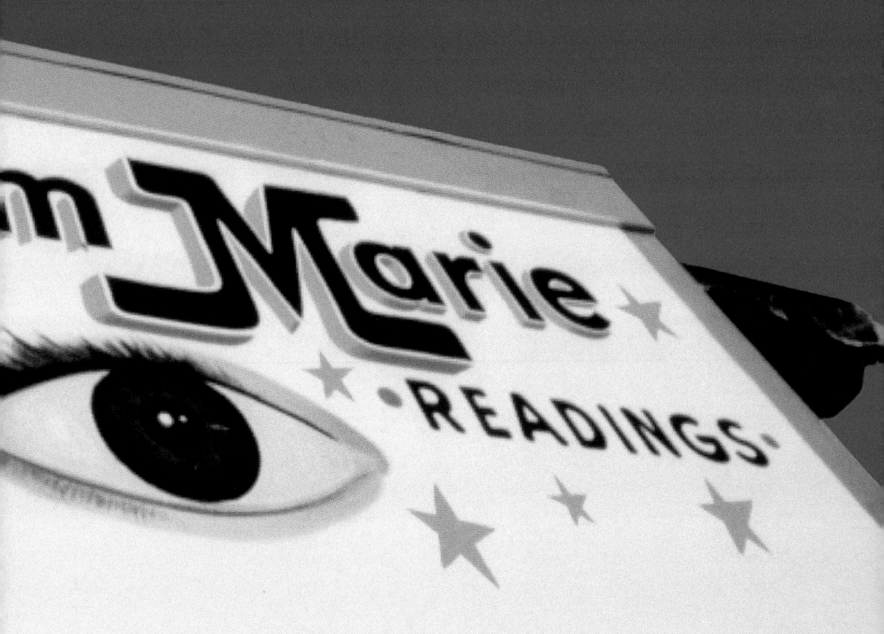

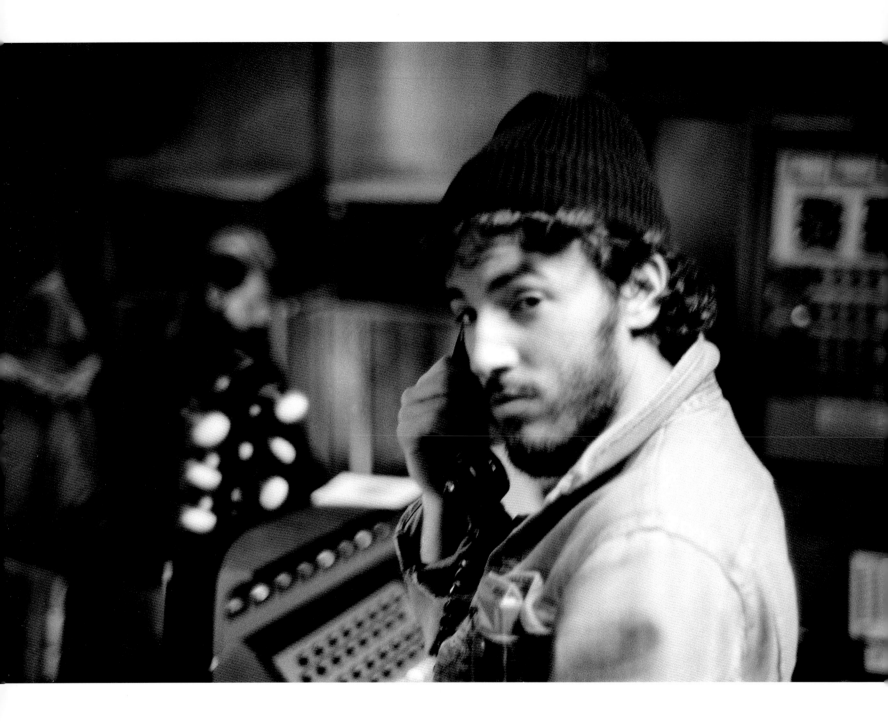

Bruce had already recorded his first two albums at 914 Sound Studios in Blauvelt, New York, on Route 303. The initial sessions for his third record were there too. The band still included keyboard player David Sancious and drummer Ernest "Boom" Carter. The site has now returned to its original function as a garage.

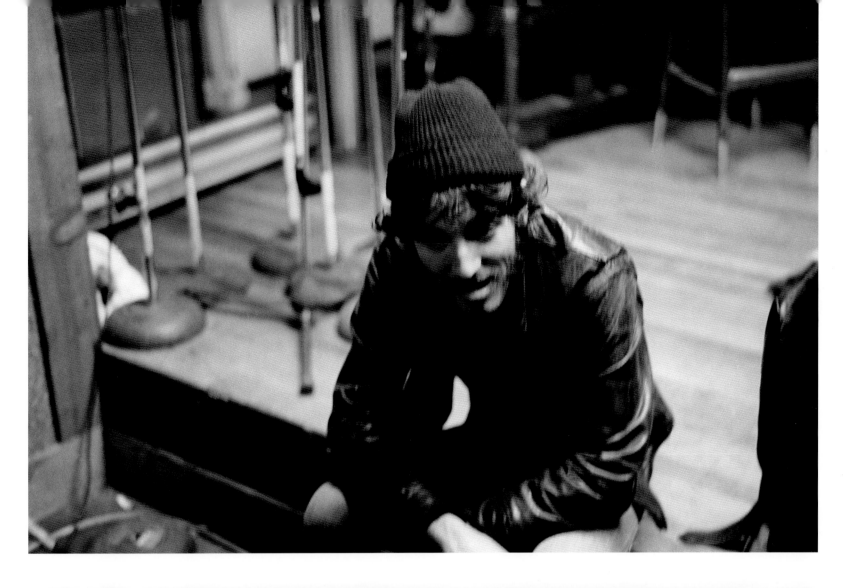

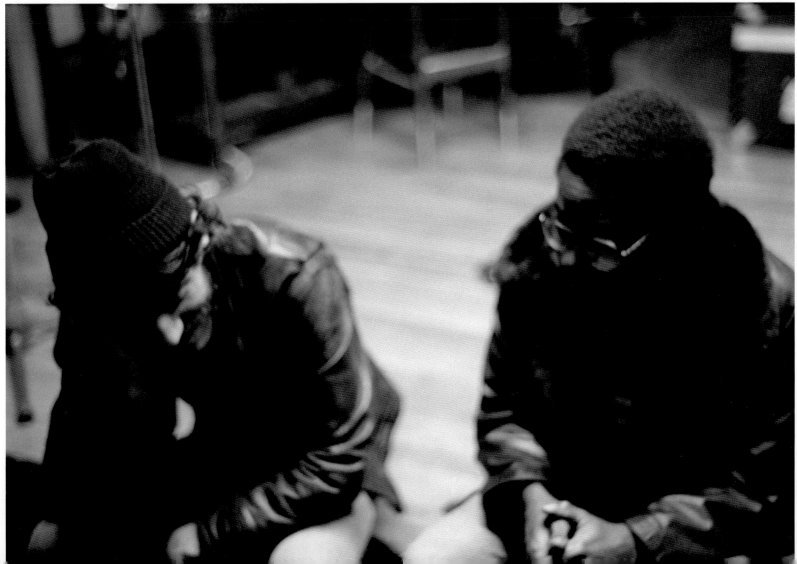

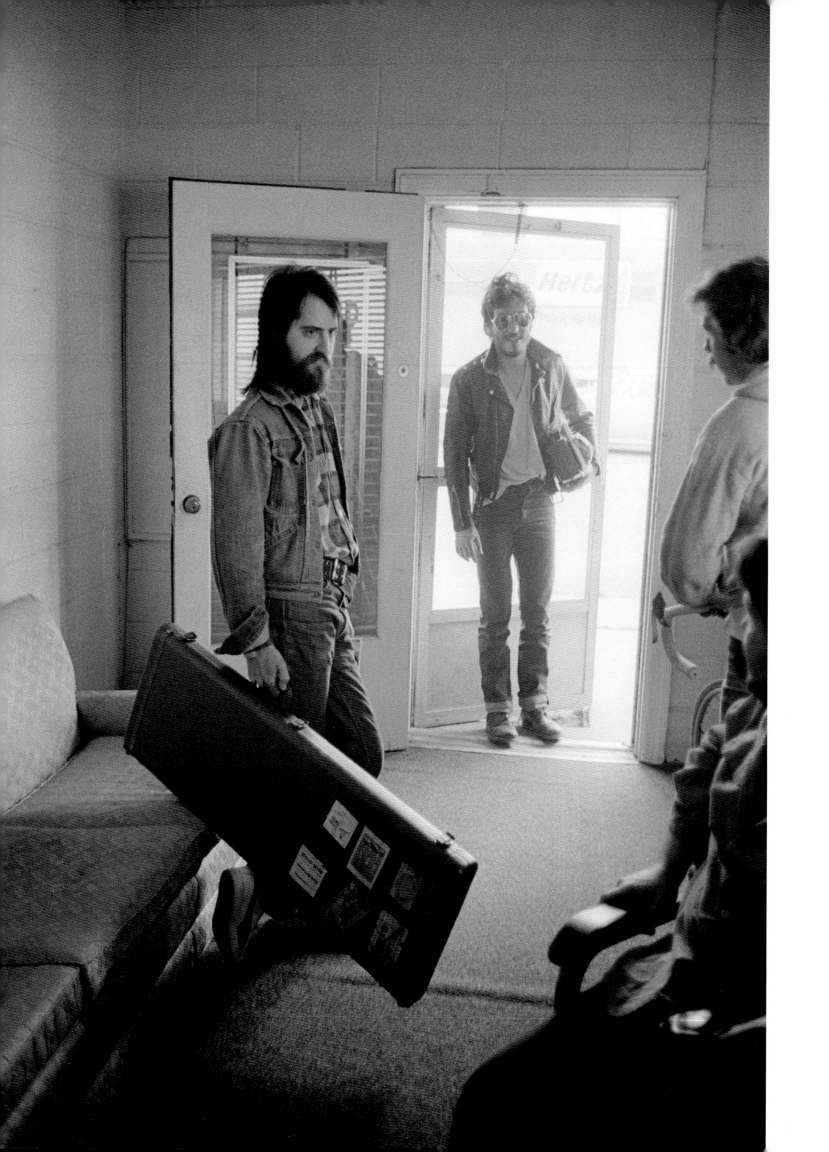

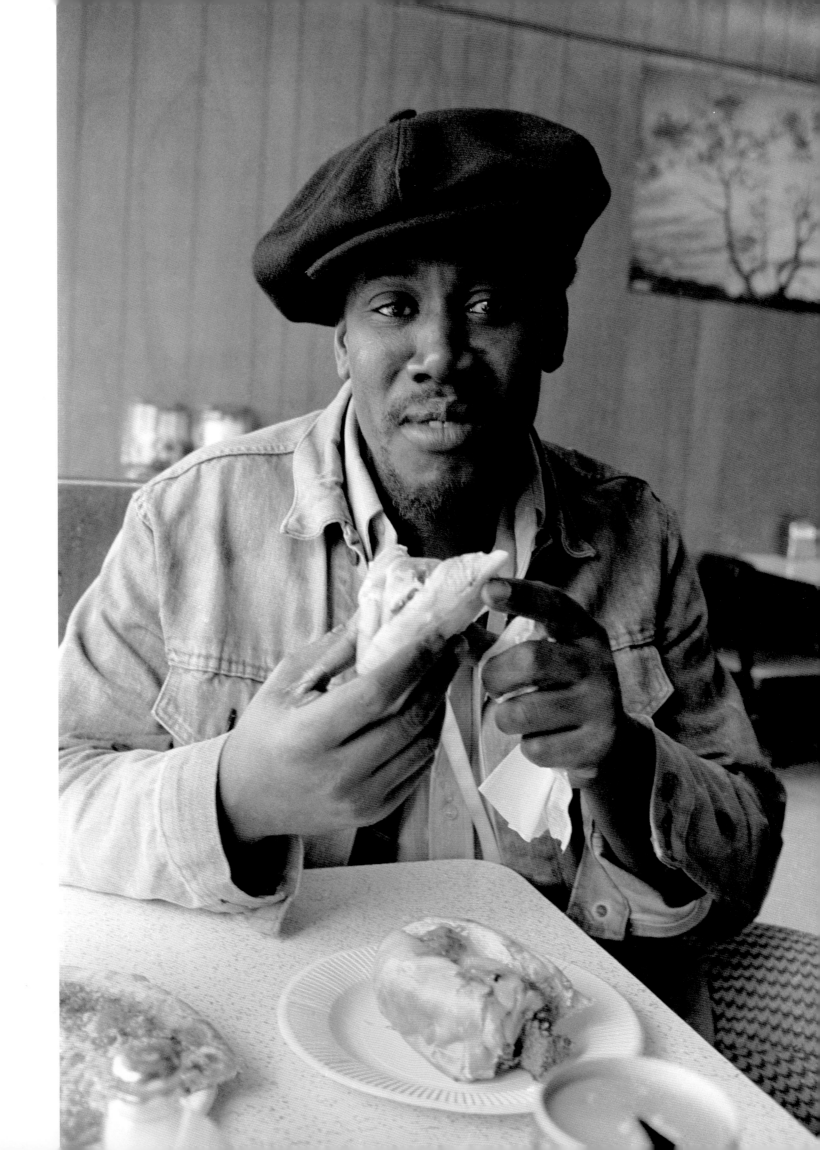

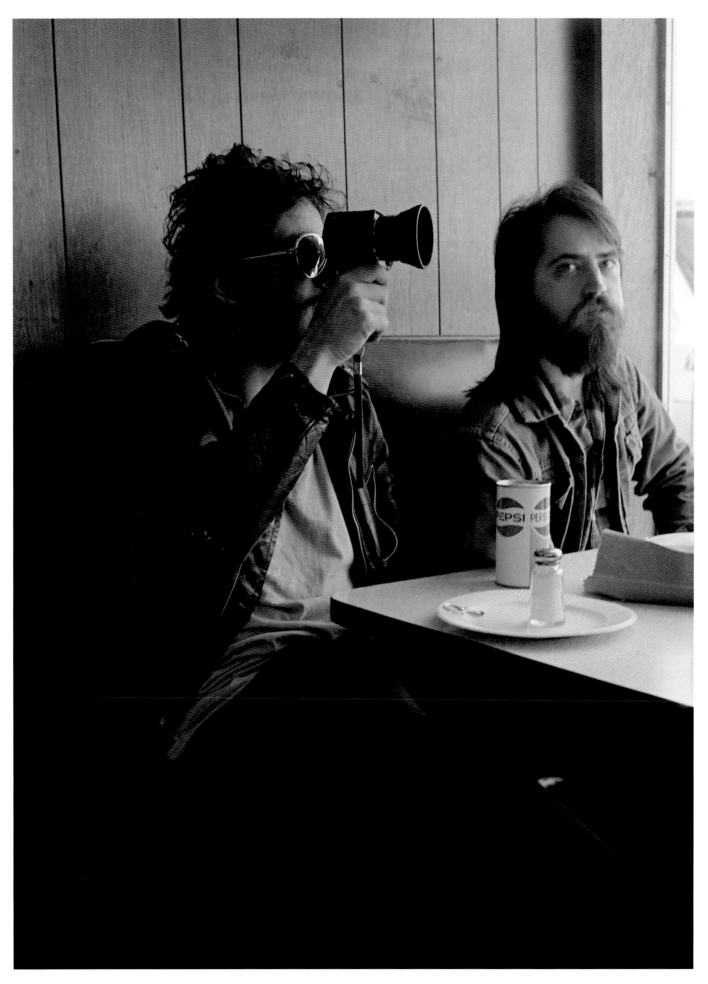

Bruce was fascinated by all the camera gear I dragged around with me. He always wanted to know how it worked and what it was for. This particular gadget is a spot-meter.

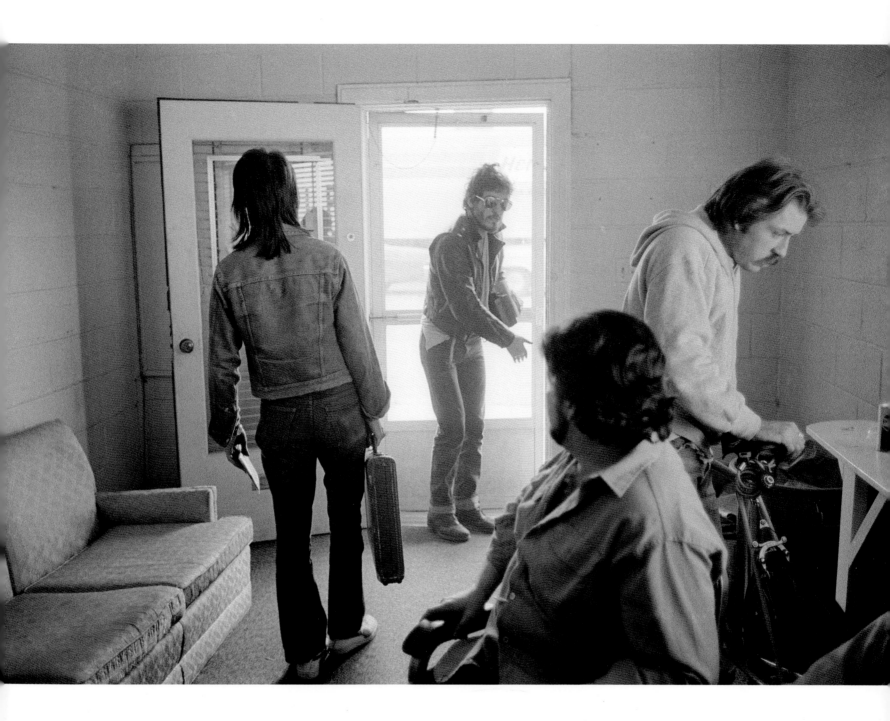

I only took a few photos at 914 because it was my first time in the studio with them. My editors at Time *magazine, Arnold Drapkin, John Durniak and Michele Stephenson, would say, "You're going to photograph Bruce who?" I would always answer back the same, "You won't be saying 'Bruce who?' for long!"*

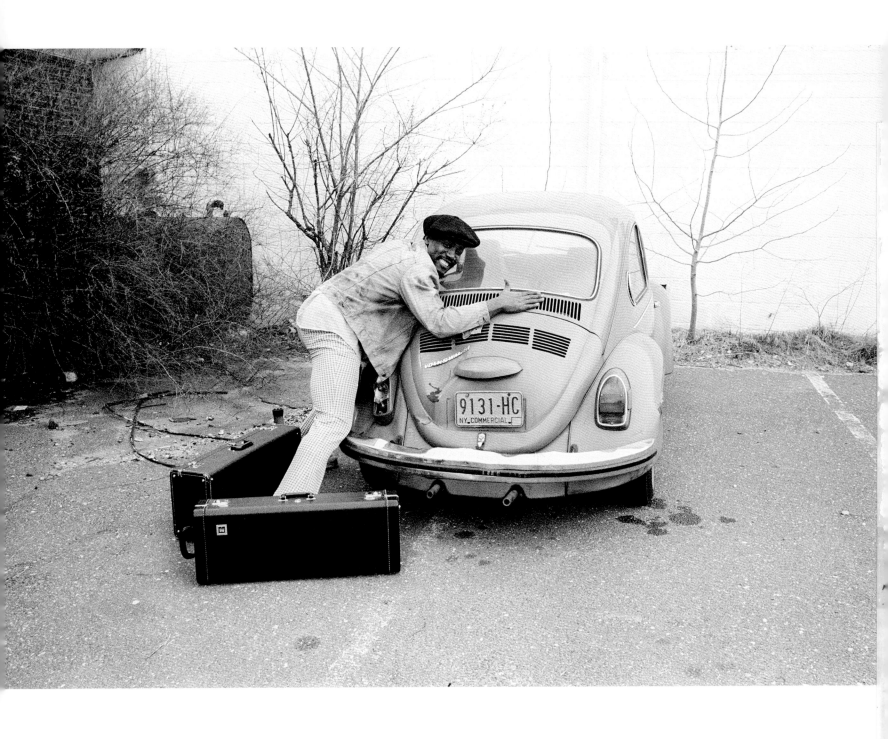

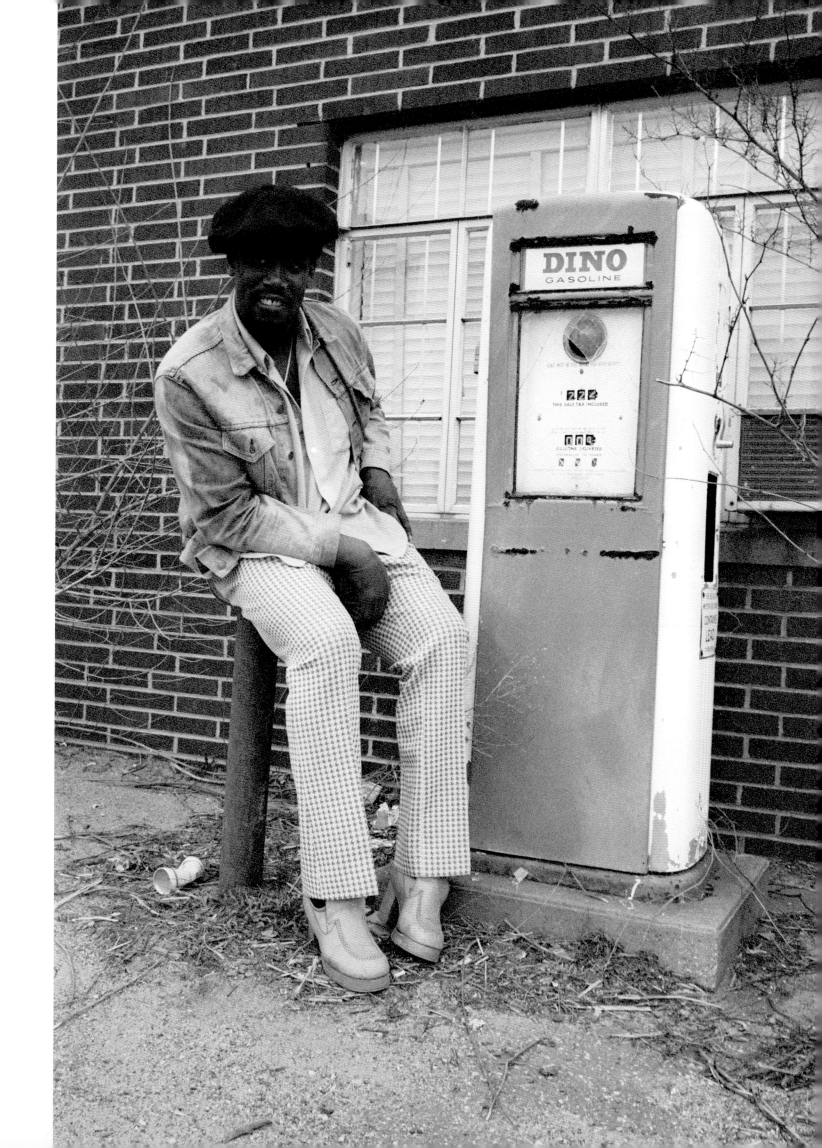

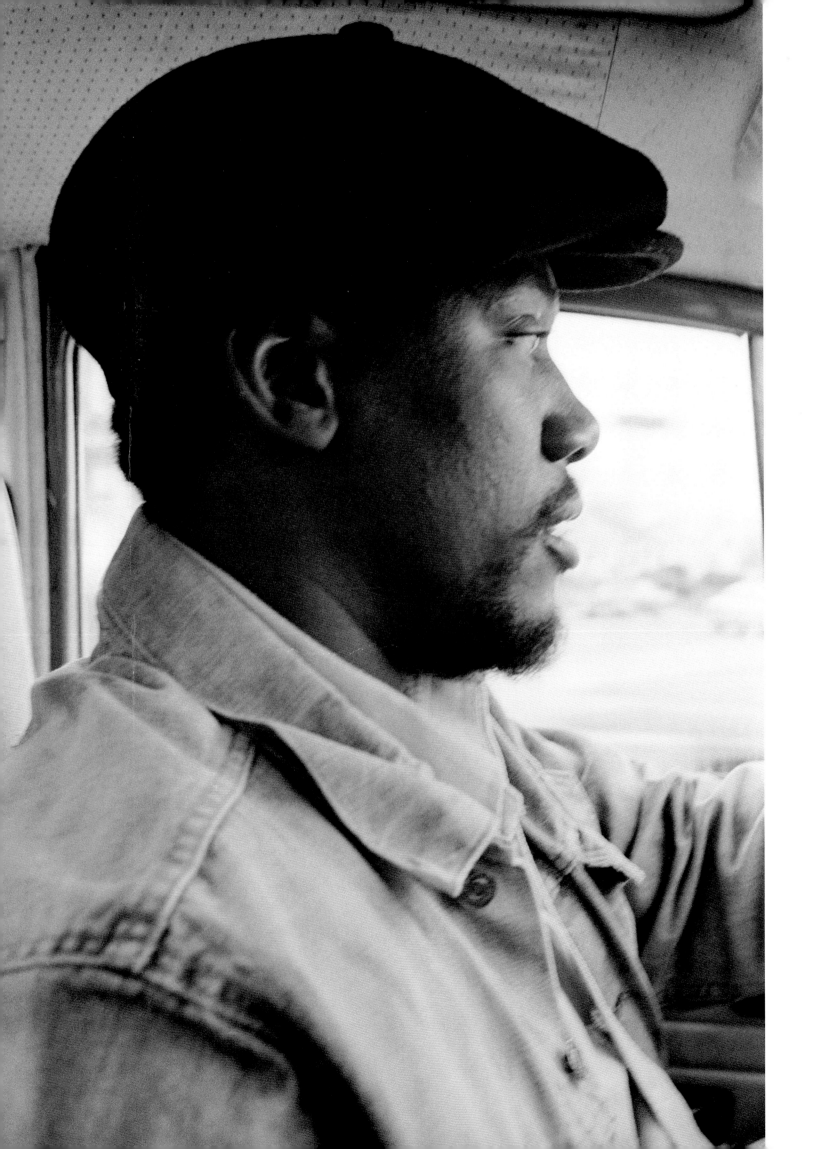

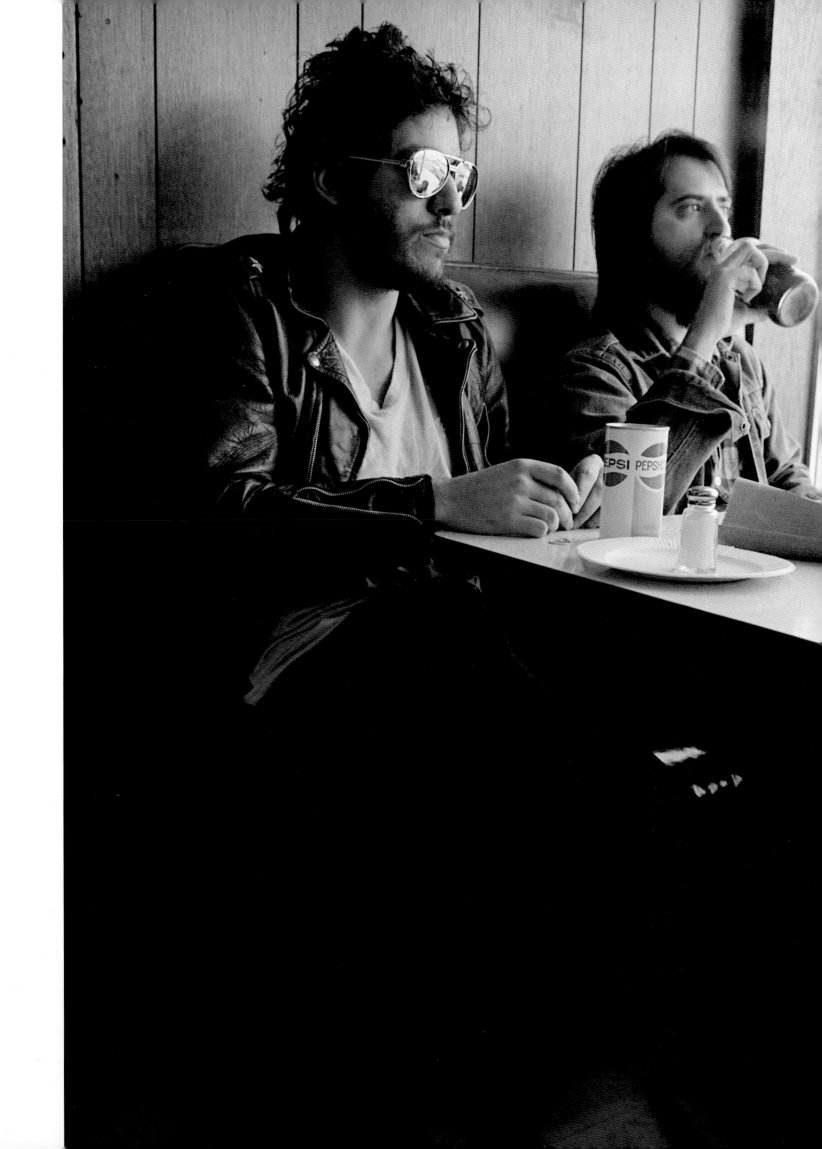

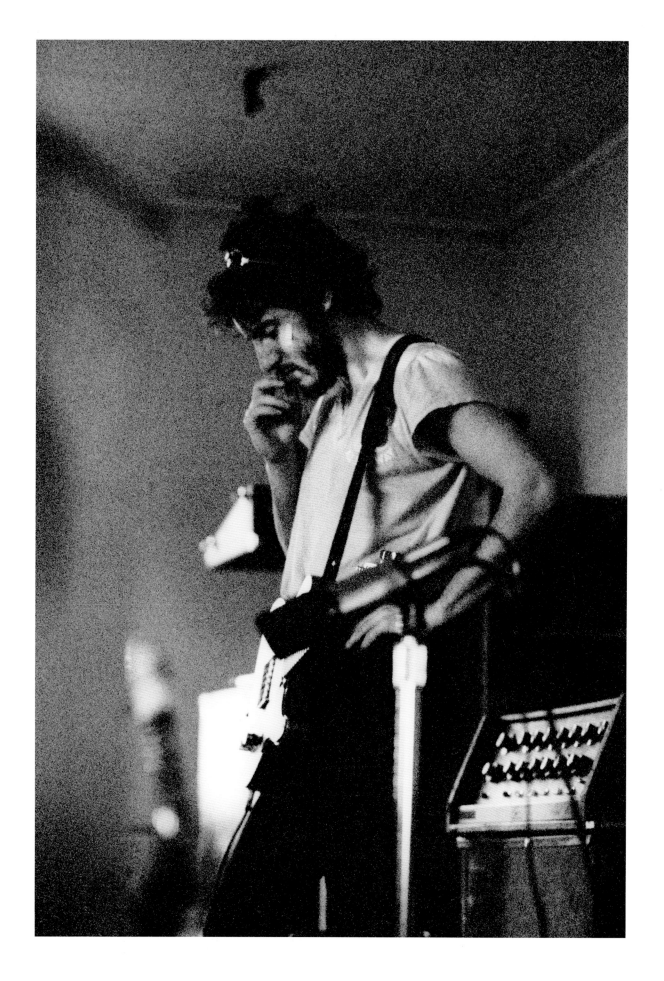

"For a while there I lost the groove. I lost the spirit of the thing somewhere. It became very confusing to me."
- Bruce Springsteen

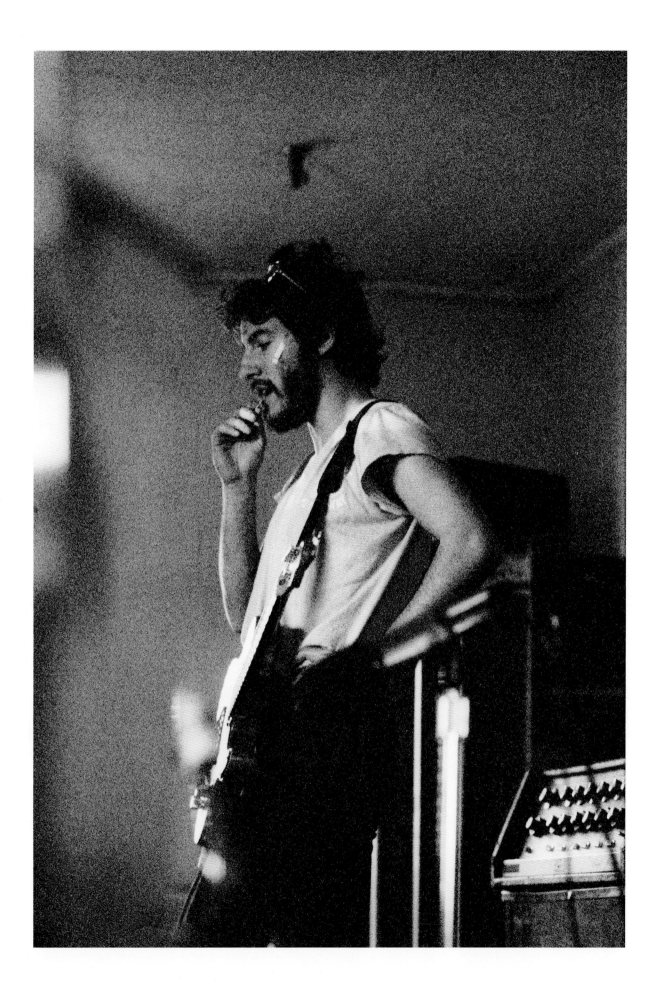

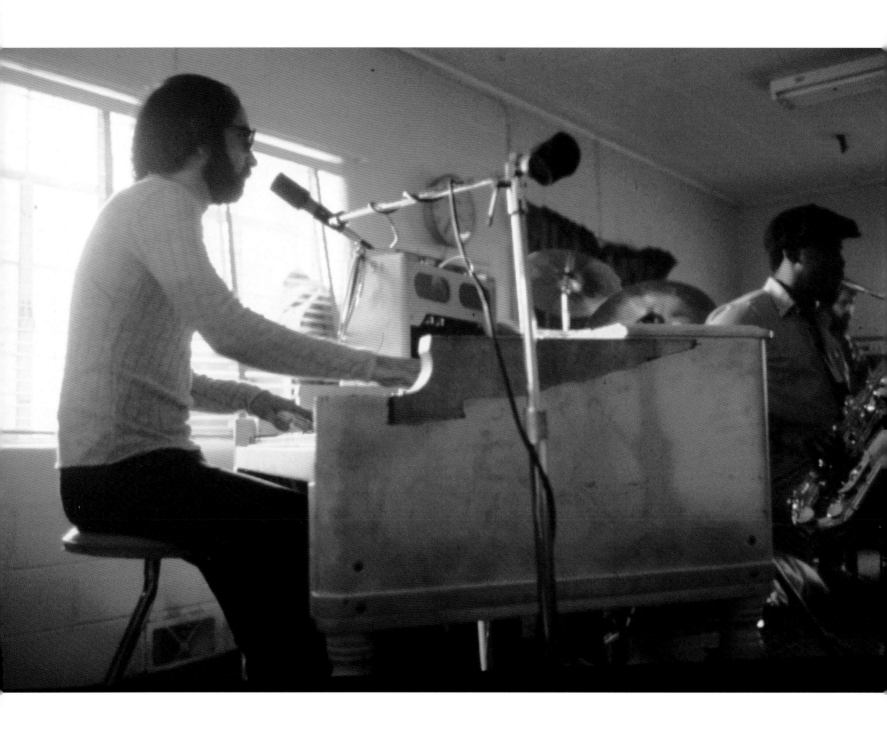

"Roy would take the intros and the themes and the melodies that I'd written and turn them into something that had a kind of power that my own very basic piano playing could never match. His piano playing really defined the sound of that record."
- Bruce Springsteen

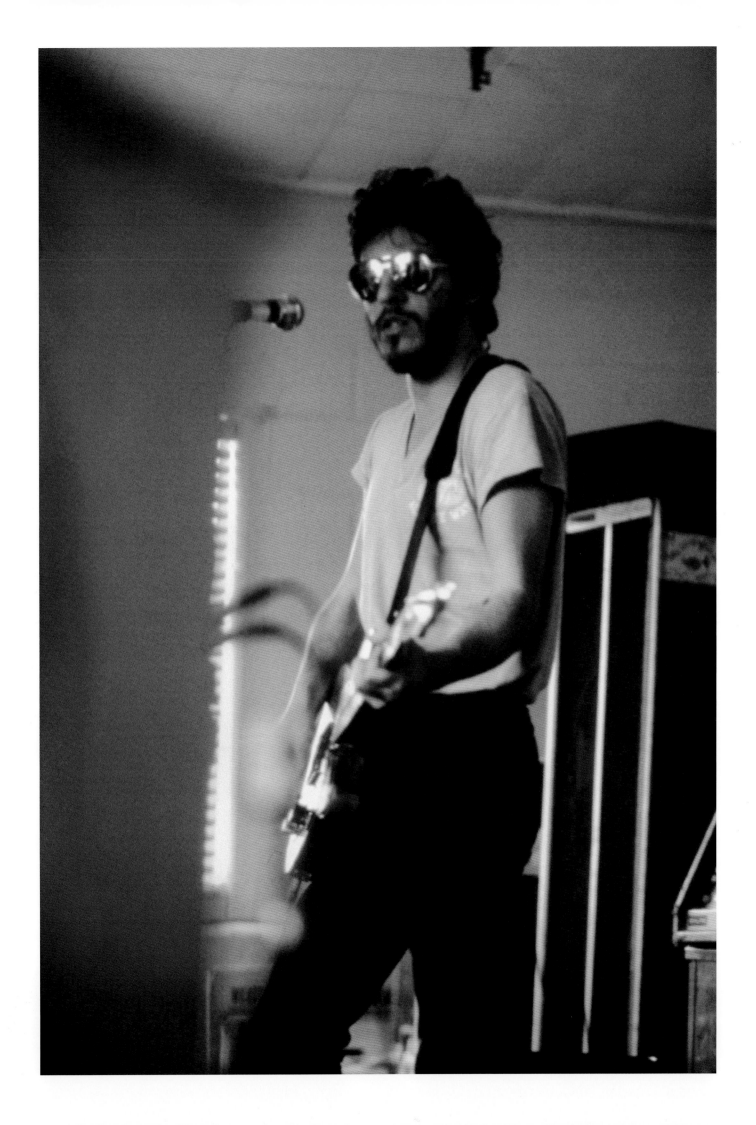

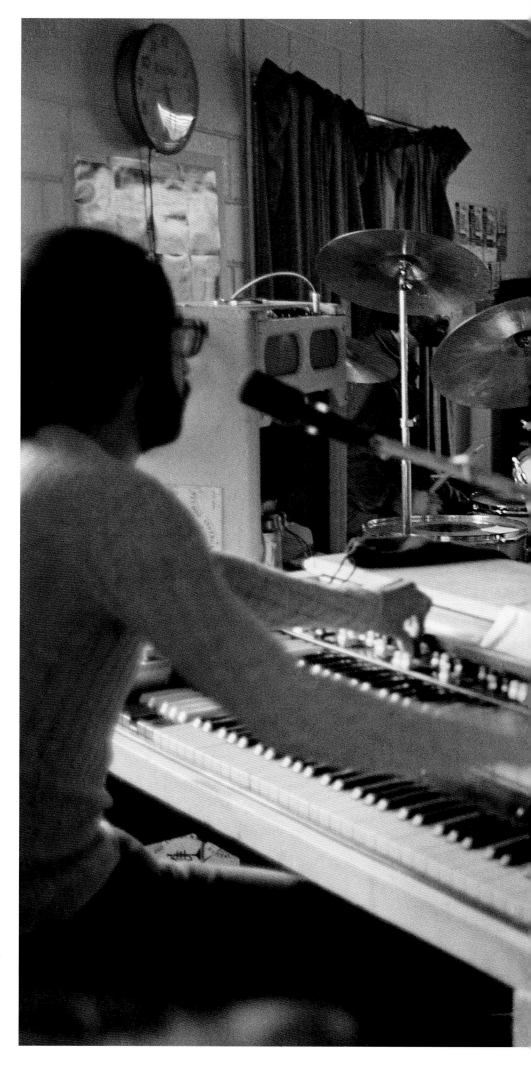

I sat behind Roy's piano so I wouldn't disturb Bruce. This rehearsal hall was on Bangs Avenue in Neptune, New Jersey.

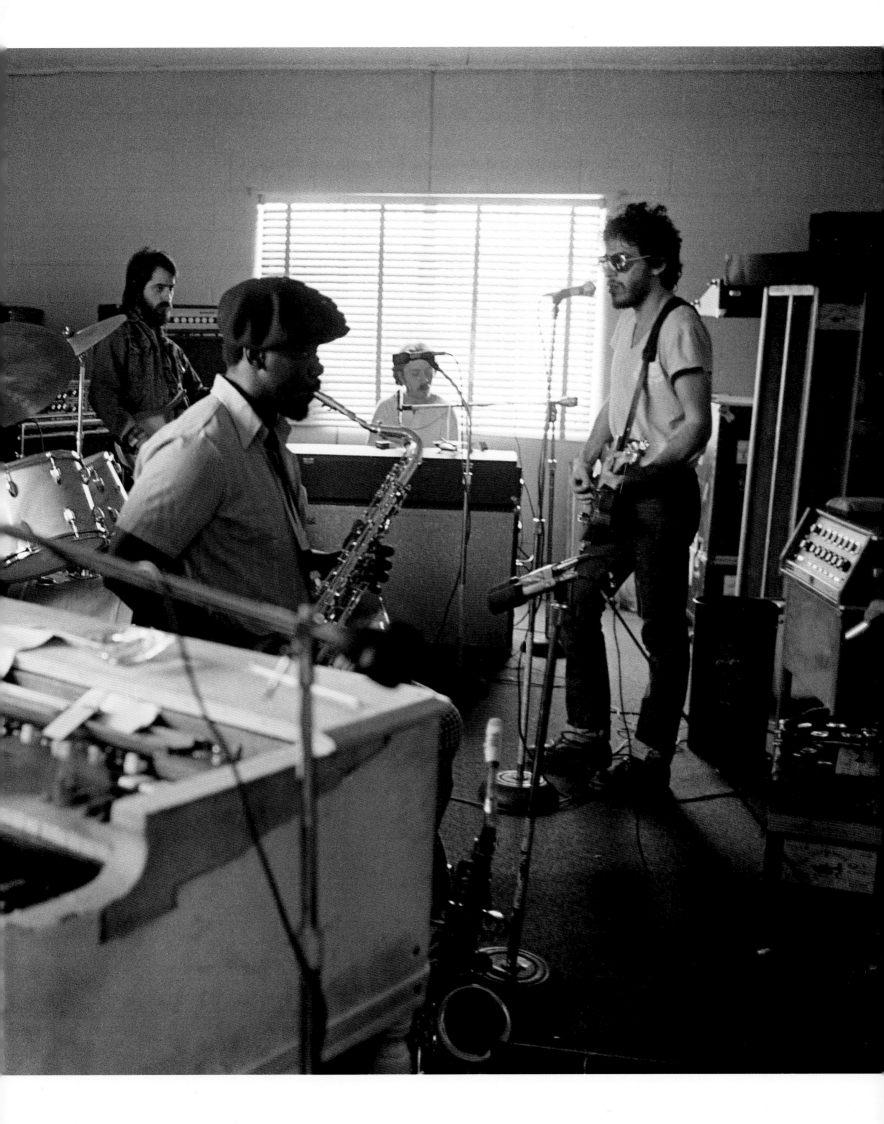

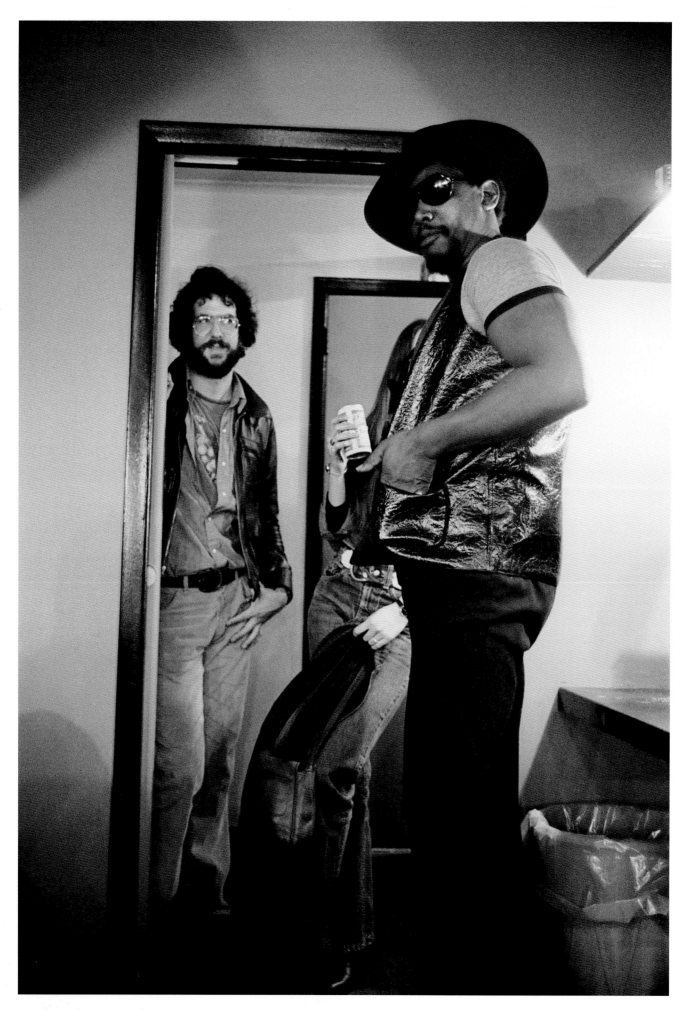

Eric Meola backstage with Clarence at one of the infamous Bottom Line concerts.

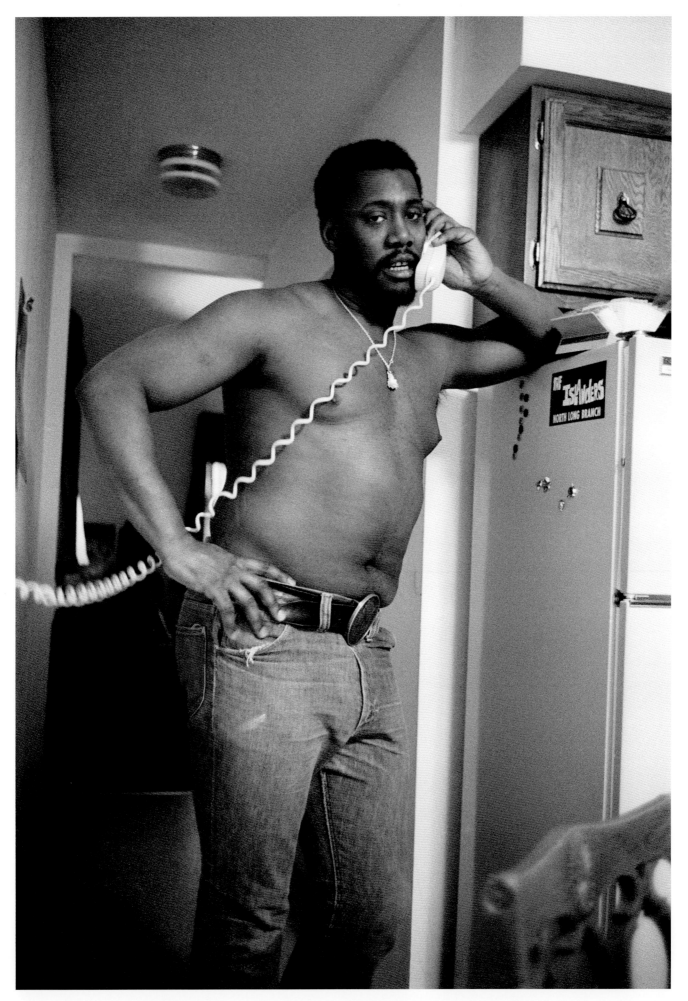

Clarence at his apartment in Sea Bright, New Jersey.

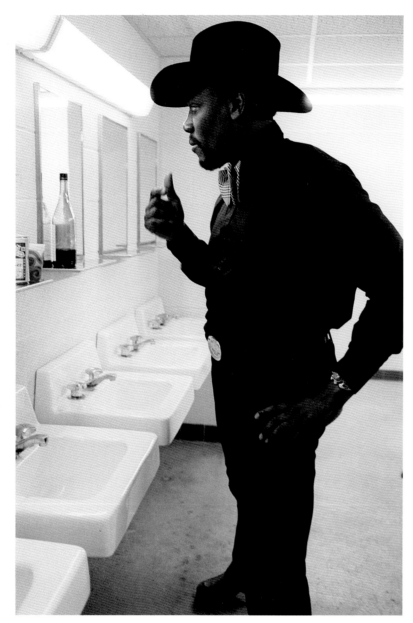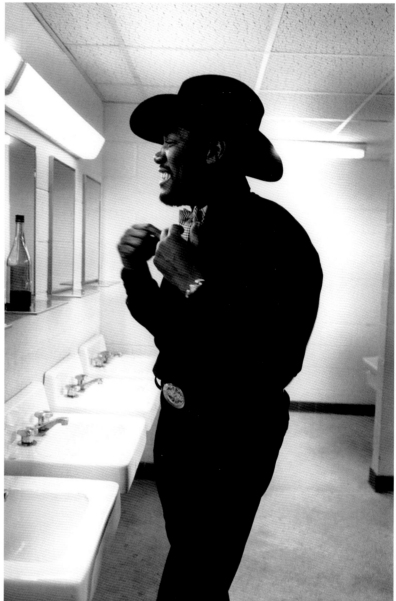

Clarence Clemons was a kind and gentle giant of a man. In front of an audience, he was the exact opposite. I would watch him in front of the mirror, here in a men's bathroom, psyching himself up. He actually became The Big Man right in front of my eyes. Offstage, he was our friend Clarence. Onstage, he was The Big Man, the perfect foil for Bruce.

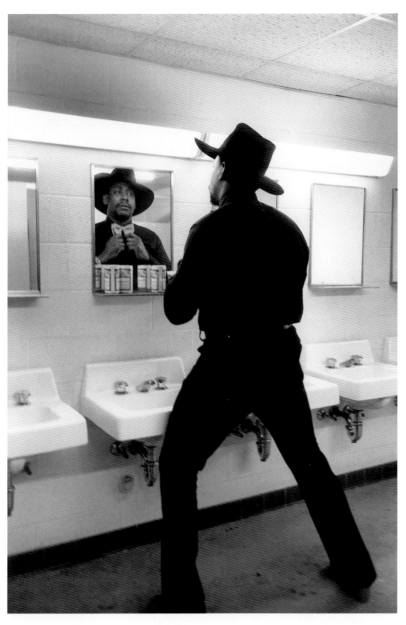
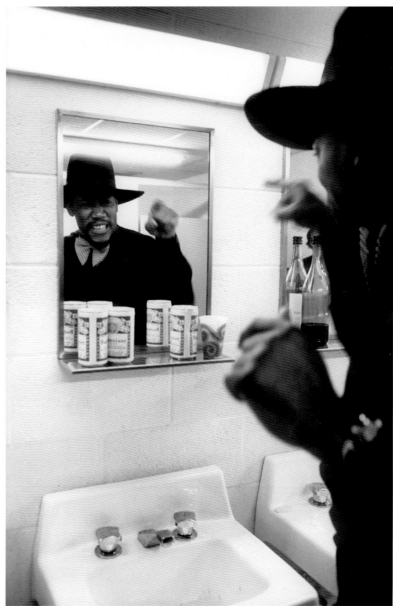

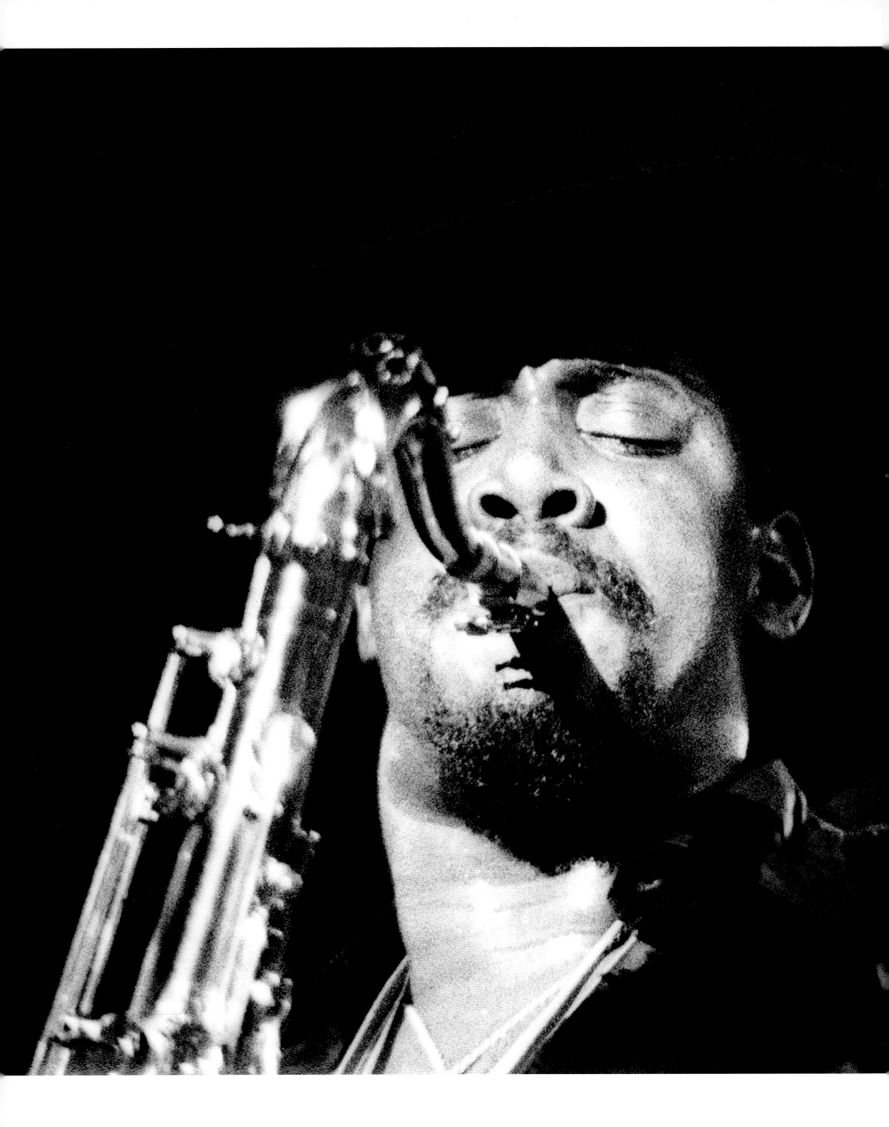

"I do read music but I prefer playing from the heart."
- Clarence Clemons

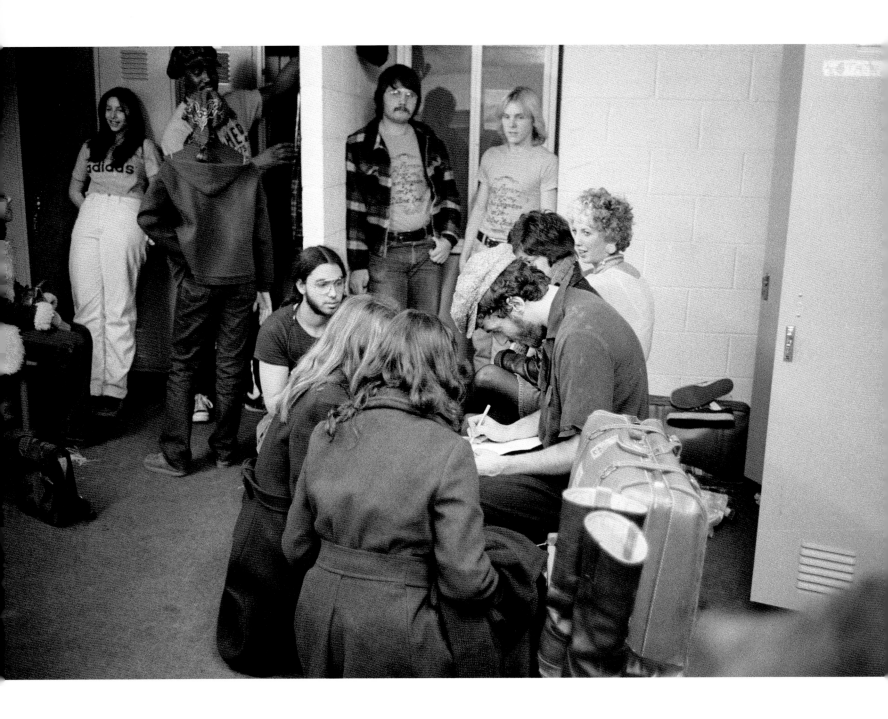

While recording Born to Run, *the band had to grab gigs wherever they could just to survive. They took dozens of college jobs. Most of the time they didn't even have dressing rooms. They got what they got. This locker room at Widener University in Chester, Pennsylvania, was better than most.*

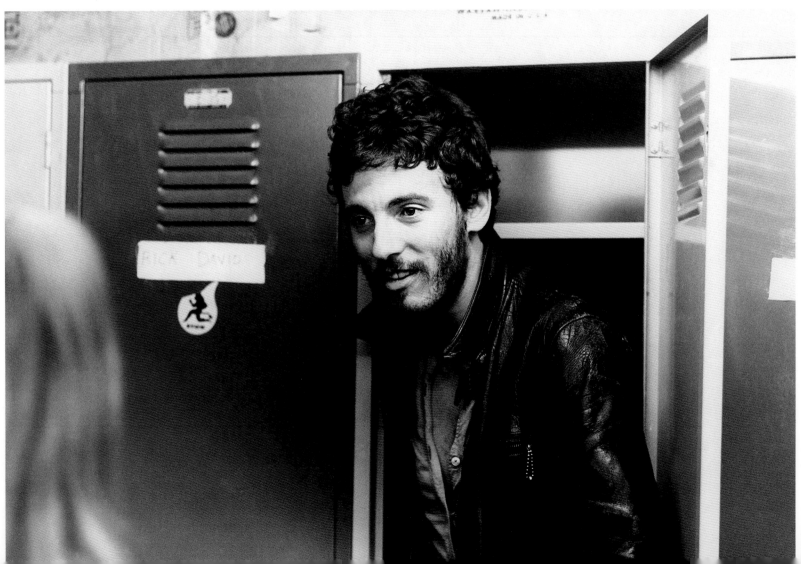

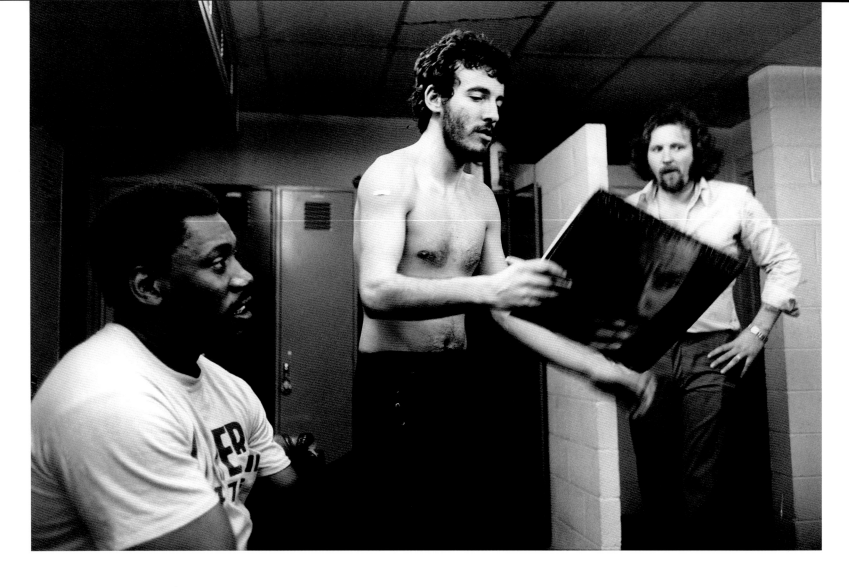

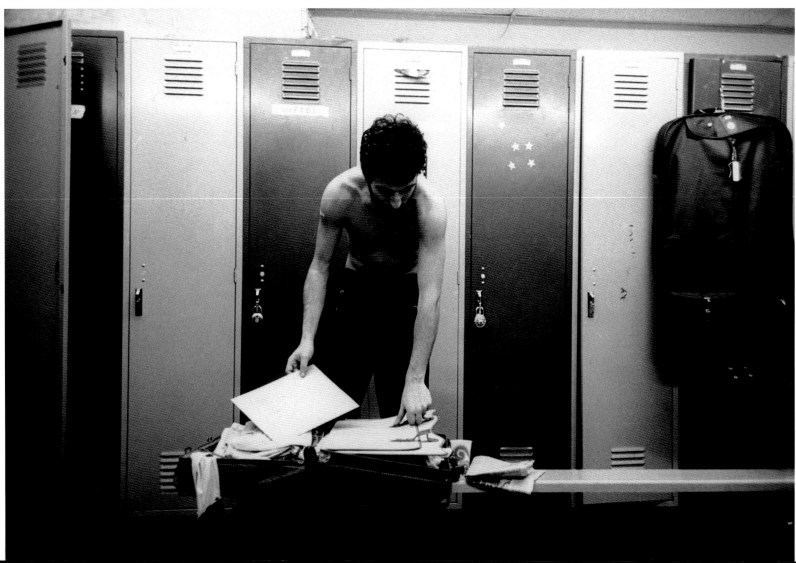

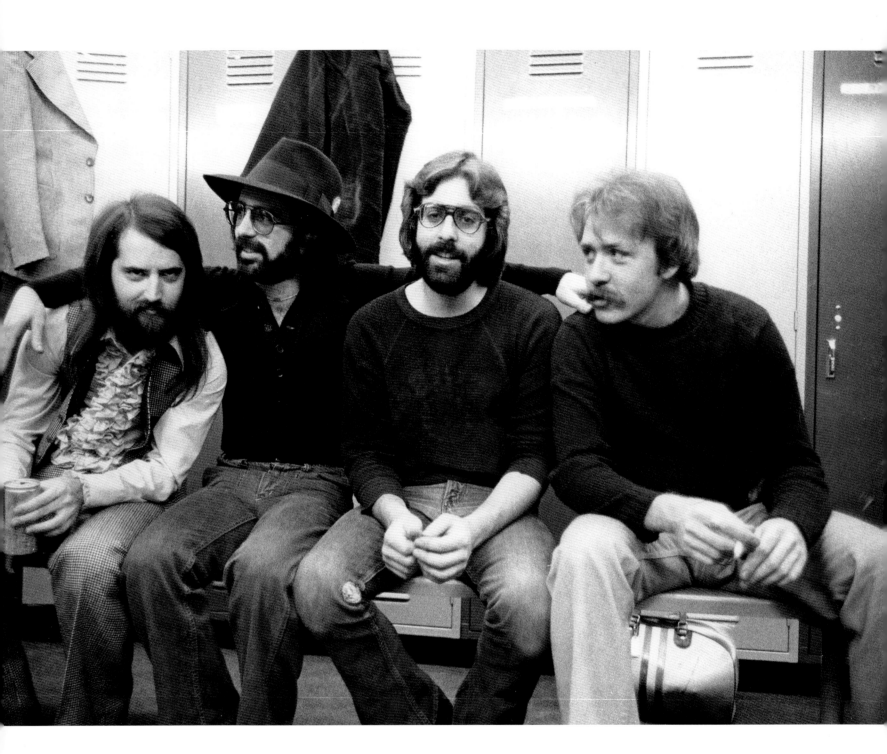

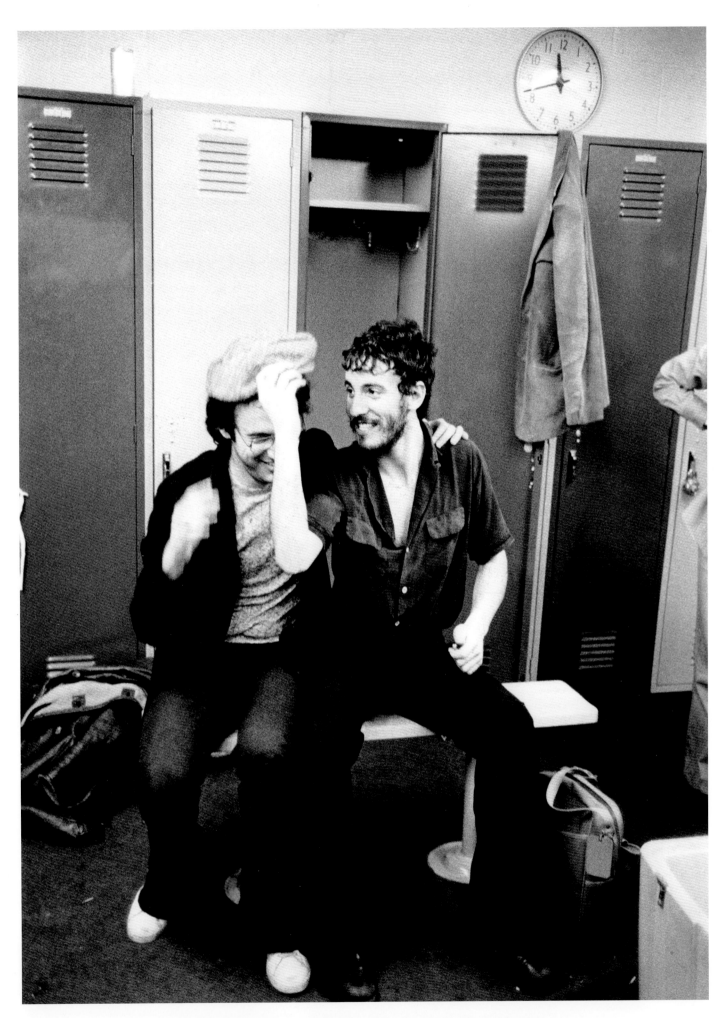

Bruce with Jon Landau, who became his manager.

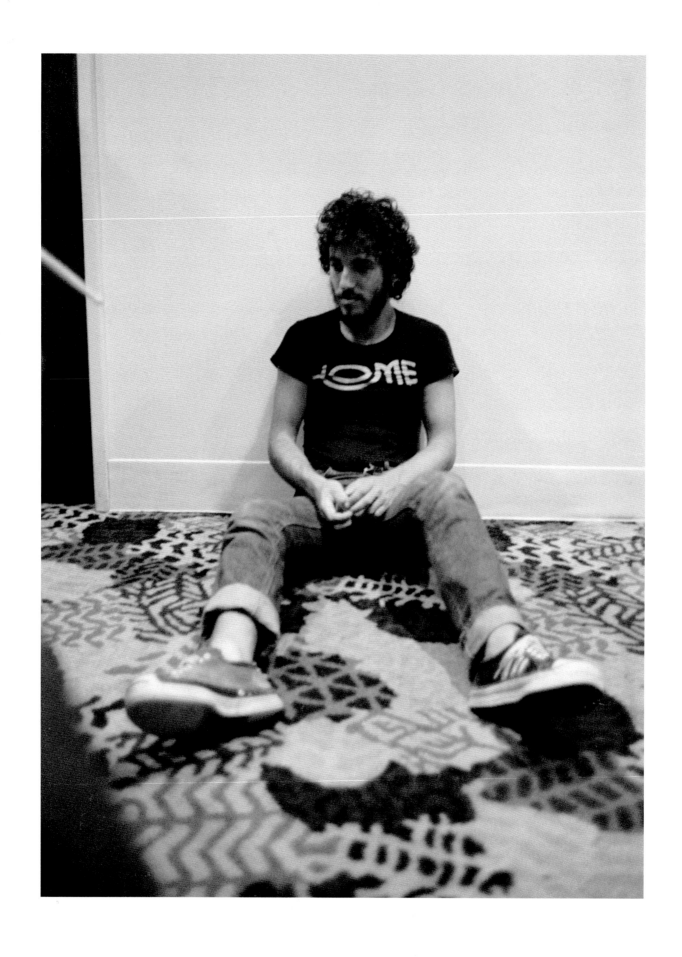

"Jimmy Iovine talked about Bruce's drift into darkness during those sessions. He would just sit there, and we would talk to him, and he wouldn't answer us."
- Mike Appel

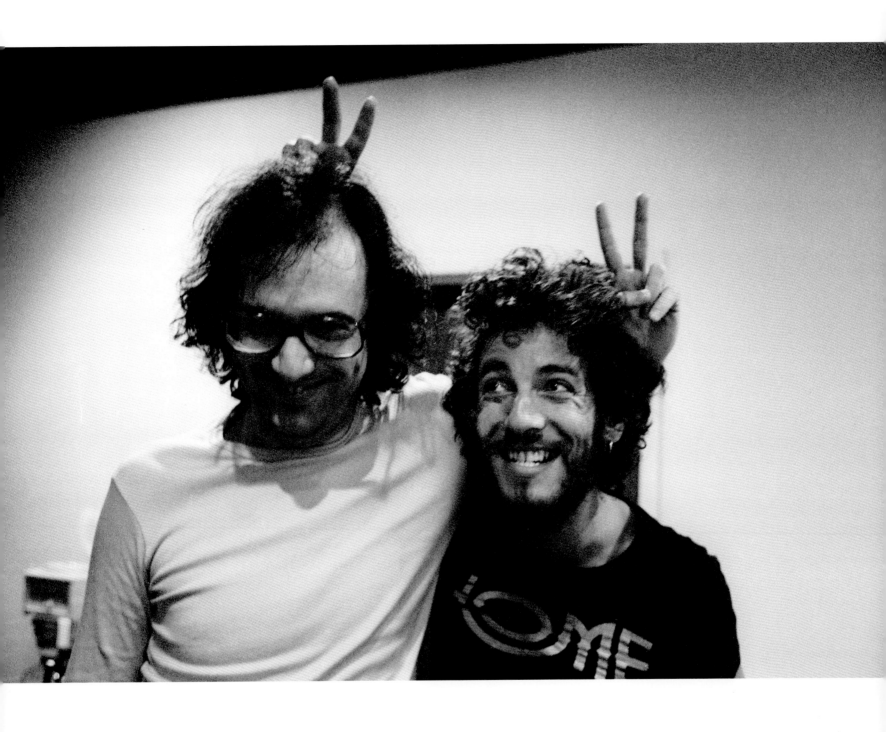

"We were in there every day trying to make the greatest of the great records. We wanted it to be something that people would never forget."
- Jon Landau

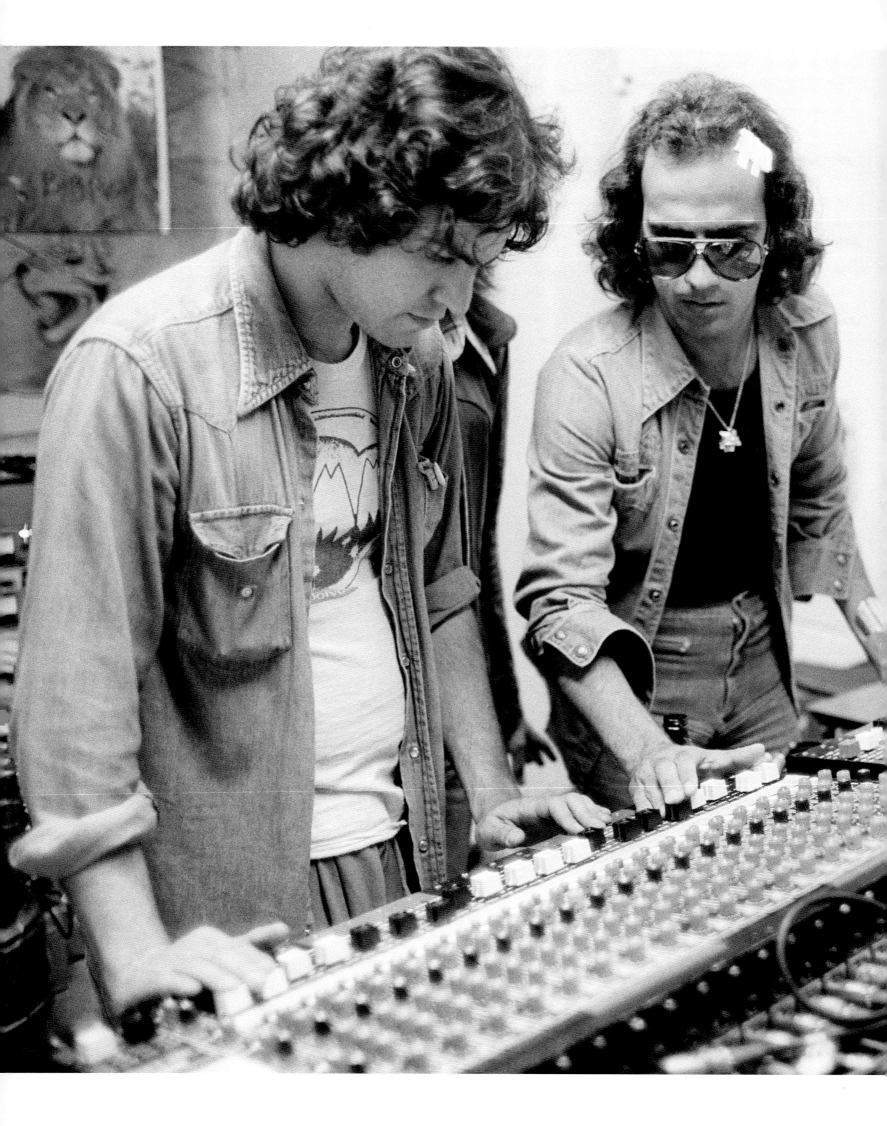

"On Born to Run, *the entire idea was at stake. We were creating everything from the ground floor. His first two albums were just songs with some electric guitar. Born to Run was 'No, I'm tired of that. No more compromise.' The guitar parts on 'Thunder Road' were thirteen hours in the studio. I fell asleep at the console in the middle of it. All he said for thirteen hours was 'Again. Again. Again.' [When the album was finished], I took a train to Baltimore to play it for him. We're listening to it on a stereo he'd just bought, with two speakers and a turntable. When the album is over, he gets up, takes it off, walks outside—and throws it in the hotel pool. I was crushed. I didn't know what to do. Bruce is going, 'I'm doing the whole album live.' I couldn't deal with it. I went back to New York on the train. I must have taken ten Valium on the way home. But Landau talked to him. It ended up being the album. Landau called me: 'It's all right.'"*
- Jimmy Iovine

In the studio, Bruce would record something, mix it, remix it, and then dump it. He had a specific sound in his head. He would hum the music and the band would lay down tracks. It was brutal. He had the record company hounding him. His then-manager Mike Appel and new confidant Jon Landau were not getting along. It was all Sturm und Drang, *pain and suffering. Clarence played his "Jungleland" sax solo countless times for Bruce. After each one he would ask, "That's it, right Bruce?" Bruce would answer, "Again, Big Man." Bruce and Jimmy Iovine edited the most brilliant and unforgettable sax solo that Clarence and Bruce ever did together. In my opinion the best sax solo ever recorded. They were still recording the last tracks for "Jungleland" right up to dawn, then they went straight into rehearsal for the* Born to Run *tour. We were all completely wiped out. Sitting on the stairs with my Leica, I finally worked up the courage to take a couple of frames. Then Bruce Springsteen and the E Street Band broke out of there to win.*

When I would drive Bruce back from Record Plant to his hotel at 7 a.m. most mornings we would talk about the future and about his responsibility to his music. We made a promise we always would remember. No retreat. No surrender. *He was intense and brilliant. He had a plan and he executed it with the band behind him all the way.*

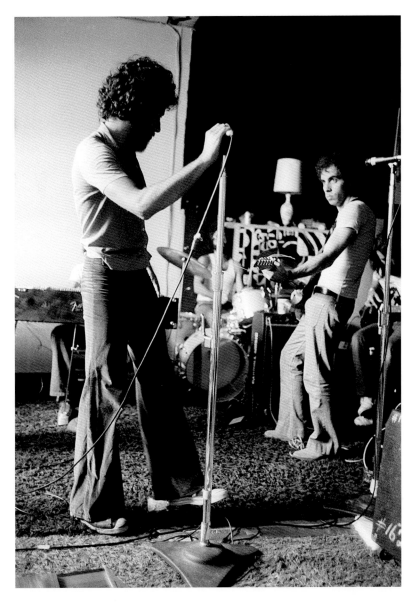
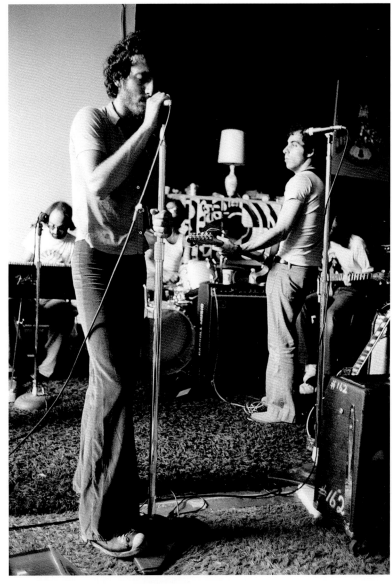

"There's a picture. It's the scariest thing I've ever seen. You have to see the band. It should be on the cover of that album. You ain't never seen faces like that in your life. We were there for four days, and every single minute is on everybody's face. The light comes through the window, it's like ten in the morning, we've been up for days. We got a gig that night, we're rehearsing, and what's worse is, I can't even sing!"

- Bruce Springsteen

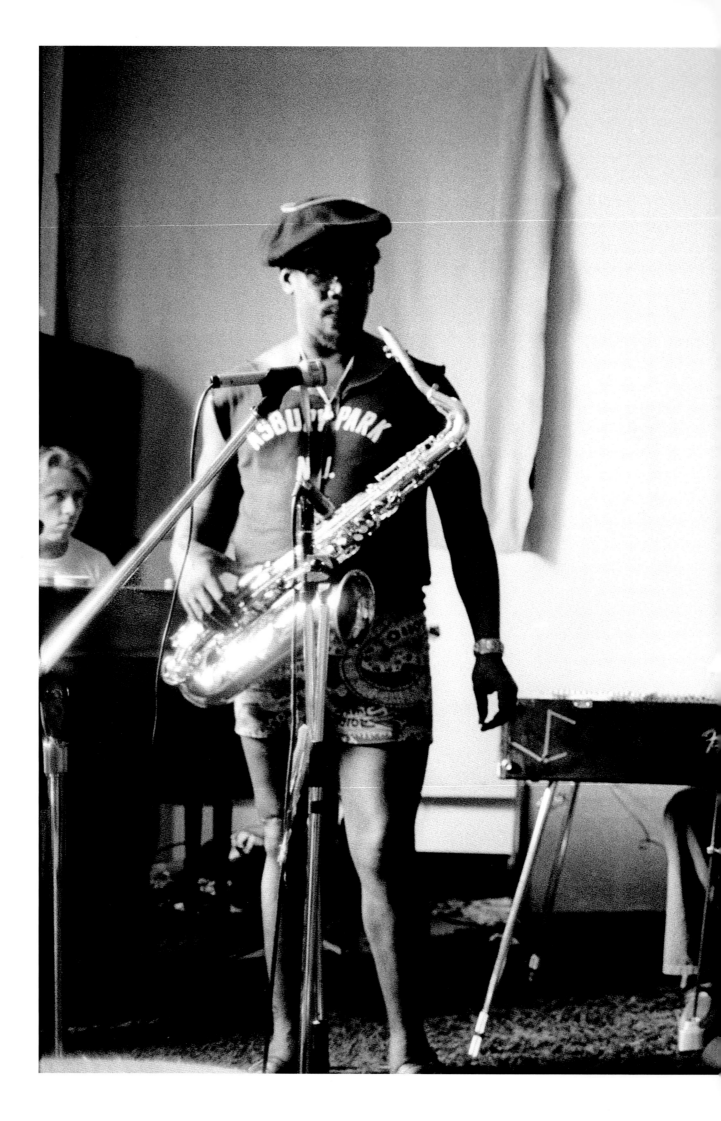

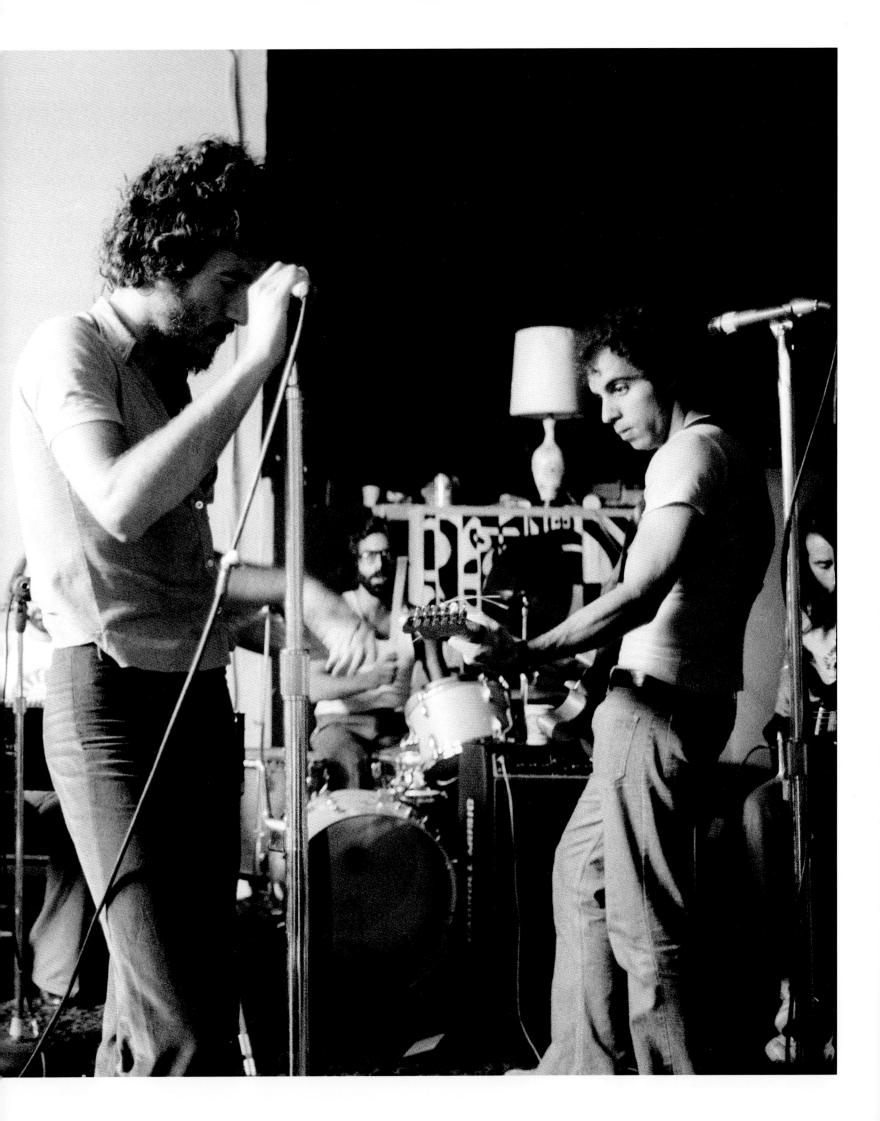

NEW ORLEANS

Betsy and I arrived in New Orleans on the same night in September 1965. Volunteering with the Red Cross was my introduction to the unique people and very special culture only found in New Orleans. The lyric "The fire we was born in" reminds me of Hurricane Betsy, which many call the prelude to Katrina. I fell in love with New Orleans and her people. I embraced the city and she embraced me back. Most of all, I loved the music. I didn't stand a chance. I was rapidly swept into the musical life of New Orleans. One of my roommates at Newcomb College of Tulane University was an African-American woman whose boyfriend was Allen Toussaint, the songwriter and producer. He is responsible for more hit records than anyone else in the history of New Orleans music. I met Lee Dorsey when he and Allen were recording "Working in the Coal Mine" at Cosimo Matassa's studio. I was caught in a perfect storm of musical influences from R&B to traditional jazz to zydeco. The music had taken me over. When Allen opened his own studio, Sea-Saint, I was there constantly and met everybody: Professor Longhair, James Booker, Dr John, the Neville Brothers, Earl King and dozens of other amazing musicians; Patti LaBelle when she was recording "Lady Marmalade" and Paul McCartney when he was in the studio for "Venus and Mars." By the *Born to Run* tour I had ten years of deep roots across the New Orleans music scene. When Bruce and the band headed for New Orleans, so did I—almost ten years to the day since Betsy. I wanted to show them the magic of the New Orleans I knew and loved. Meeting Bruce and the E Street Band there was a moral imperative because my New Orleans musical roots allowed me to fall in step with them quickly. Music lies at the heart of it. I call New Orleans "my heart, my soul, my inspiration." The city's spirit and beauty inspired my photography. Bruce and the band saw a side of New Orleans they never would have, the New Orleans I have loved all my life.

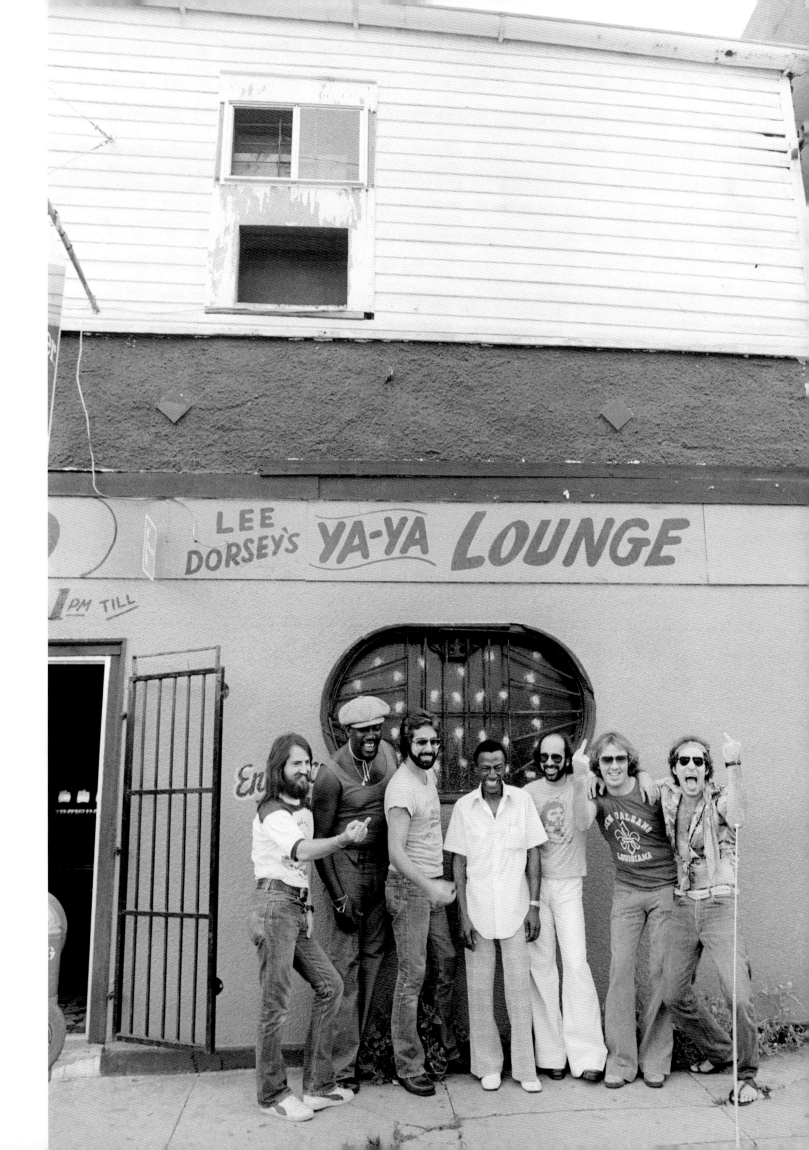

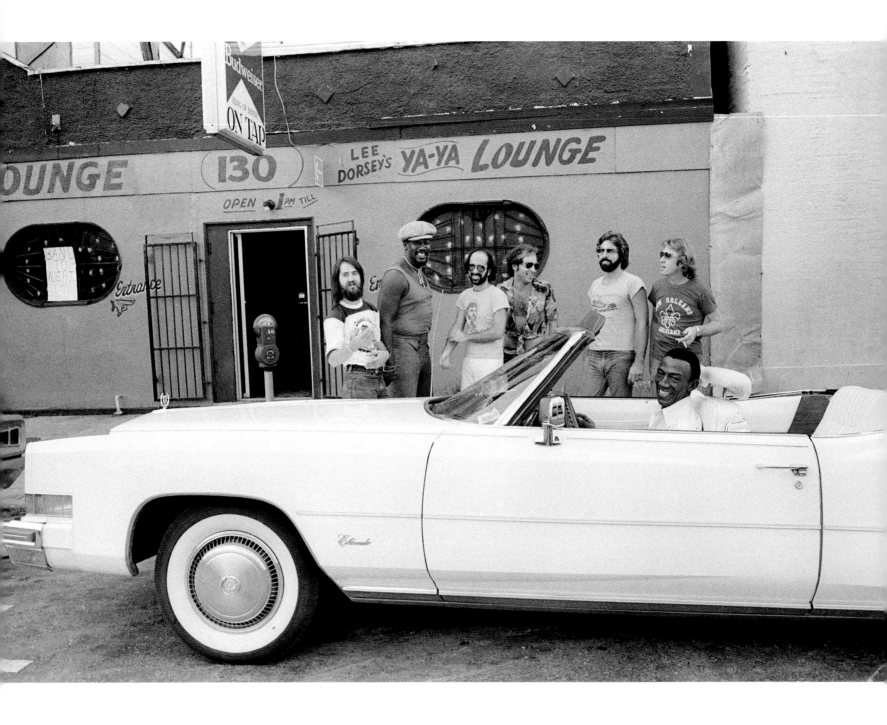

I took Bruce and the band to meet Lee Dorsey at his Ya Ya Lounge on North Villere, between Canal and Iberville. He named his joint after one of his earliest hits. Bruce, Stevie, promoter Bill Johnston and roadies Doug Sutphin and Mike Batlin spent hours on his pool tables.

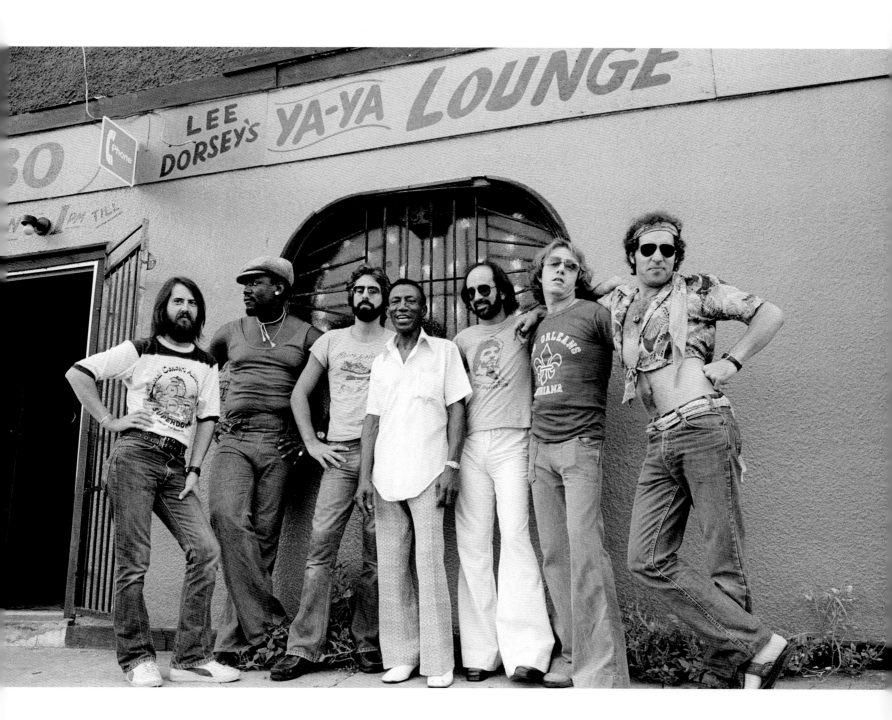

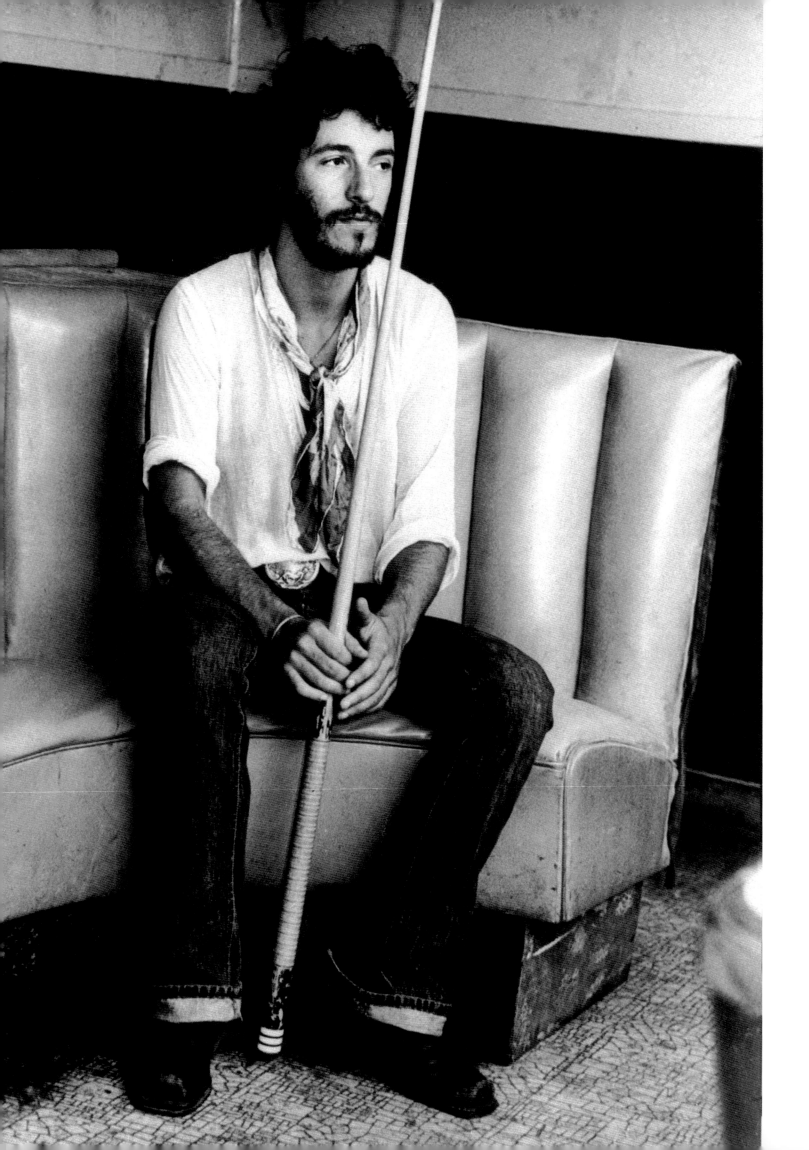

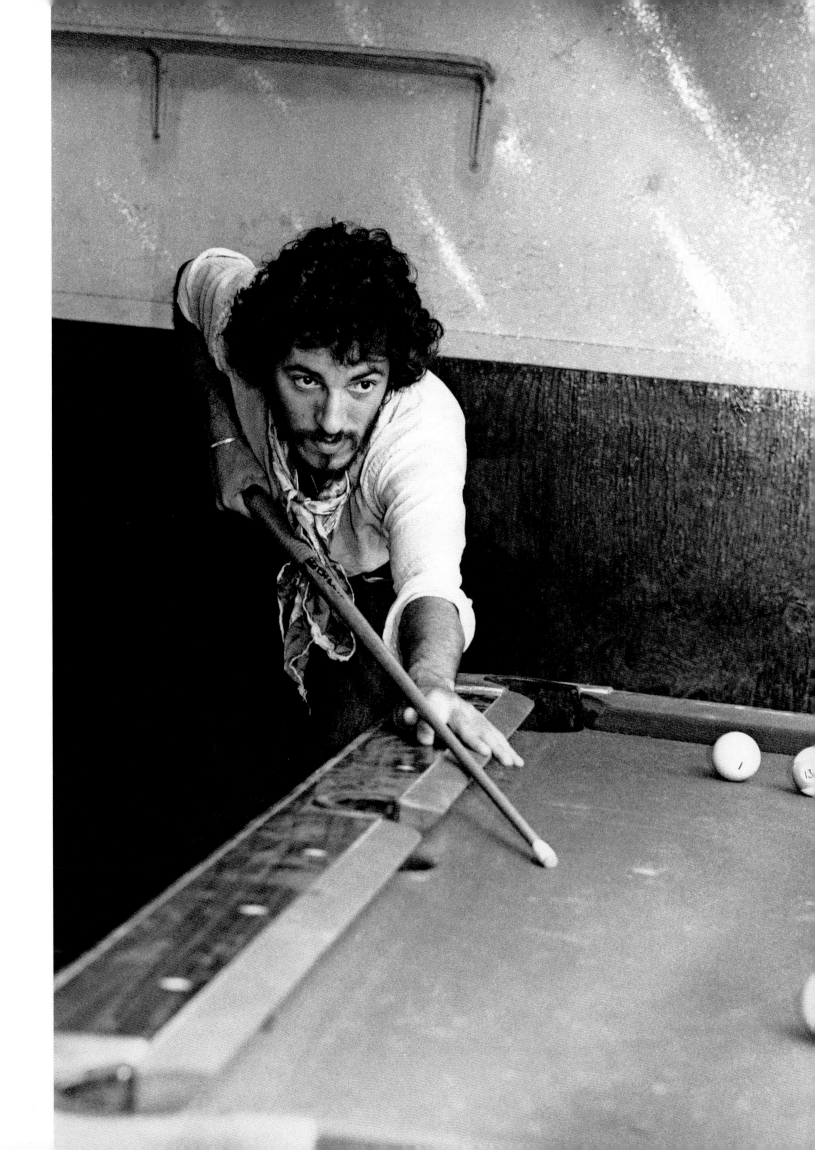

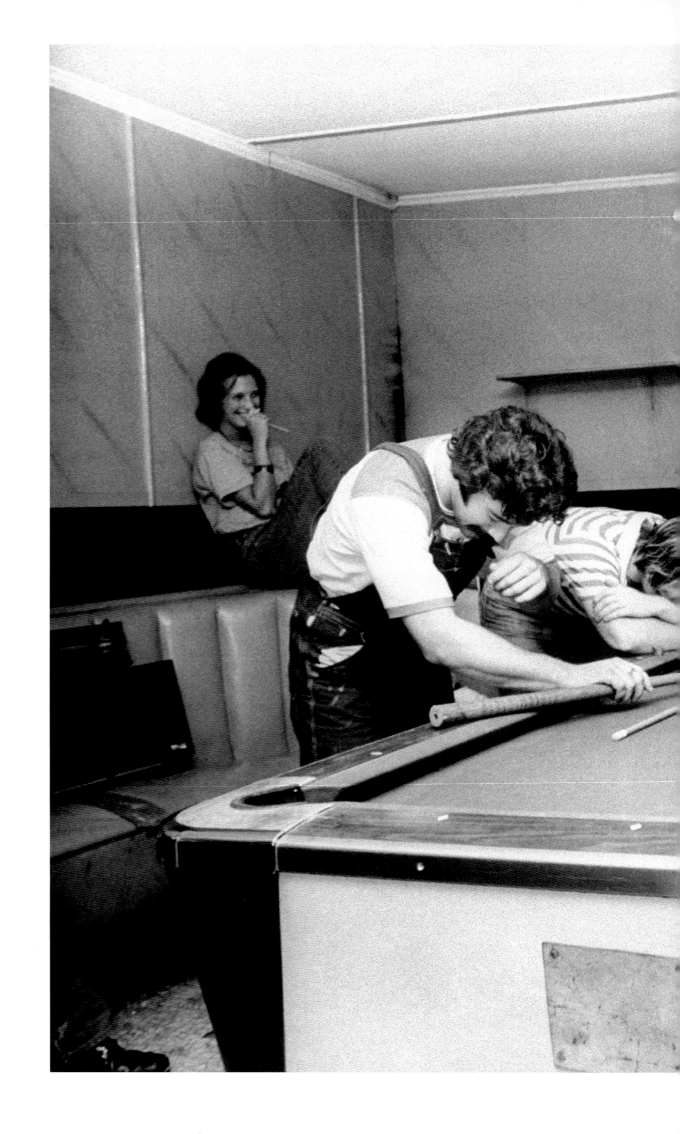

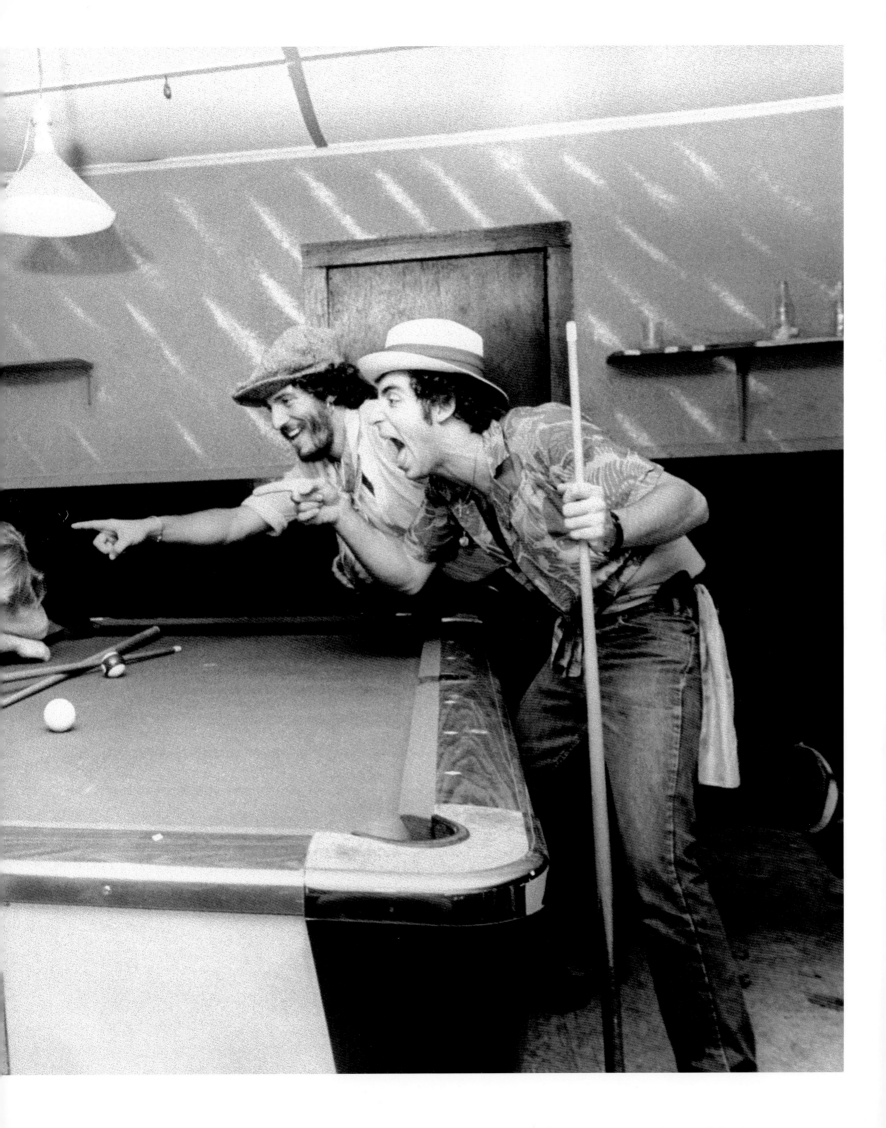

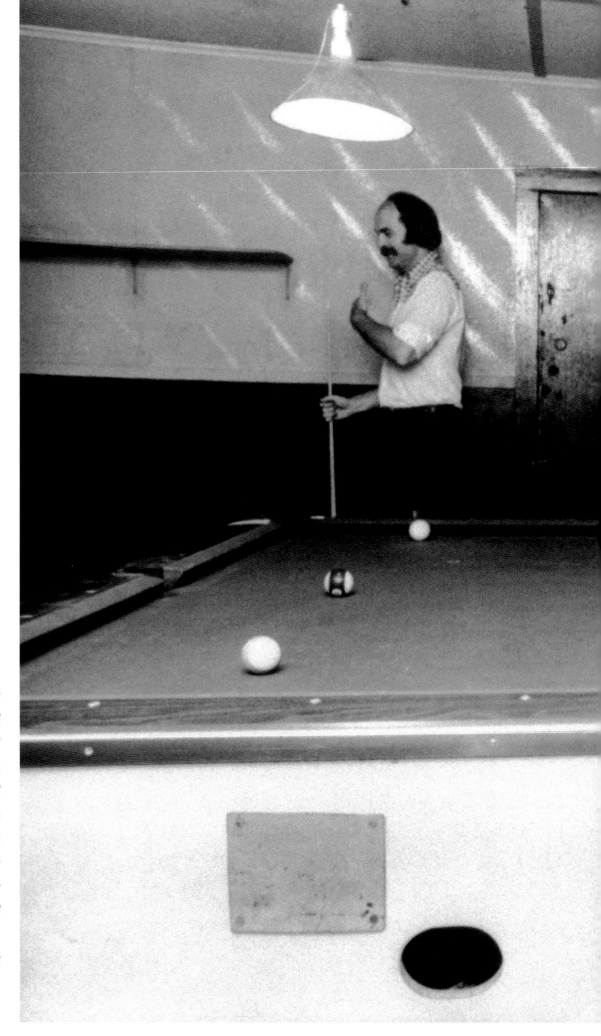

Bill Johnston is at the back of the pool table. He founded his bar "The Warehouse" at 1890 Tchoupitoulas in 1970. Fleetwood Mac and the Grateful Dead were the opening acts and Jim Morrison played his last show with The Doors there that same year. Bill left to found Beaver Promotions in 1975. He was another guy who just loved the music.

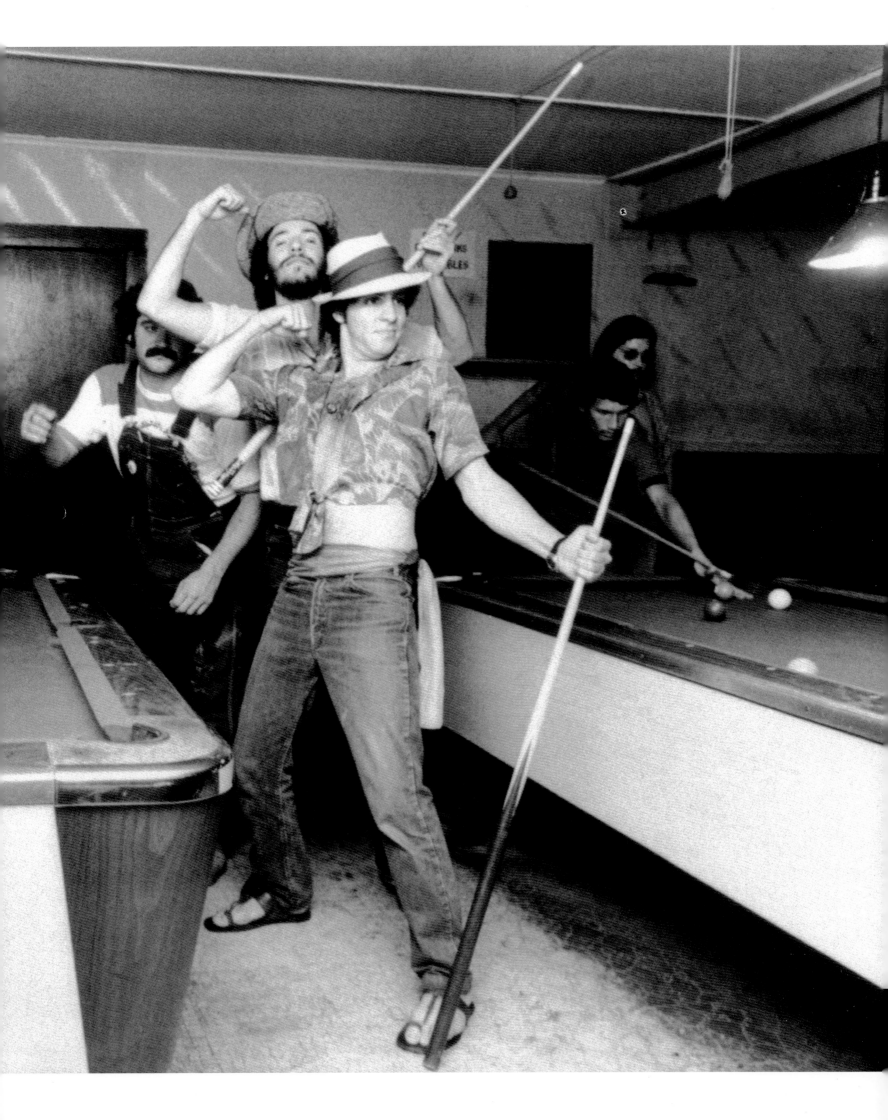

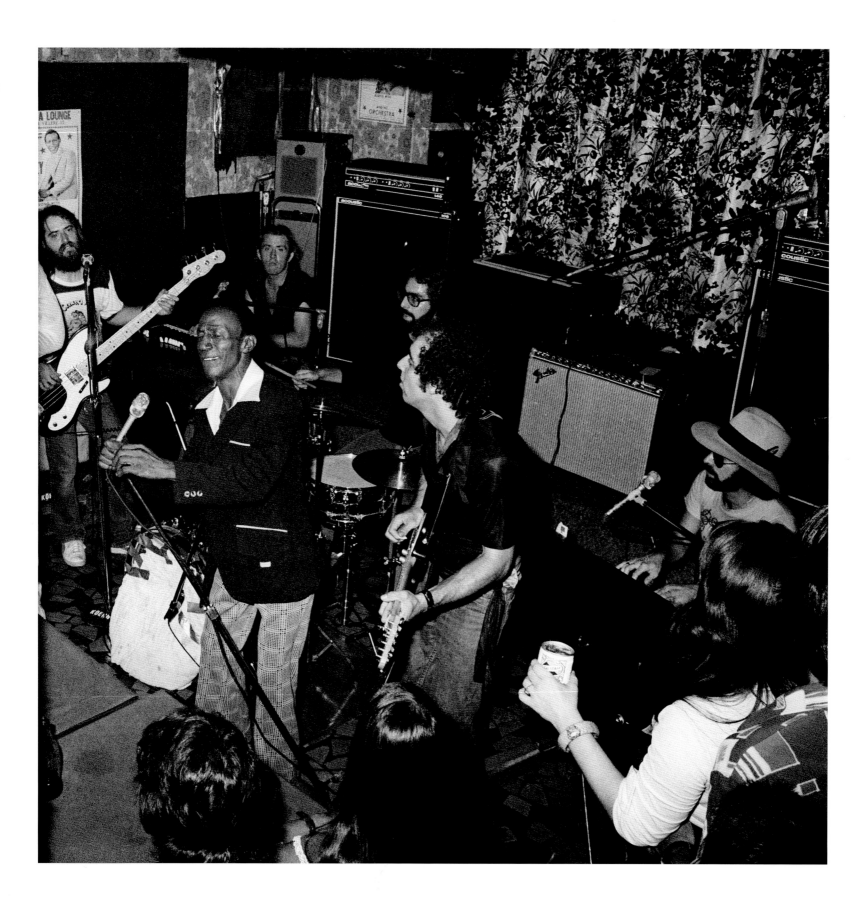

Stevie Van Zandt convinced Lee Dorsey to jam with the E Street Band at his Ya Ya Lounge. They played some R&B and rock'n'roll classics before backing Lee on his own hit songs.

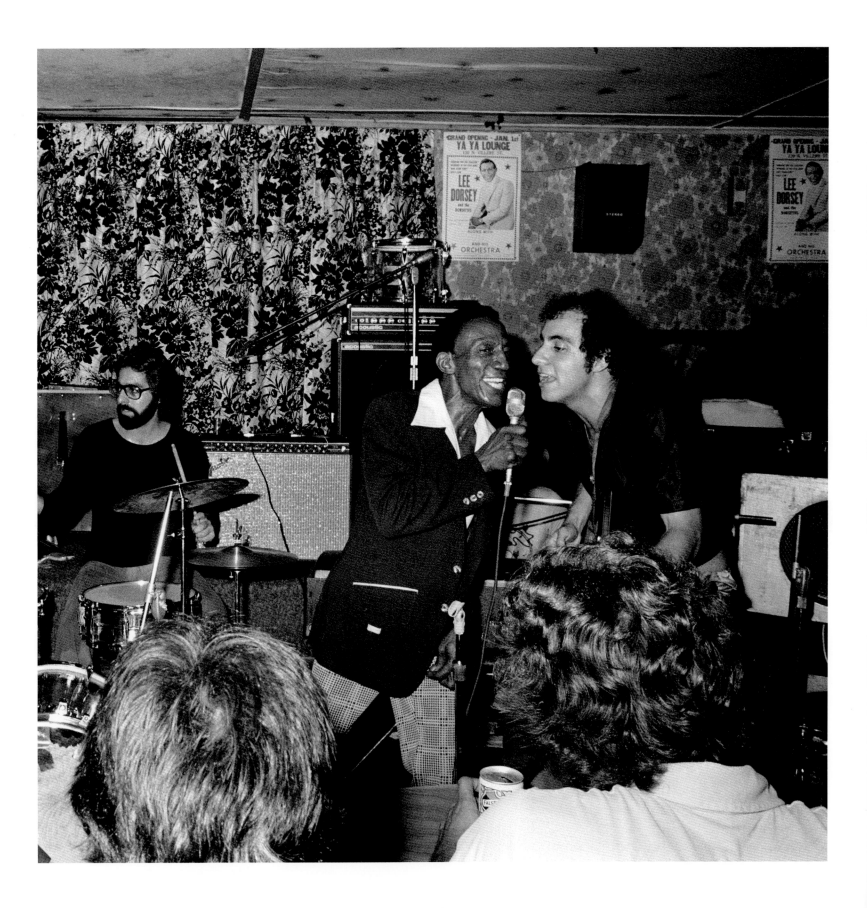

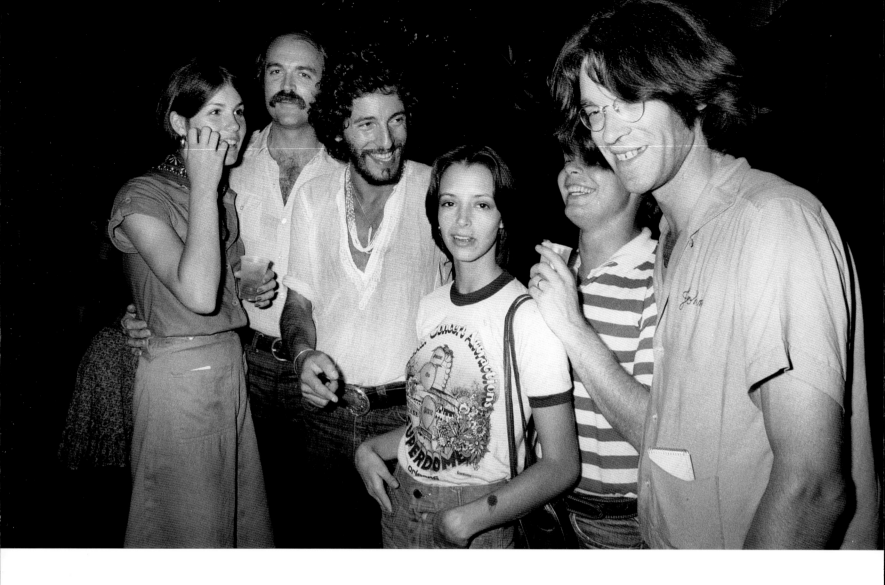

I threw a party so Bruce and the band could meet my New Orleans musician friends. It was at 808 St. Philip, next door to Lafitte's, the oldest bar in America. Bill Johnston, his wife and some other friends are talking to Bruce. That's "Fats" Houston in the photograph with Stevie and Bruce—CBS's Peter Philbin is on the left smiling like a Cheshire cat with Clarence beside him. Matthew "Fats" Houston was the Grand Marshal of Harold Dejan's Olympia Brass Band, who led many of the New Orleans Jazz Funerals. He was a custodian at Newcomb College and my first introduction to New Orleans music. He had such a quiet dignity about him. I was fascinated. It wasn't long before he had me in the streets "second lining" in the parades. The very next year an image of Fats lit up the New Orleans Jazz Fest poster produced by Bud Brimberg of ProCreations, now called Art4Now. He and Roy Bittan were childhood friends. It was Bud who introduced me to Roy years earlier. Fats and Harold Dejan led me to Preservation Hall where I got to know all of the traditional jazz musicians, including the Humphrey Brothers, George Lewis, Kid Thomas, Kid Sheik and Pat Crawford who worked with Dick Allen in the New Orleans Jazz Archive. I met Swedish clarinetist Orange Kellin there, we became lifelong friends. He let me use his French Quarter Courtyard to throw this party. It was the very first time I had seen Bruce smile in over a year.

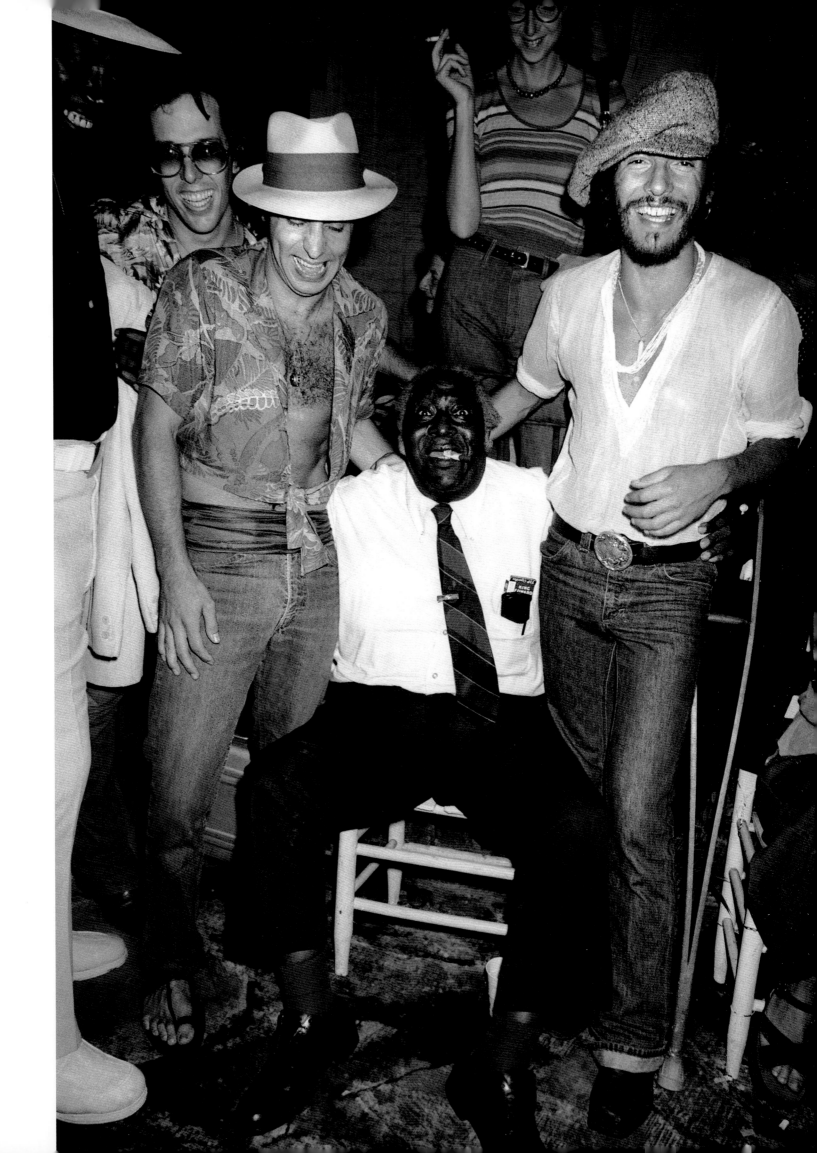

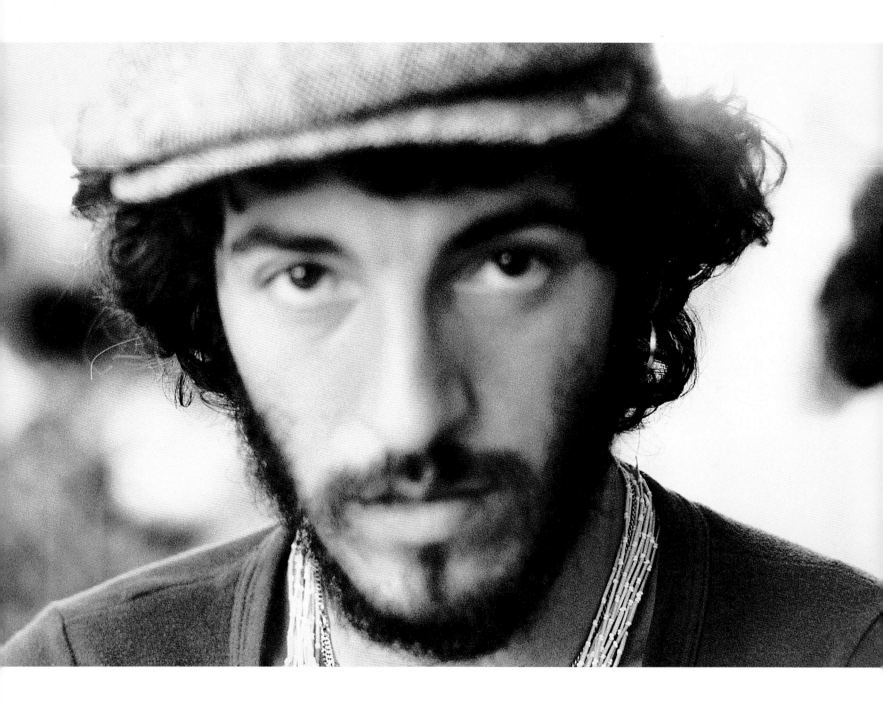

This picture is called "Waiting." We were literally waiting for my car in front of the parking garage on Iberville at Bourbon Street. My '69 white Cougar convertible was called "The Ghost" because together we haunted all the late night New Orleans music joints. Metaphorically, Bruce was waiting to see if he had delivered the hit that the record company was demanding. Metaphysically, he was waiting to see if his vision translated to his fans. Bruce looked like his lyrics, a working guy from the Jersey shore, just struggling to make it. Of course, this was true. He was a guy from the shore, just struggling to make it. He had perfected that faded jeans, leather jacket look. It took him about as long to look that way as it would have taken some other guy to put on a suit and tie. He had it down. If Bruce looks as if he has the weight of the world on his shoulders, it's because he did! Born to Run had taken over fourteen arduous months to record, and that album was truly his "one last chance to make it real."

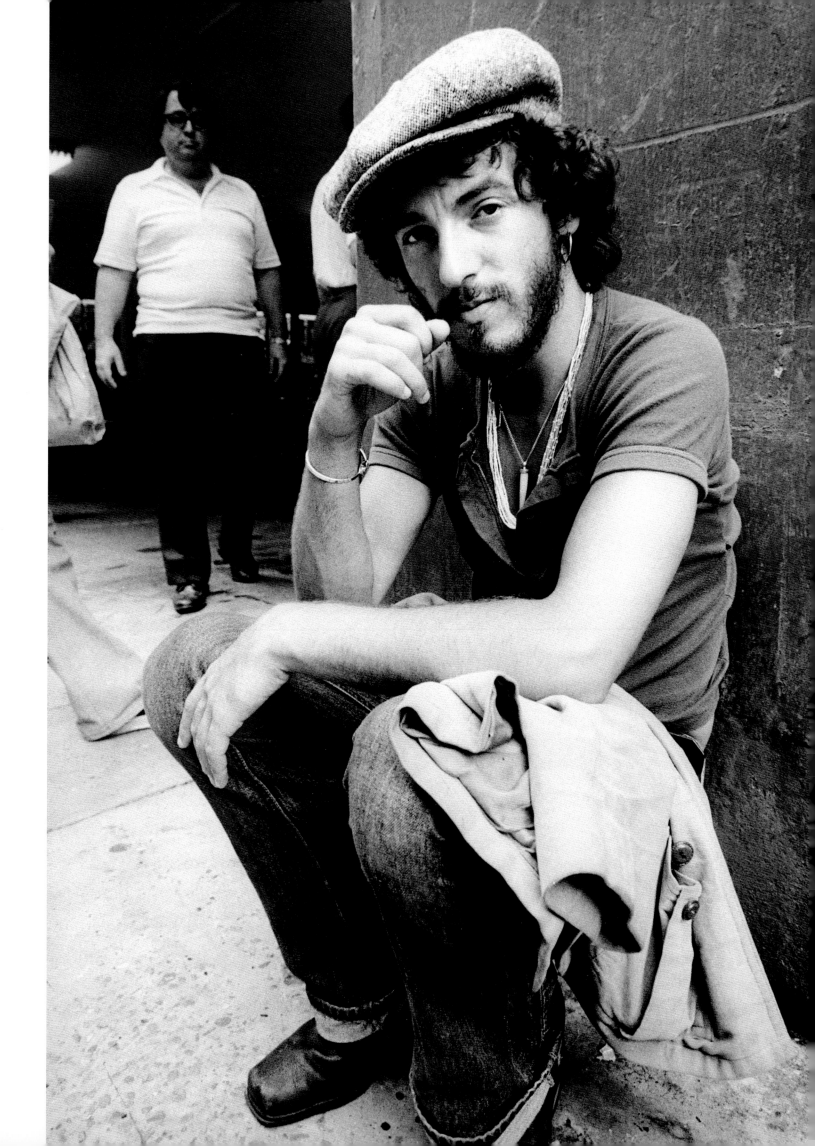

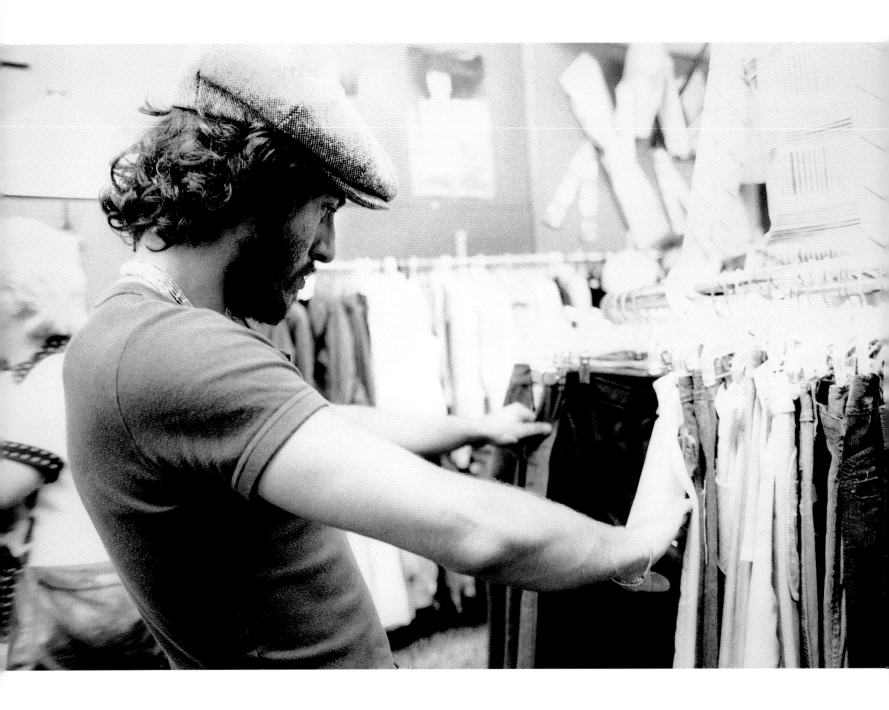

Bruce wanted to go shopping so I took him to Canal Street at St. Charles Avenue. We went to Rubinstein's but he couldn't find any jeans he liked. The next stop was Meyer the Hatter, family-owned and operated since 1891. Sam Meyer helped Bruce choose one of his iconic newsboy caps. We went across the street for a Big Mac Attack. Back then, Bruce was an expert on fast food.

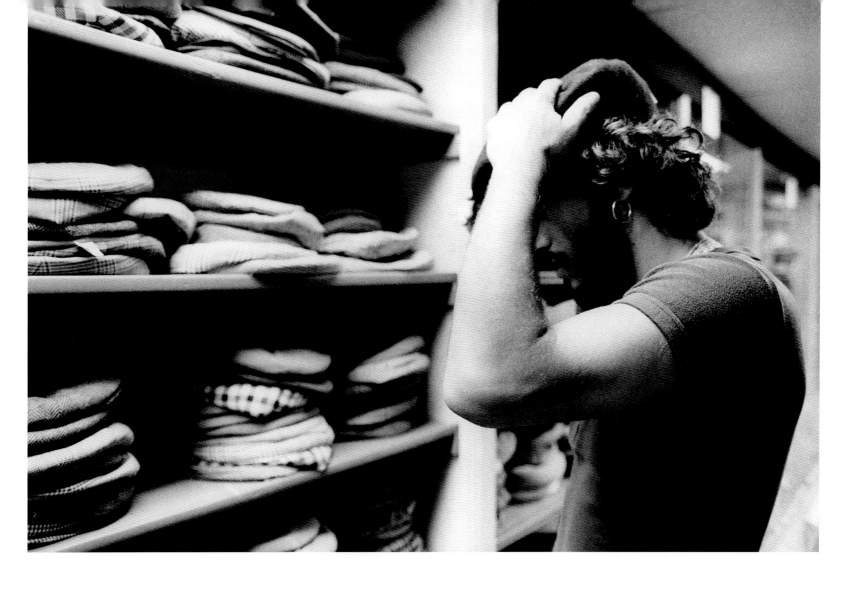

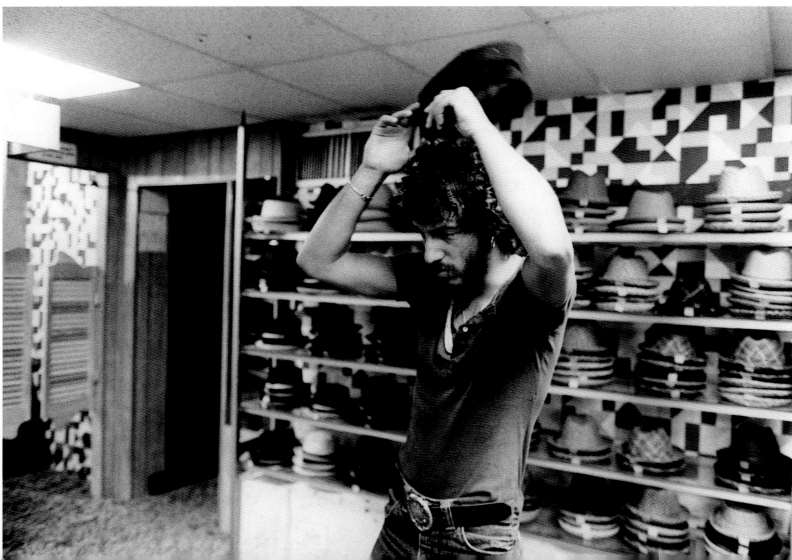

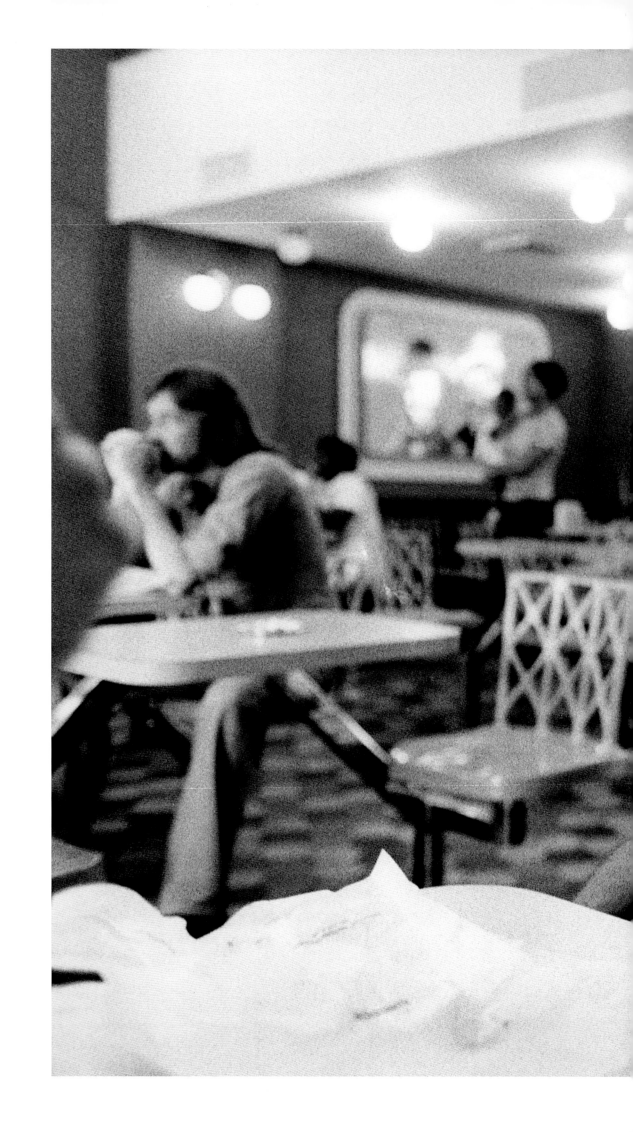

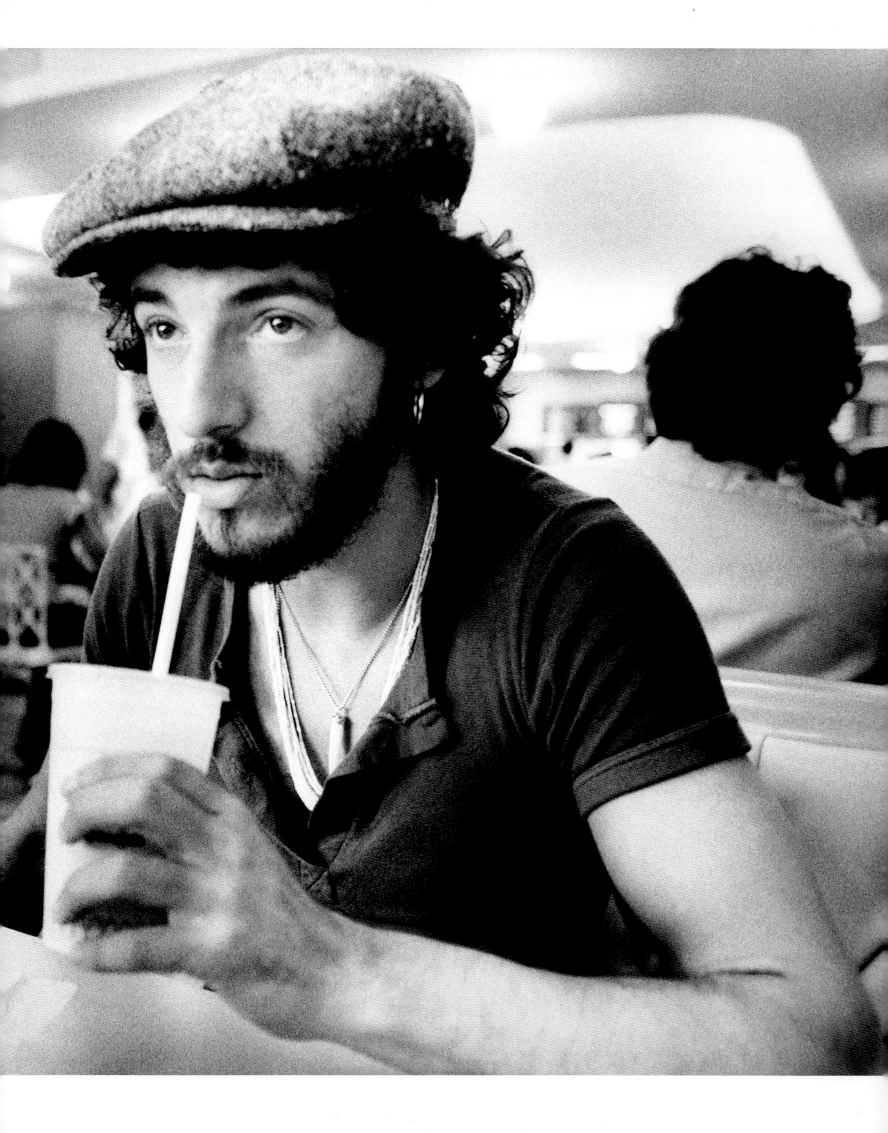

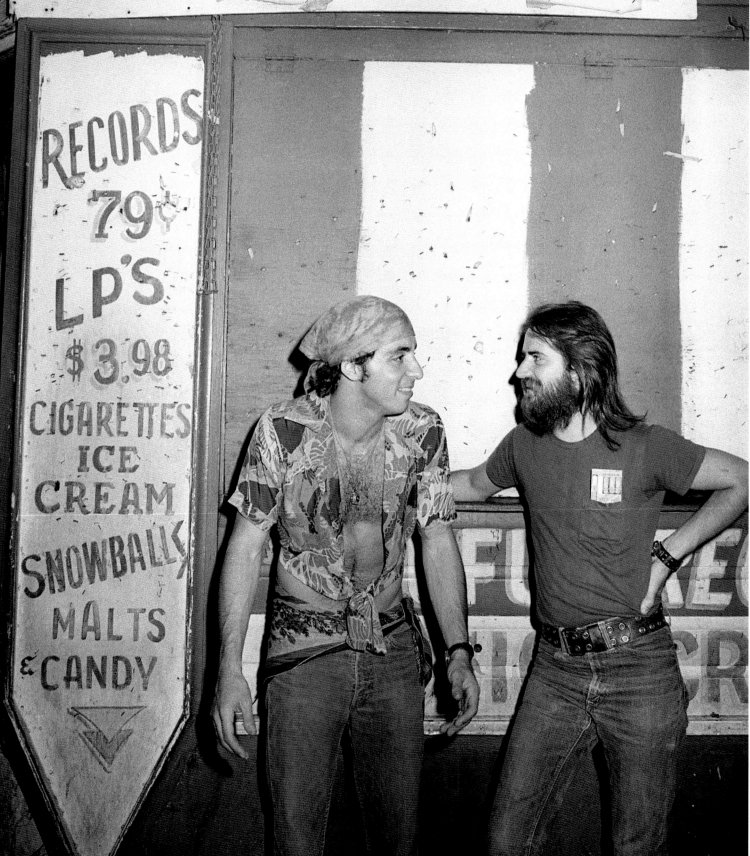

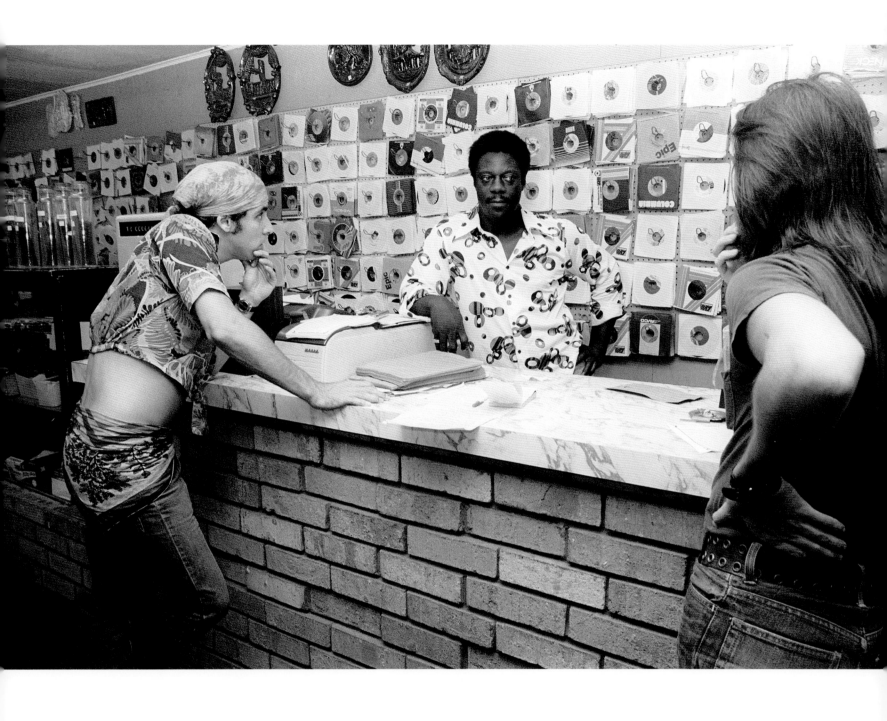

The Rufus Record Rack was on Magazine Street. Stevie and Garry were serious record collectors who loved New Orleans R&B.

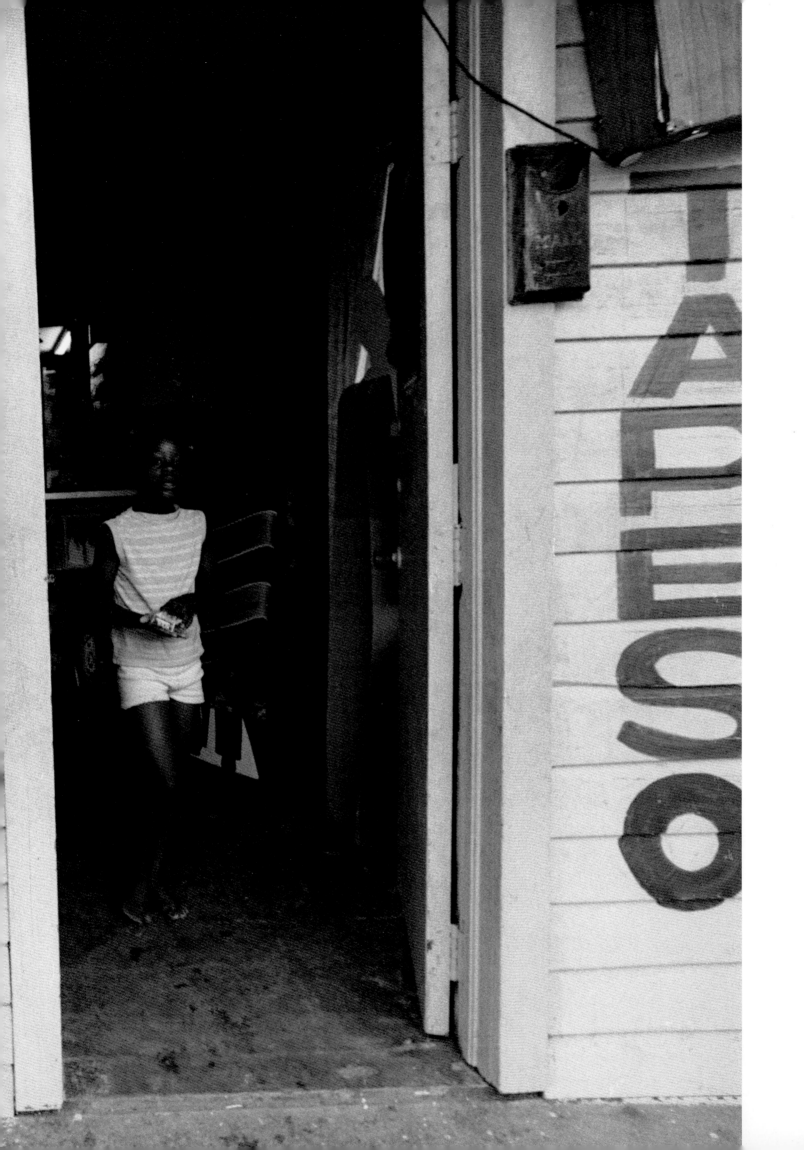

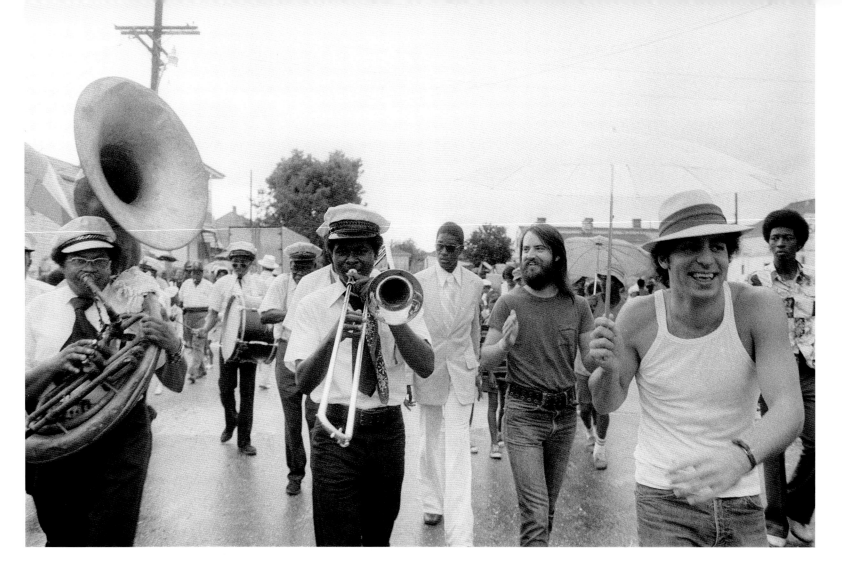

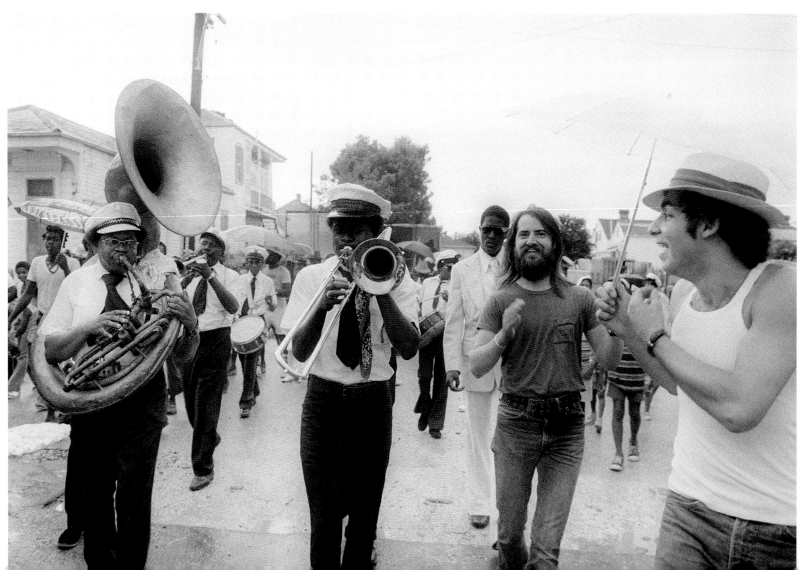

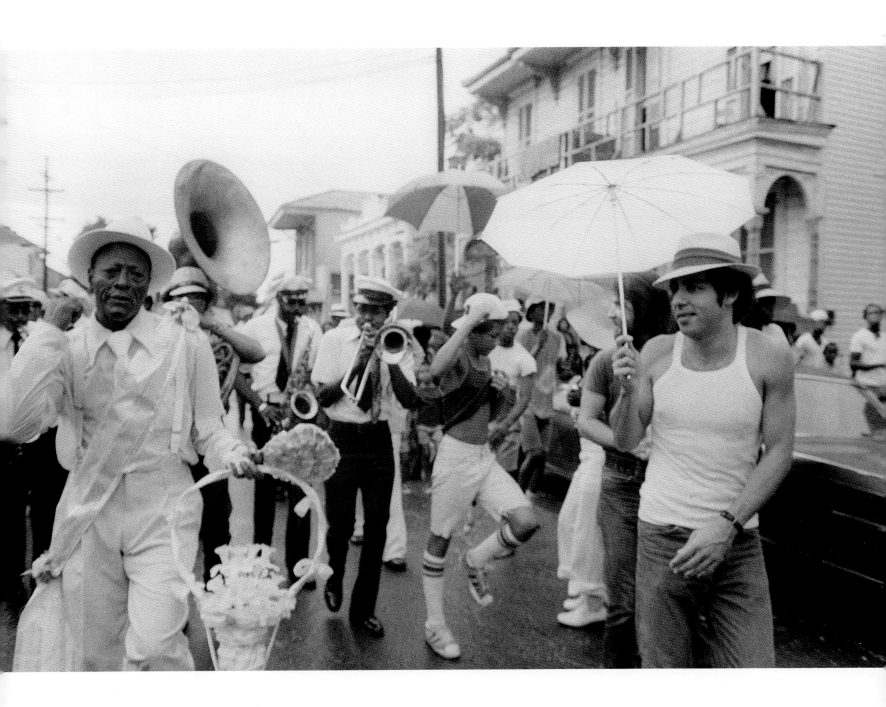

On any day in the neighborhoods of New Orleans you can hear music—either a parade of a Social Aid and Pleasure Club, a Sunday school event or a Jazz Funeral. "Second lining" is dancing in the streets next to the band. It is a tradition as old as New Orleans Jazz itself. I got tipped off about a Social Aid and Pleasure Club having a parade down in Tremé. Garry and Stevie fell into second lining as if they had been doing it all of their lives.

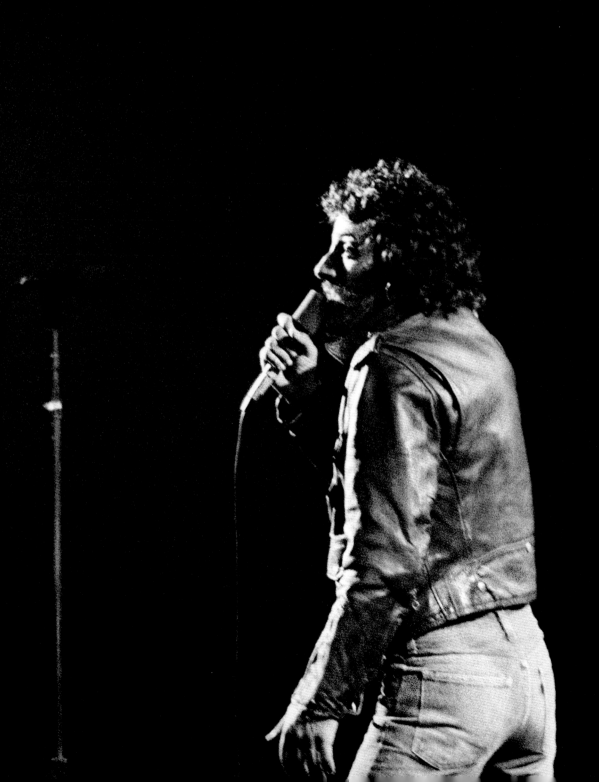

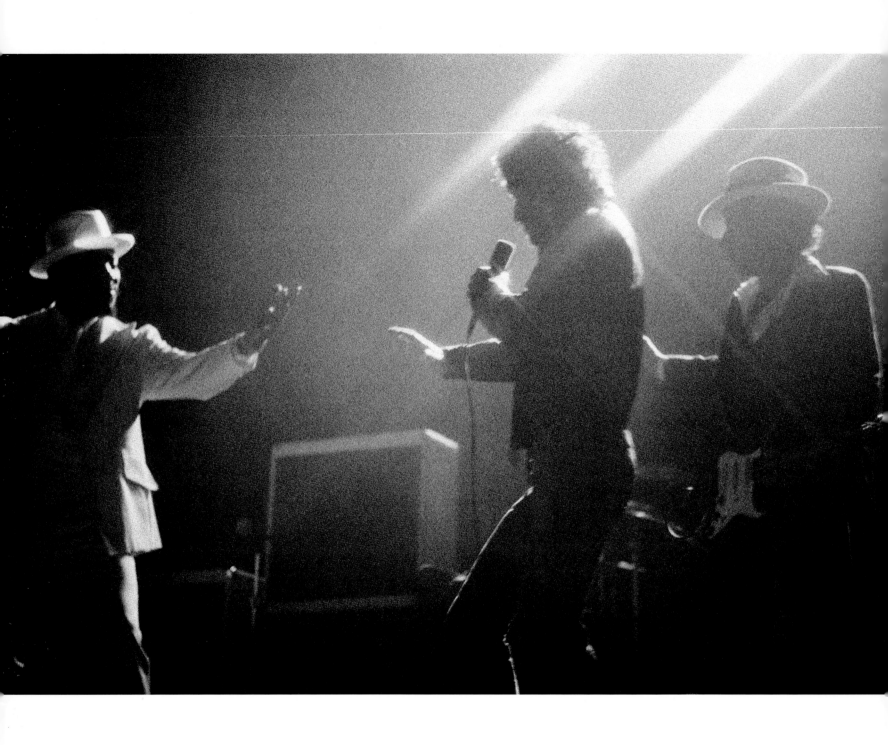

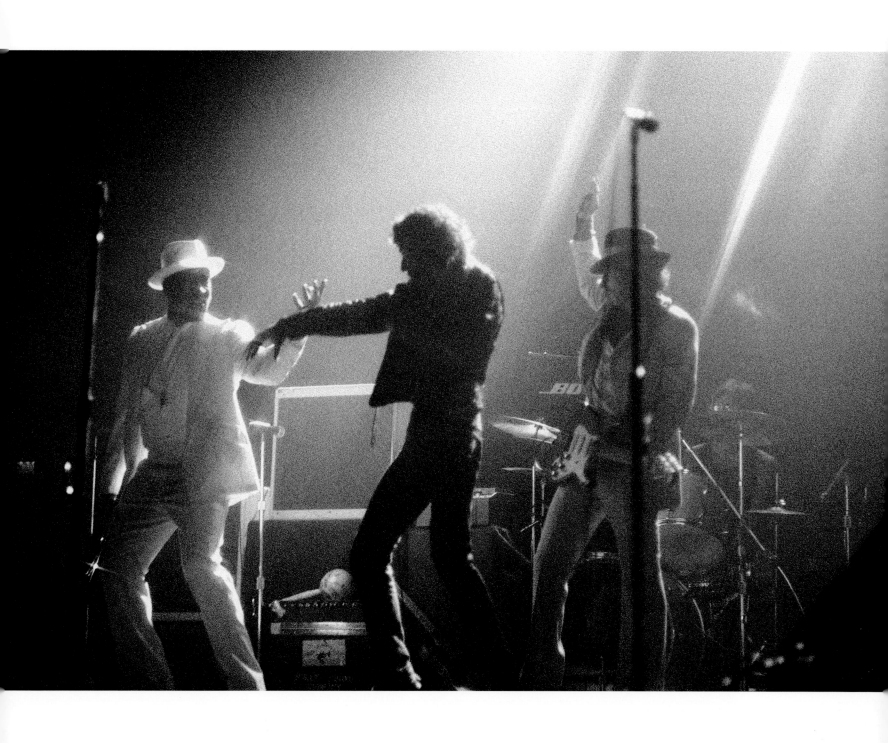

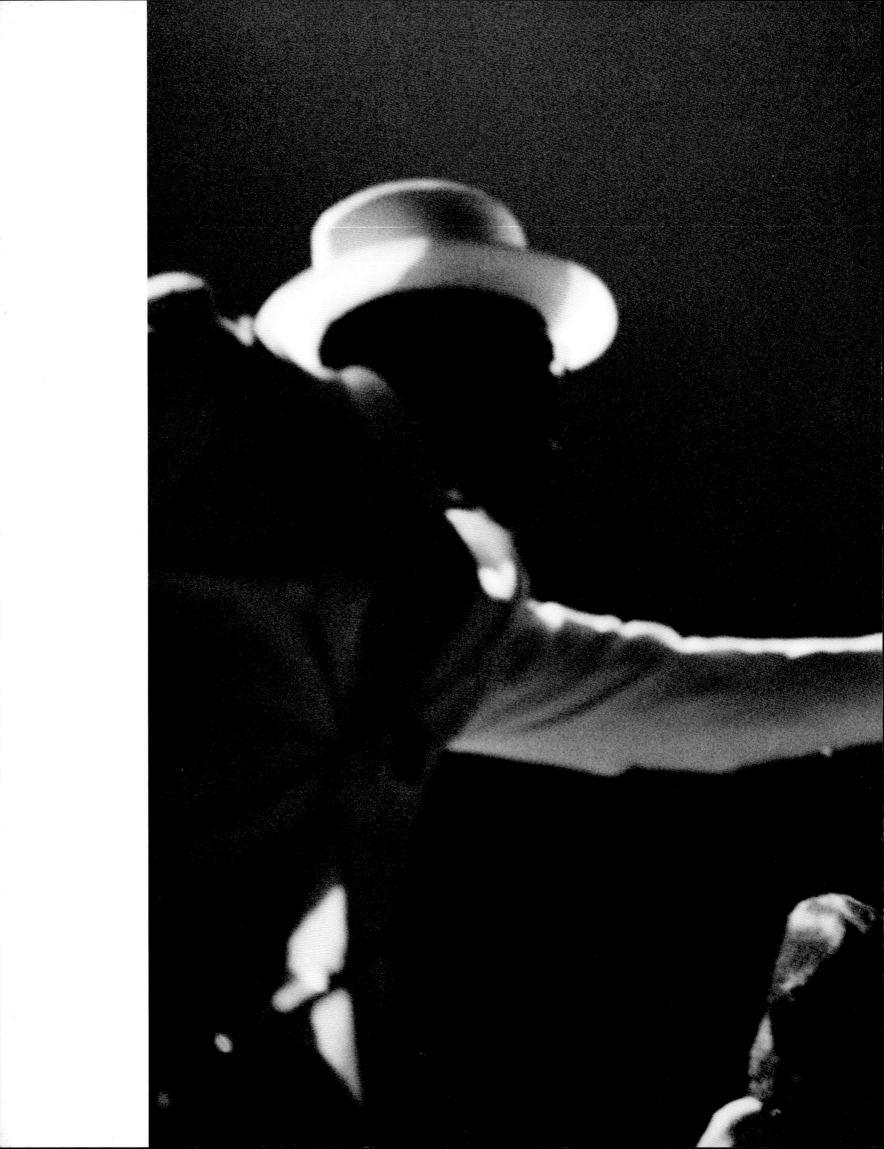

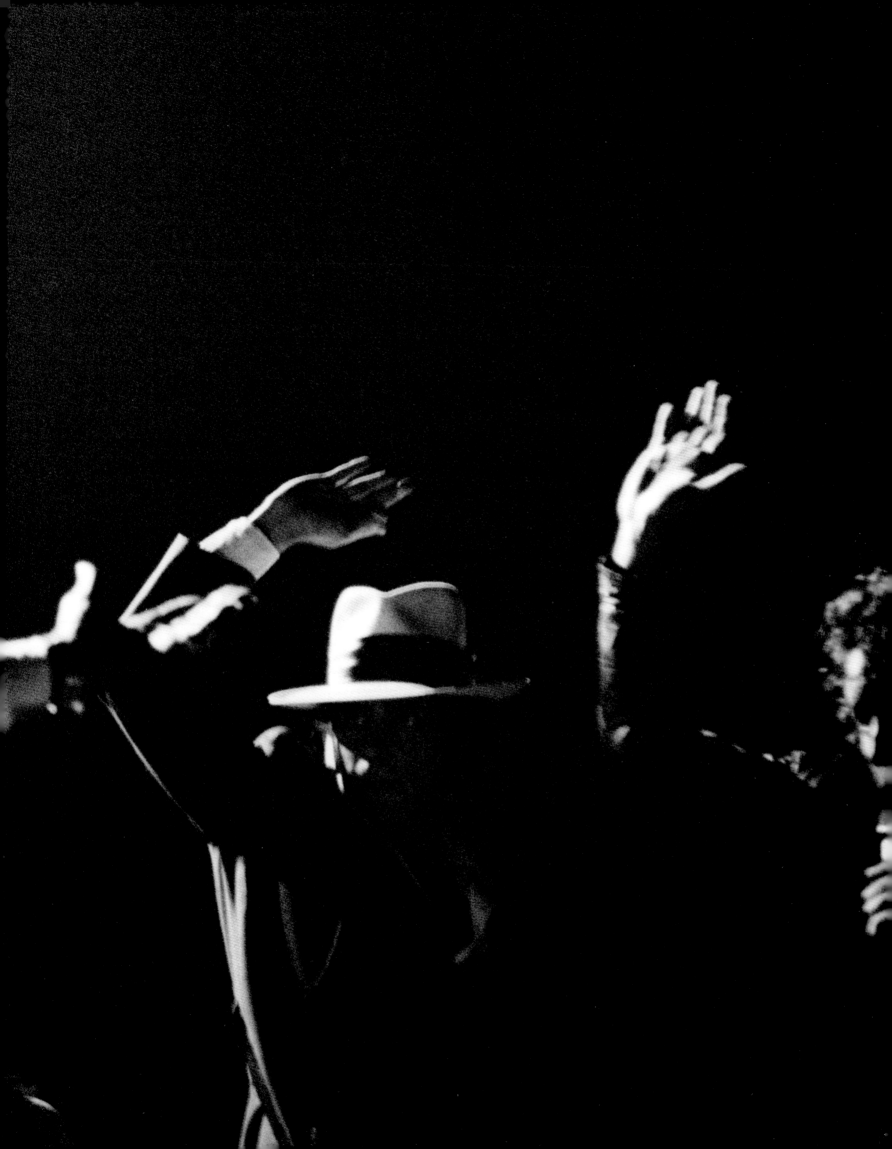

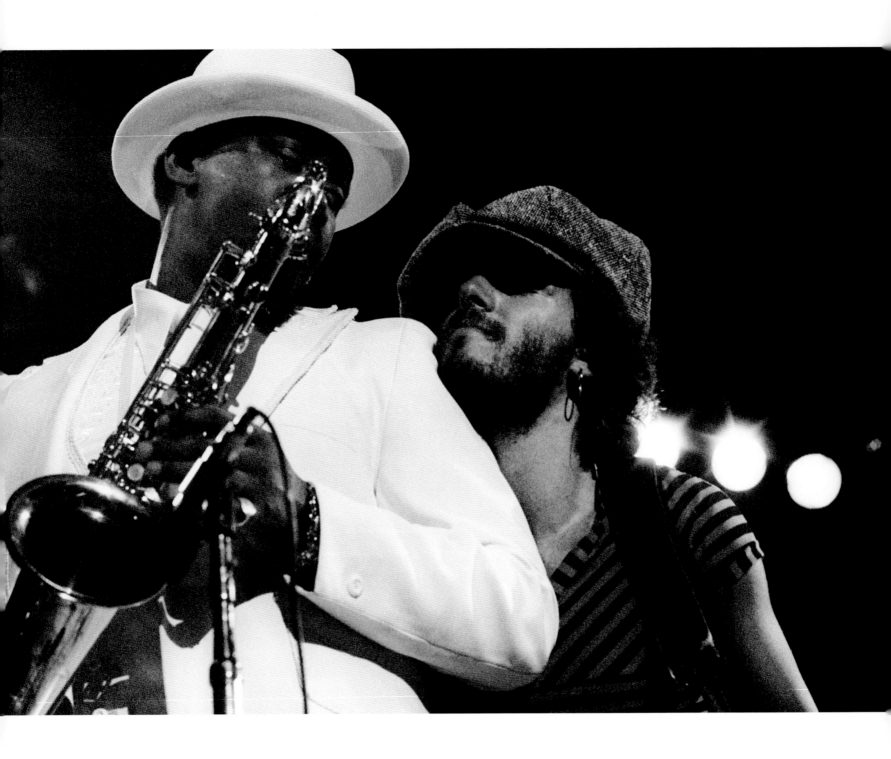

"Bruce and I looked at each other and didn't say anything, we just knew. We knew we were the missing links in each other's lives. He was what I'd been searching for. In one way he was just a scrawny little kid. But he was a visionary. He wanted to follow his dream. So from then on I was part of history."
- Clarence Clemons on Bruce Springsteen

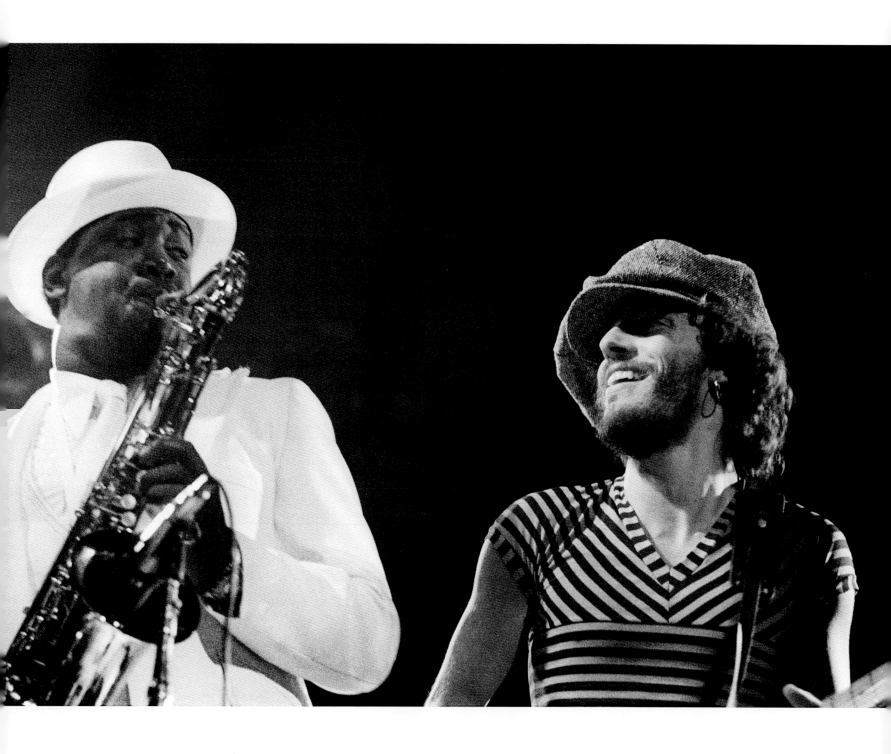

"We had a relationship that was elemental from the beginning. We played one song together and I said to myself, this is the guy who I've been looking for all my life. And ever since then we stuck together."
- Bruce Springsteen on Clarence Clemons

TEXAS

The whole band really had a blast in New Orleans with me showing them around. When they left, they wanted me to meet them in Houston. I was riding on the tour bus, not as a photographer but because they knew I could find cool places. It wasn't my first ride in a band's bus, I had already toured with Fats Domino. They wanted to experience what life was like in the streets of Texas. We went exploring, just the way we had in New Orleans.

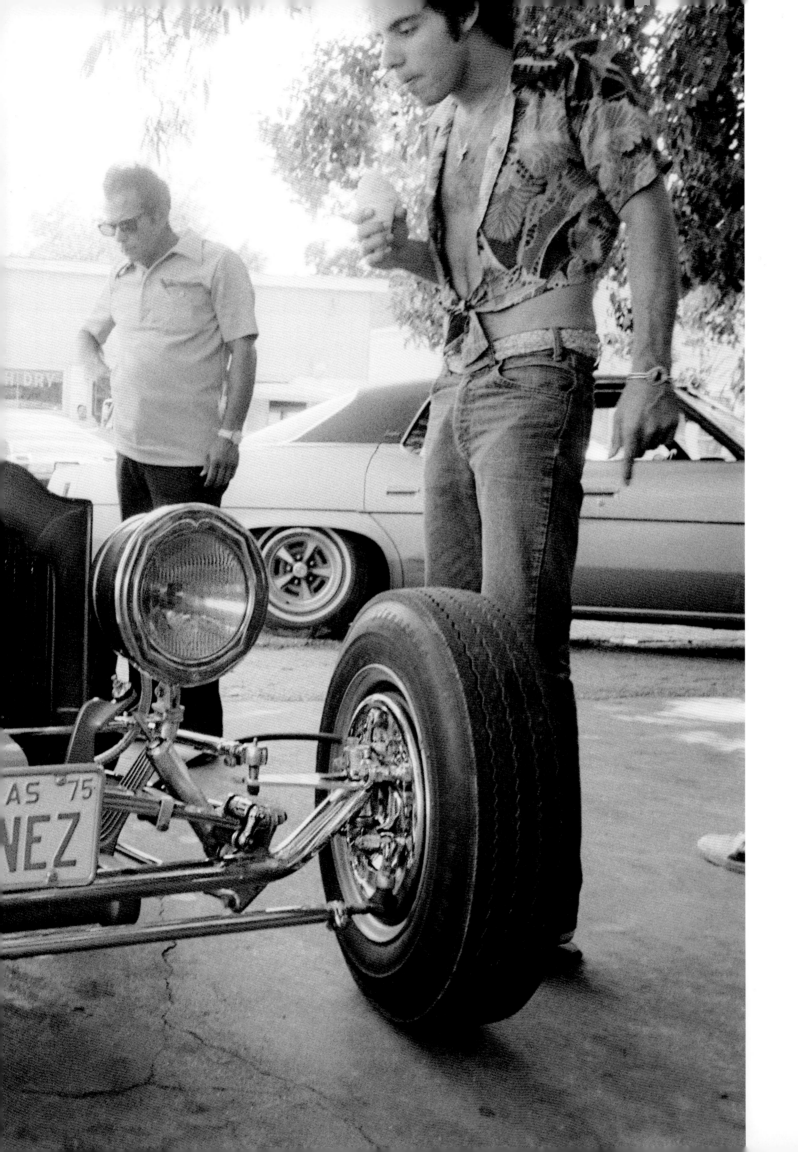

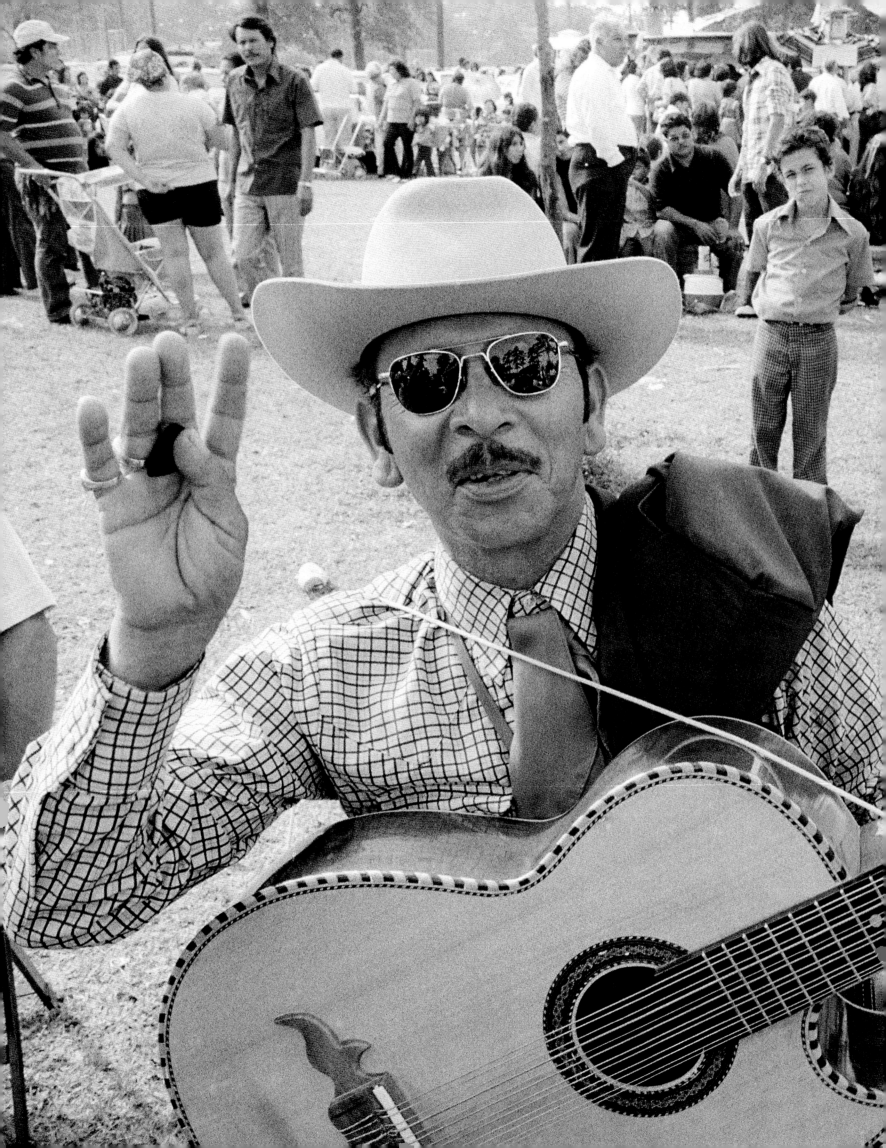

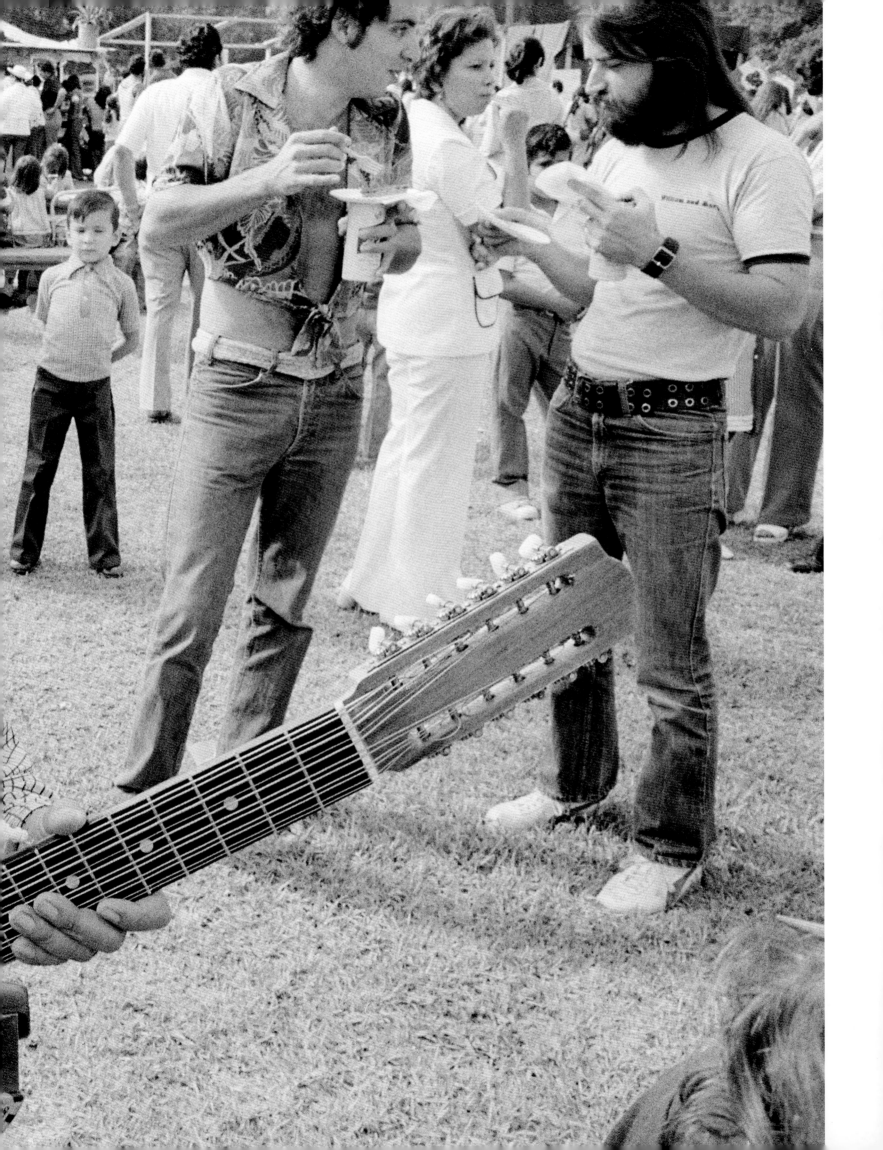

Max and Roy are both wearing early Born to Run *T-shirts*. Max's was from the July 25 and 26 concerts at Keystone Hall in Kutztown State College, Philadelphia.

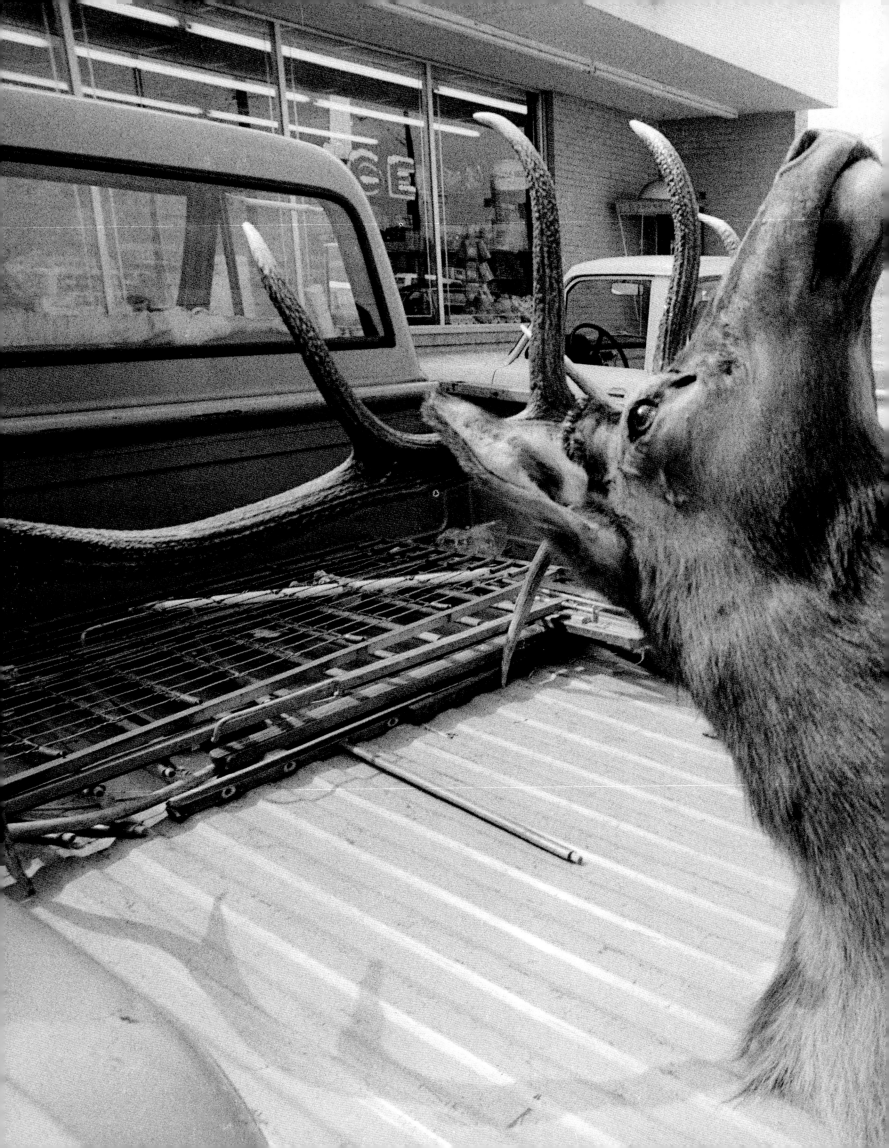

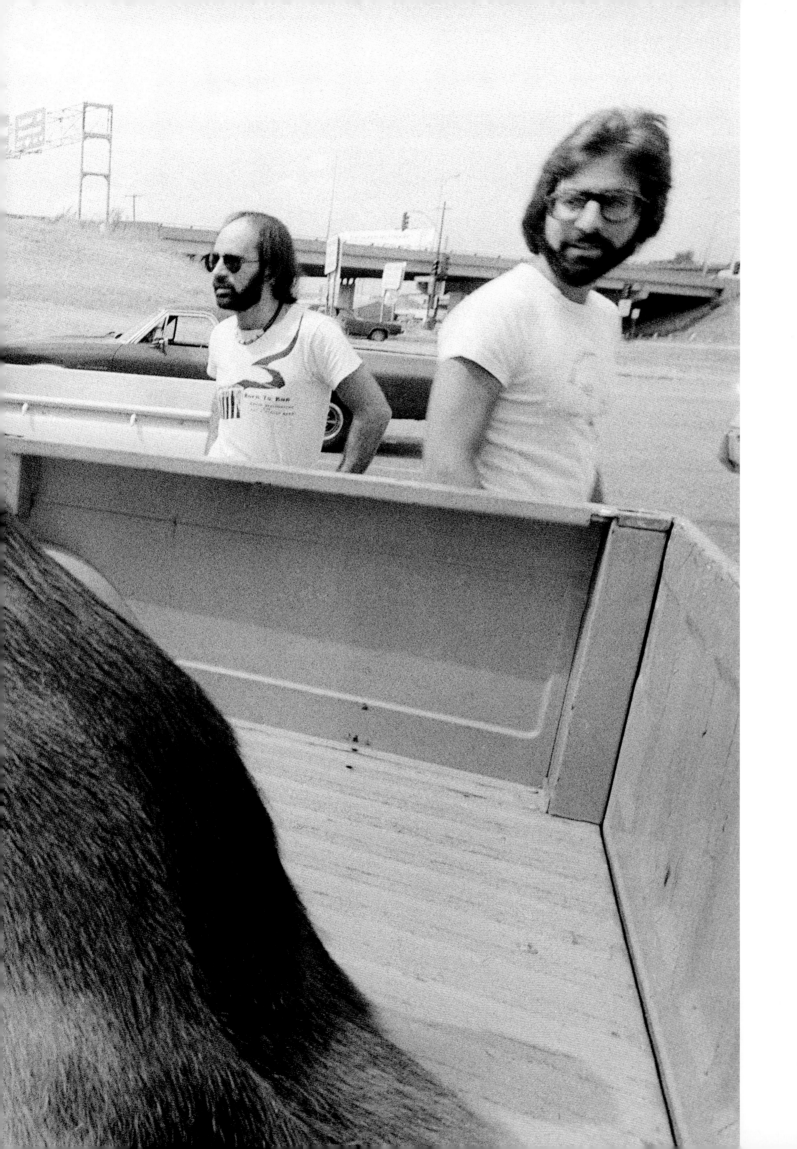

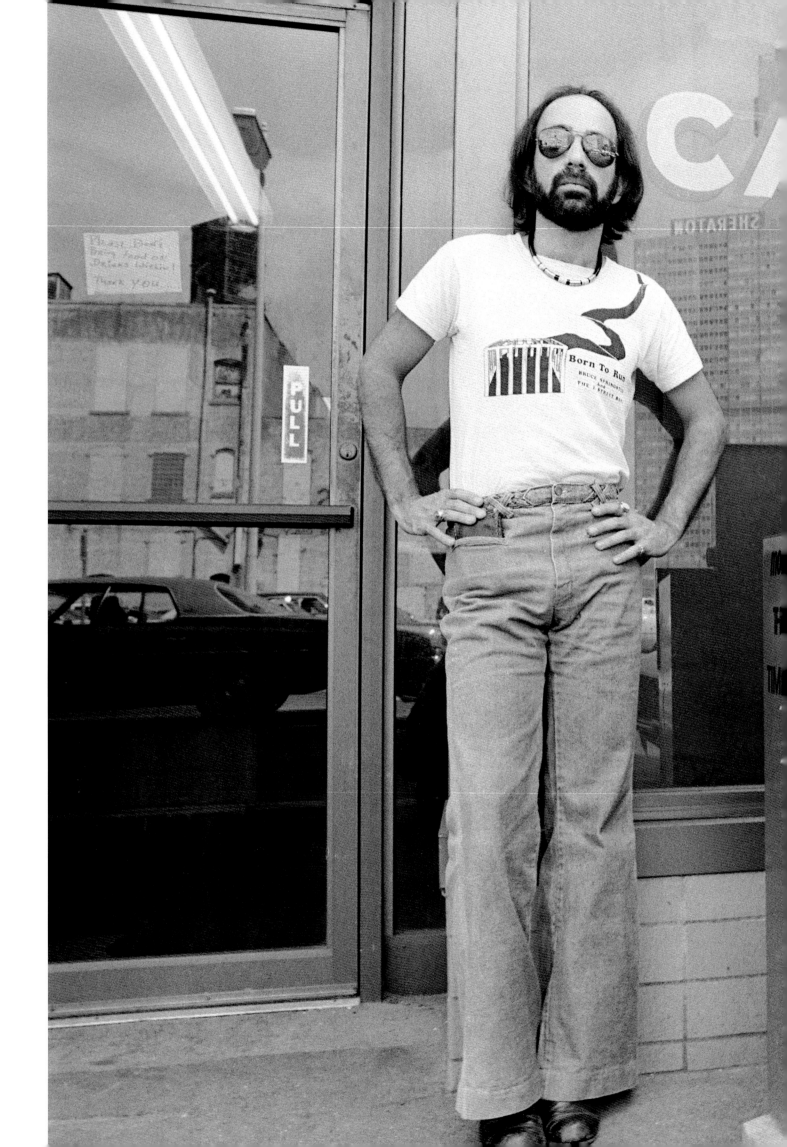

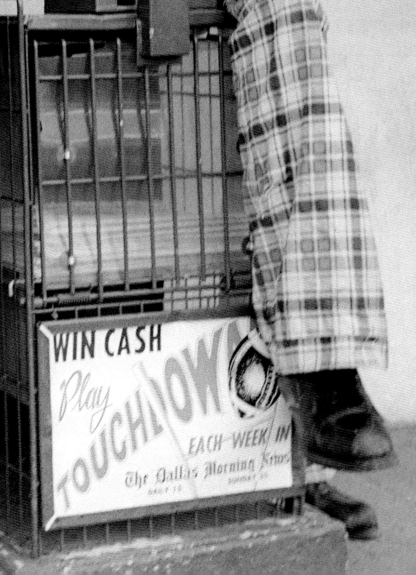

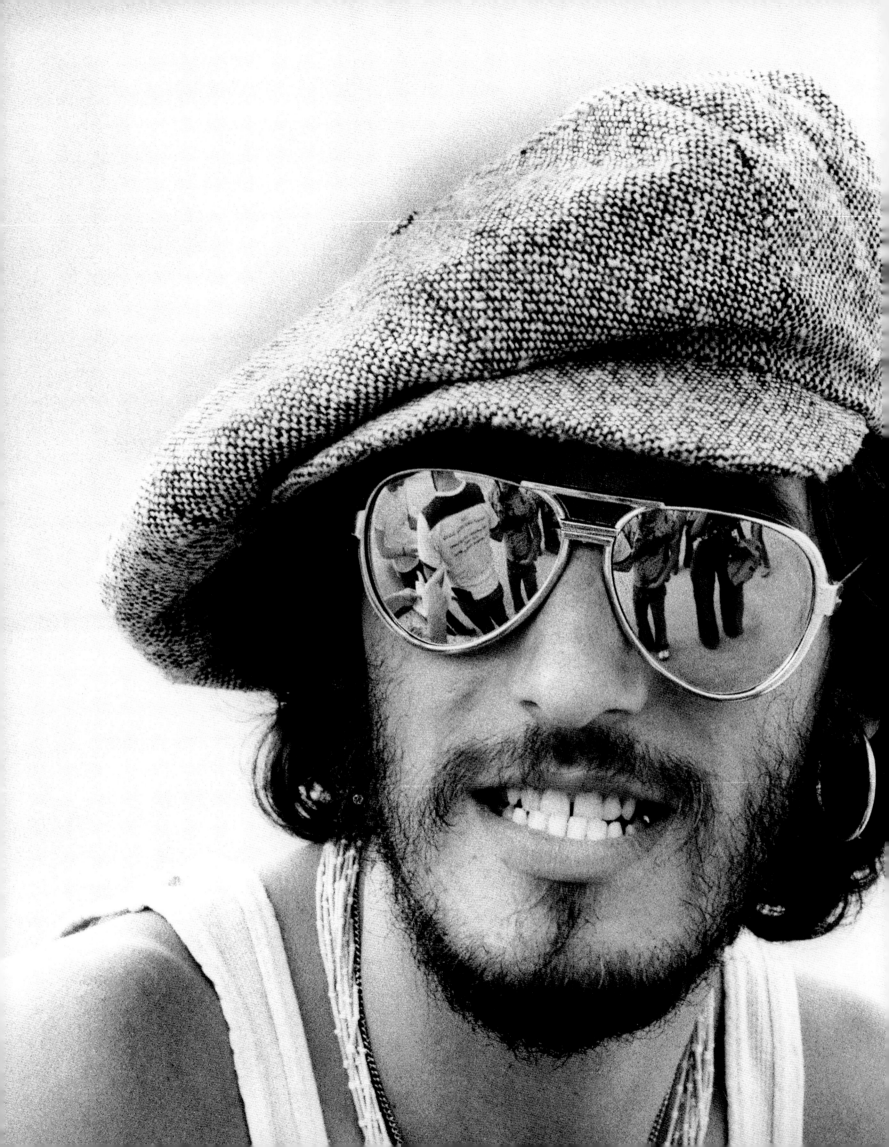

That's me and the roadies with my photographic gear reflected in Bruce's glasses.

"What we did was we went to a place where we were not known and we played in a club for twenty or thirty people. And then two months later we came back and we played for fifty people. Two months later, we came back again to the same town and we played for about 100 people. We did try for new audiences but we did it our way."

- Bruce Springsteen

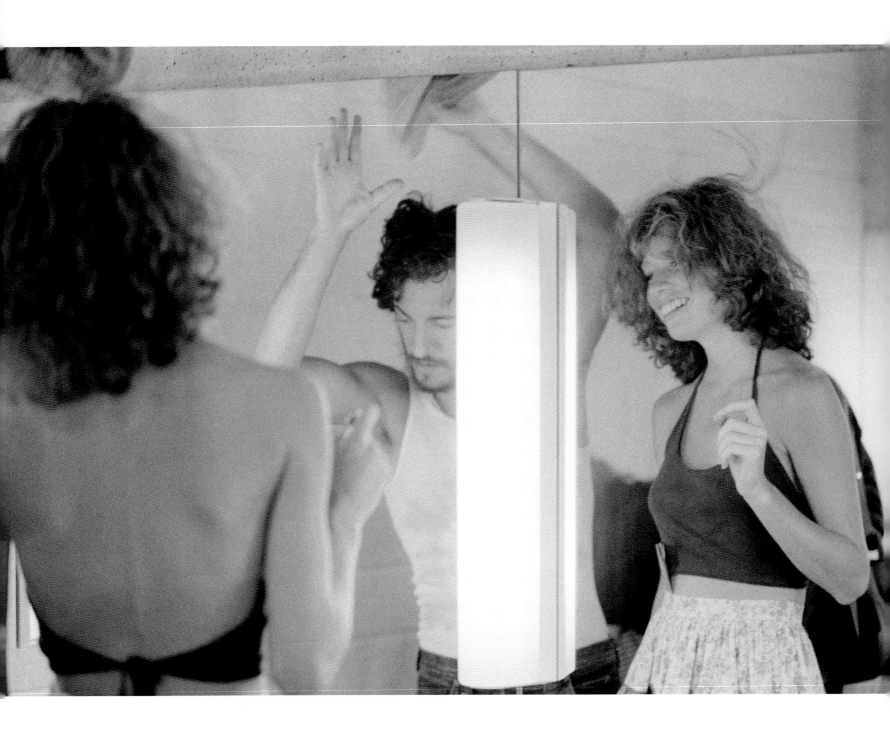

Bruce with his girlfriend, Karen Darvin. We picked her up from her parents' house in Dallas, Texas.

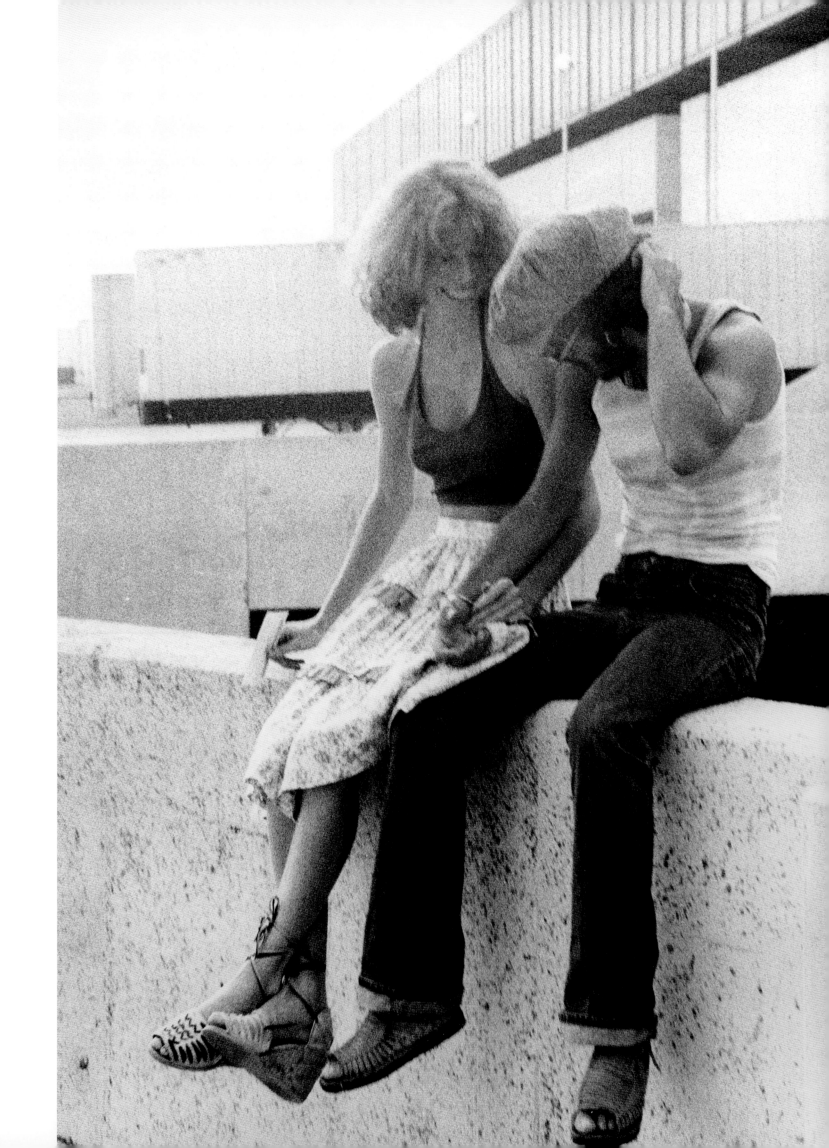

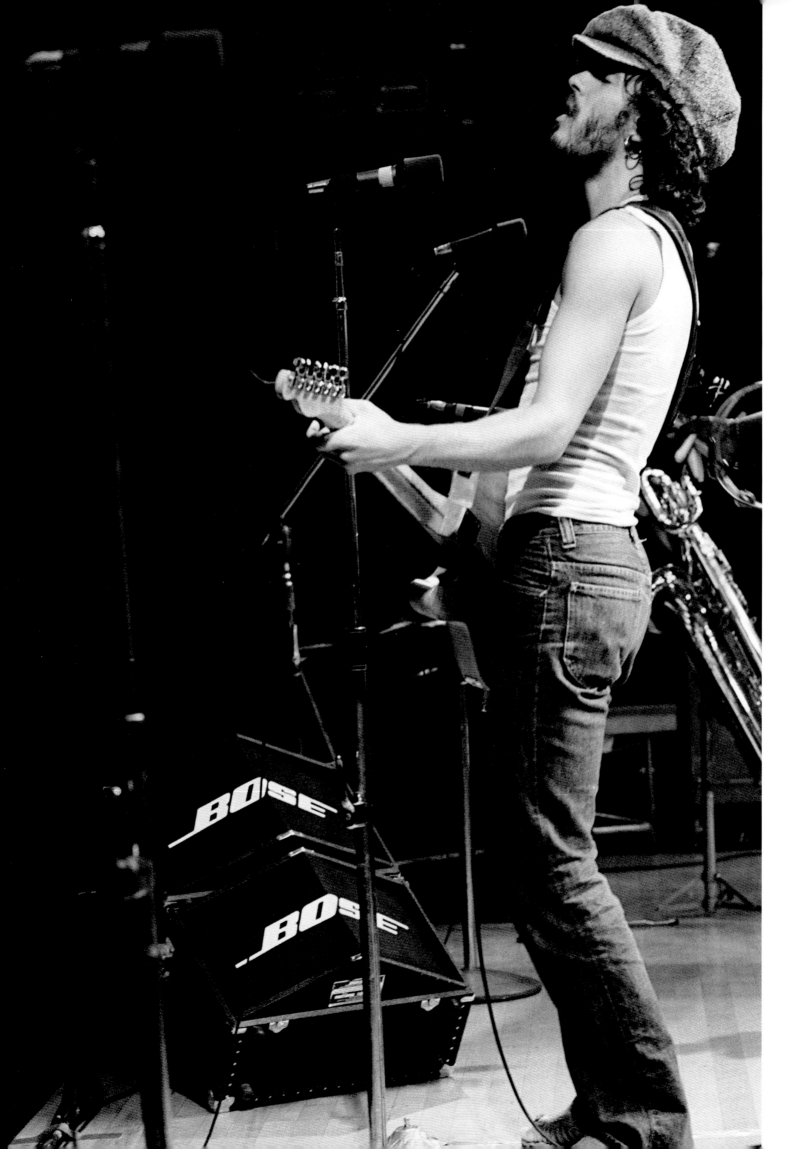

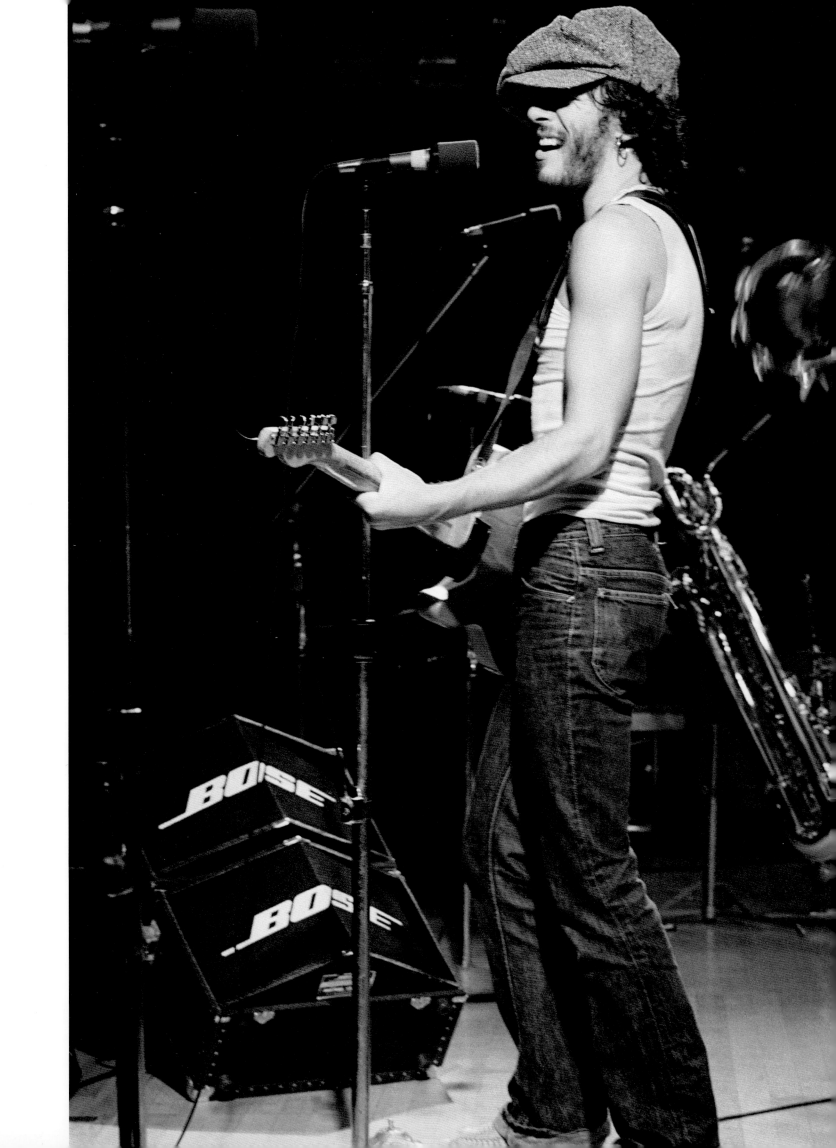

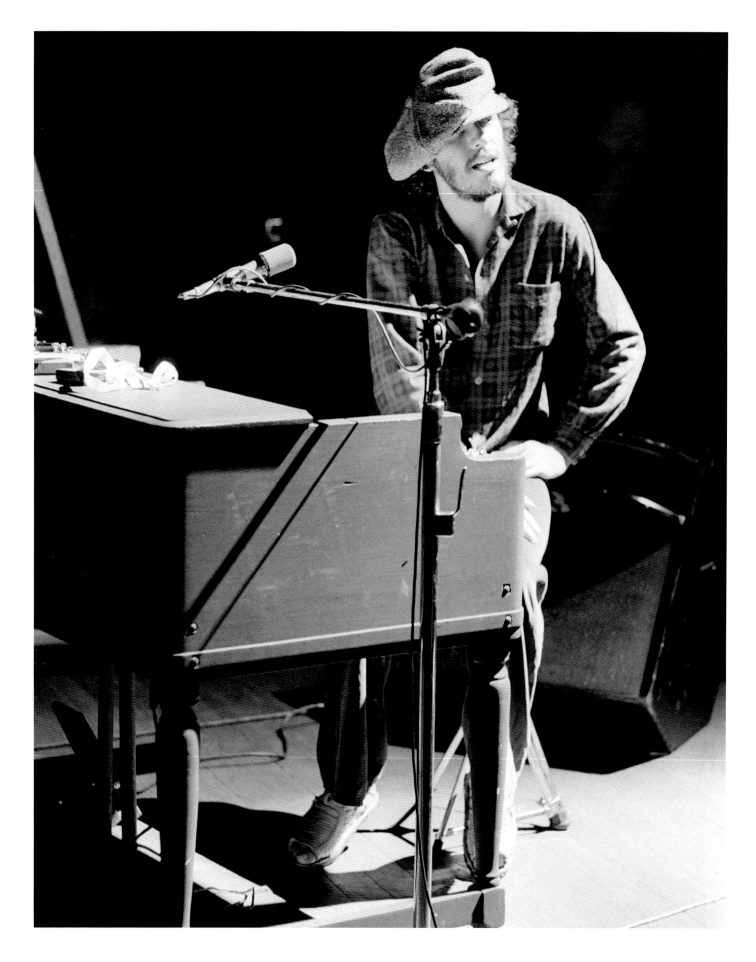

"Most of Born to Run was composed on the piano. Not most of it, actually, all of it."
- Bruce Springsteen

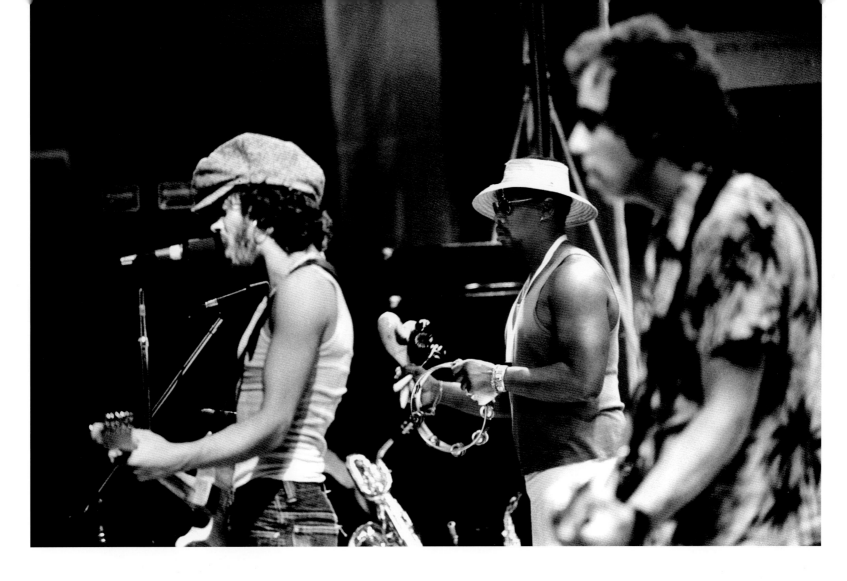

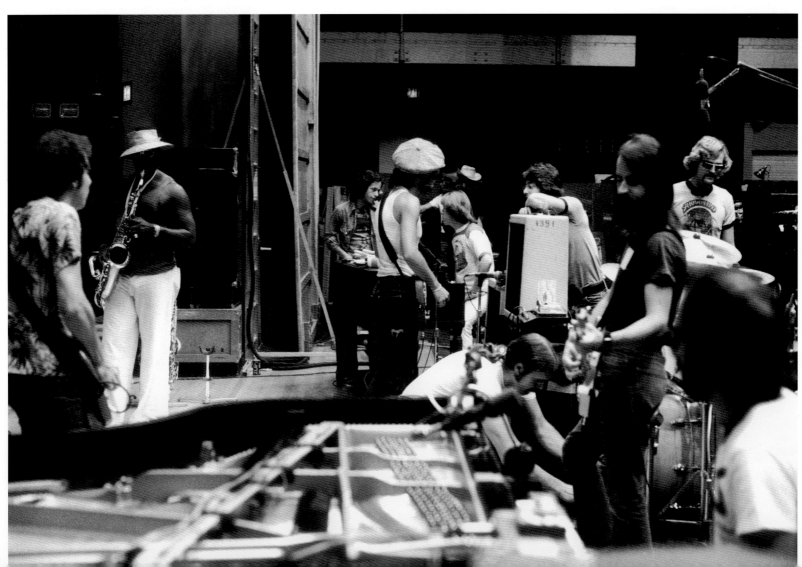

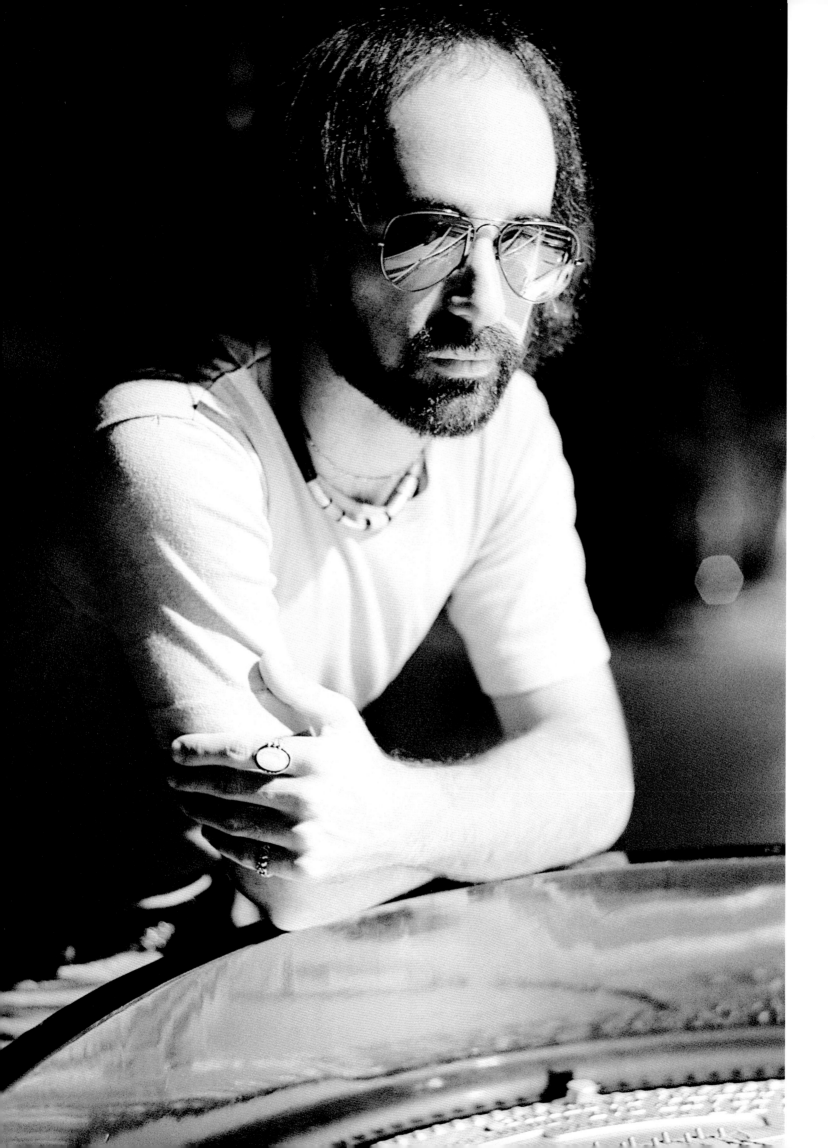

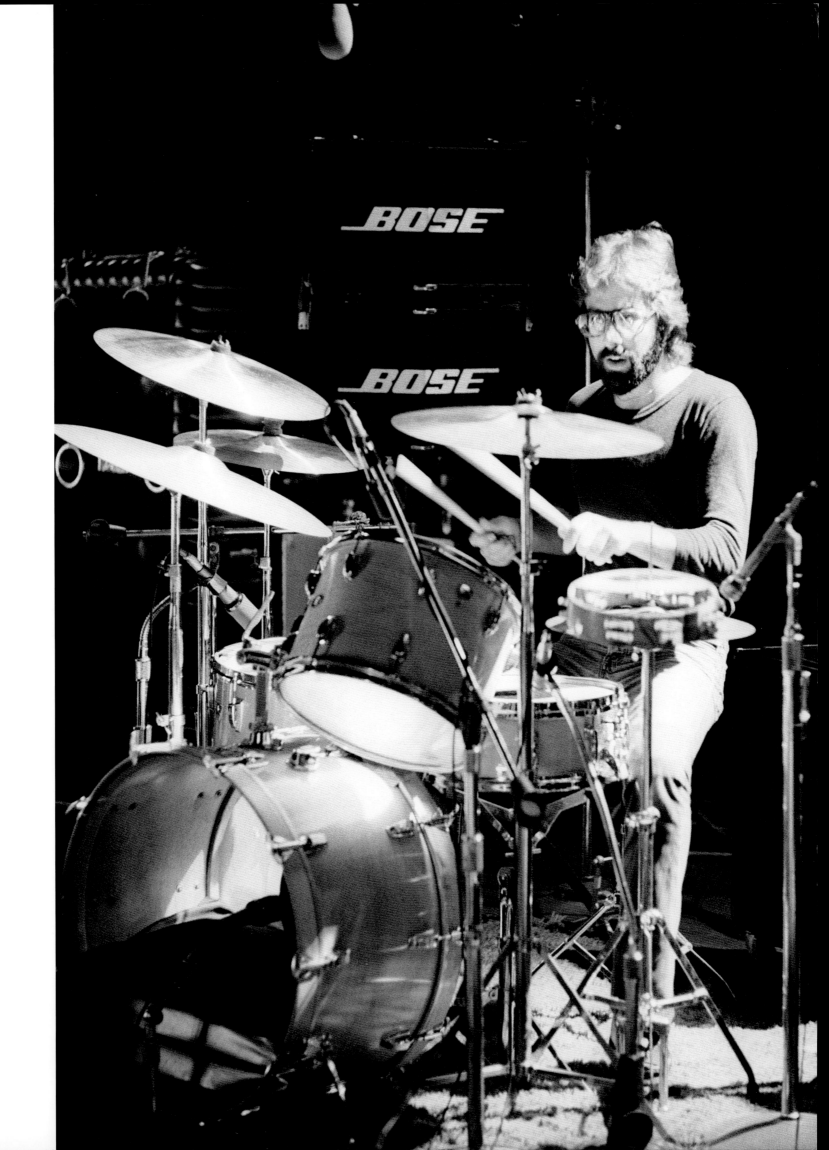

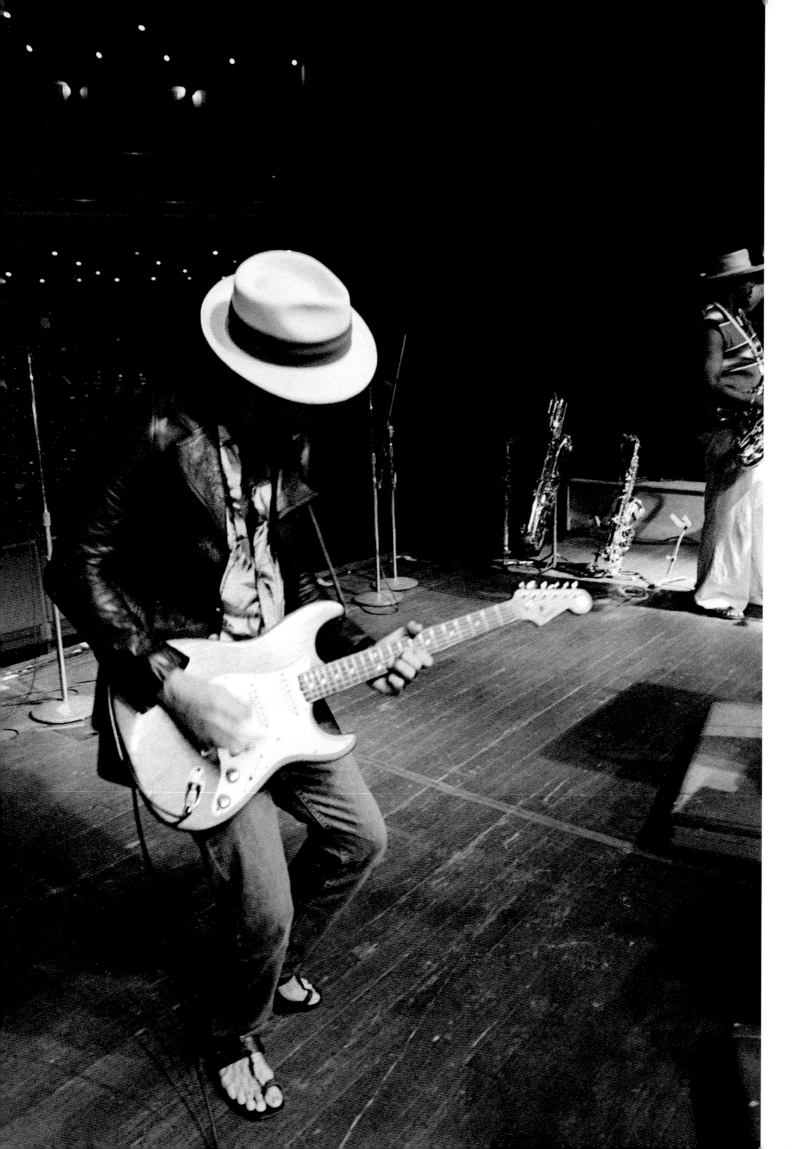

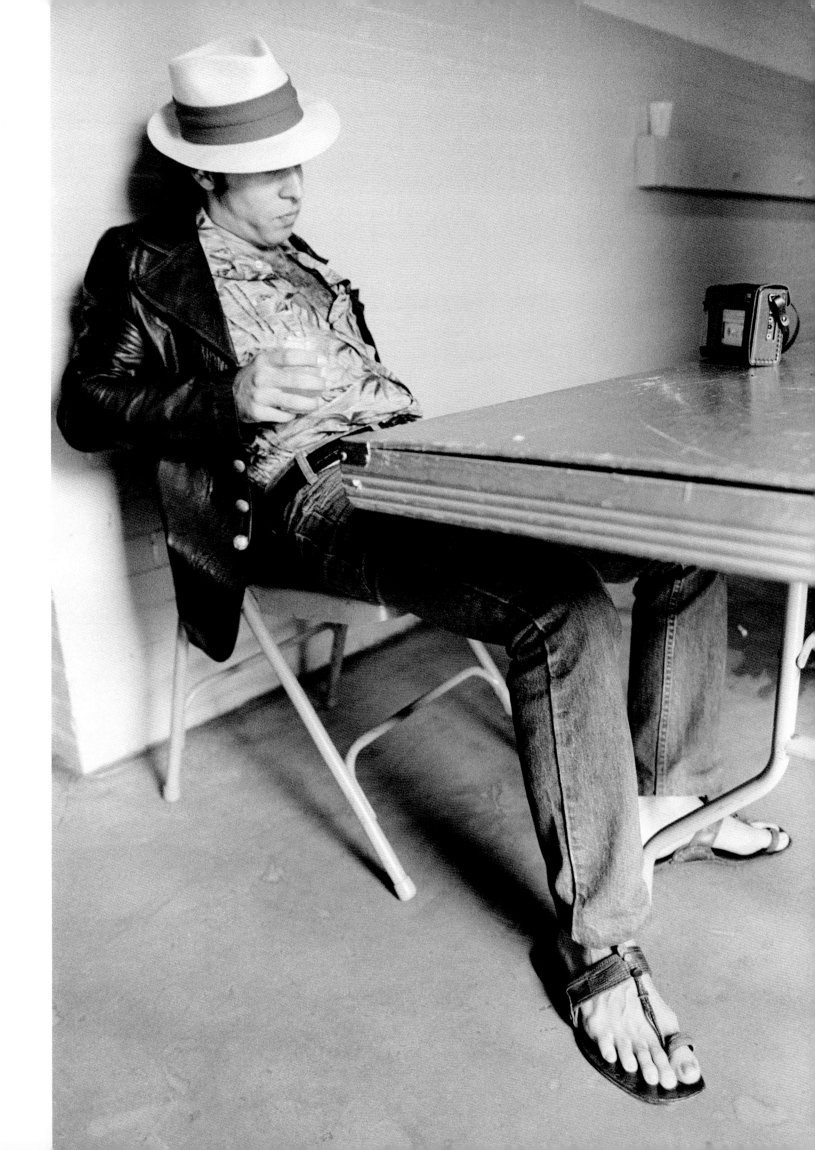

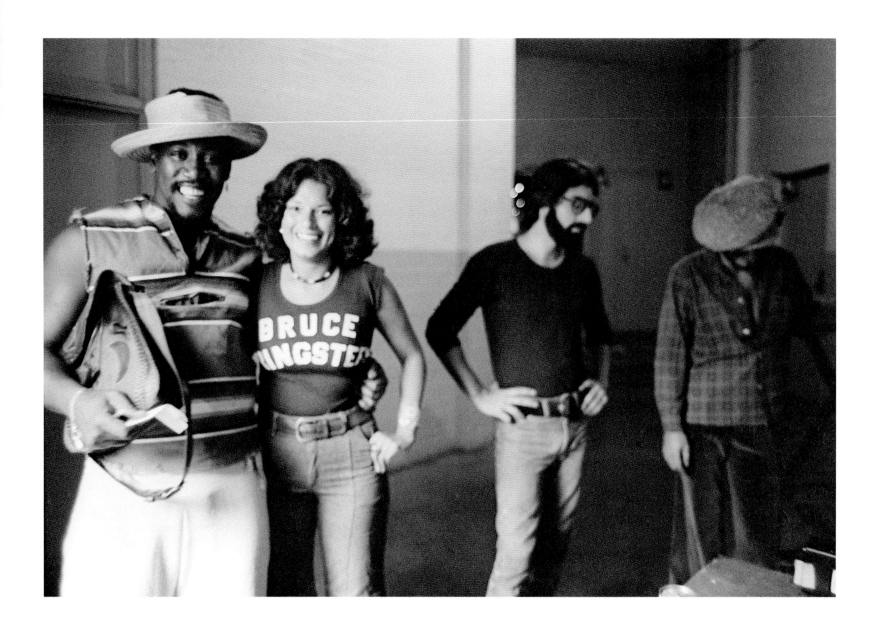

Clarence was a chick magnet and a massive flirt. Girls loved him and he loved them back.

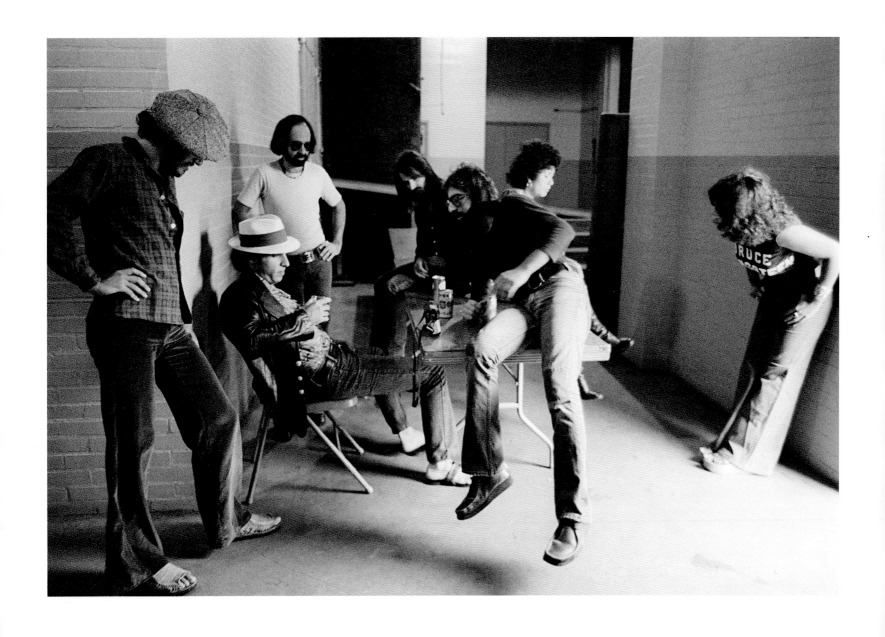

This is what an E Street Band meeting looked like. Music was what they cared about more than anything. For Bruce, everyone in the band had a voice, every opinion mattered to him. Every member of the E Street Band made his own unique contribution to their sound. Ultimately, there was only one man in charge.

In one word, Clarence was epic. He was magical, he was mystical and he had a rare spiritual quality about him. He was the soul of the E Street Band. We became close friends and remained so over the years. He was there for me with his full support during the most challenging years of my life. My favorite photo of him is now the award given at the Little Kids Rock Benefit, called Big Man of the Year, created to honor Clarence. Proceeds from the sale of this photo go to Little Kids Rock. Clarence was unpredictable and in constant motion. He was full of surprises. I miss him and his kind and generous spirit will be with me always.

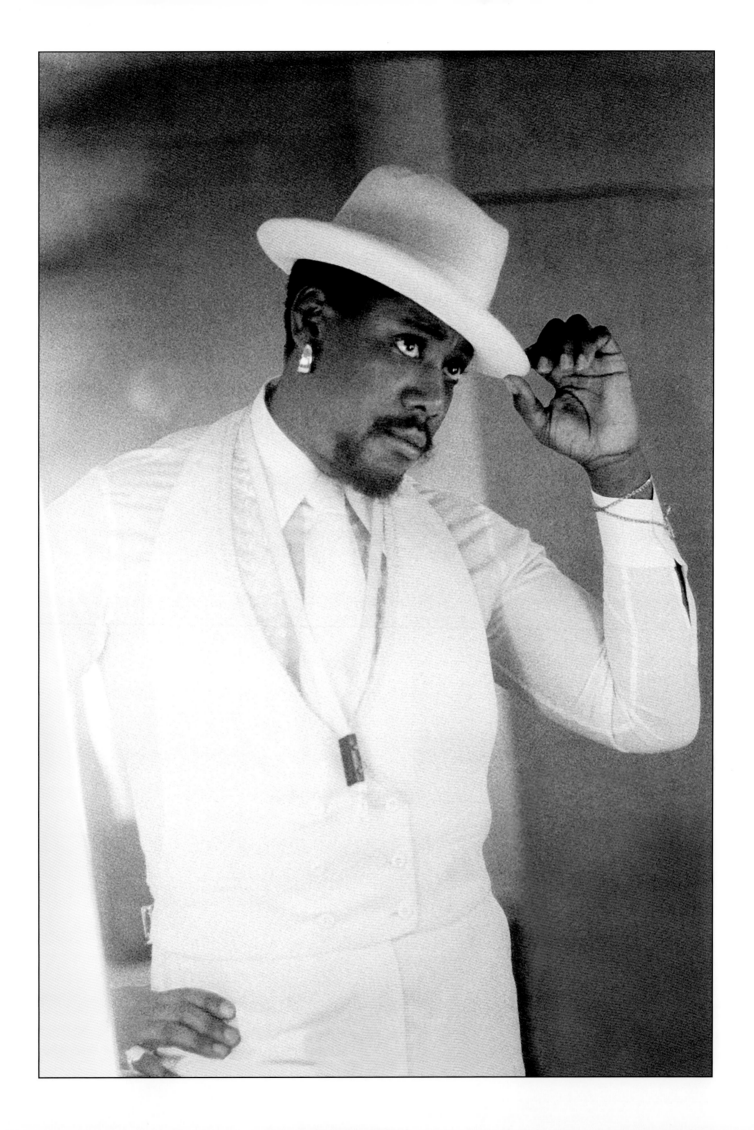

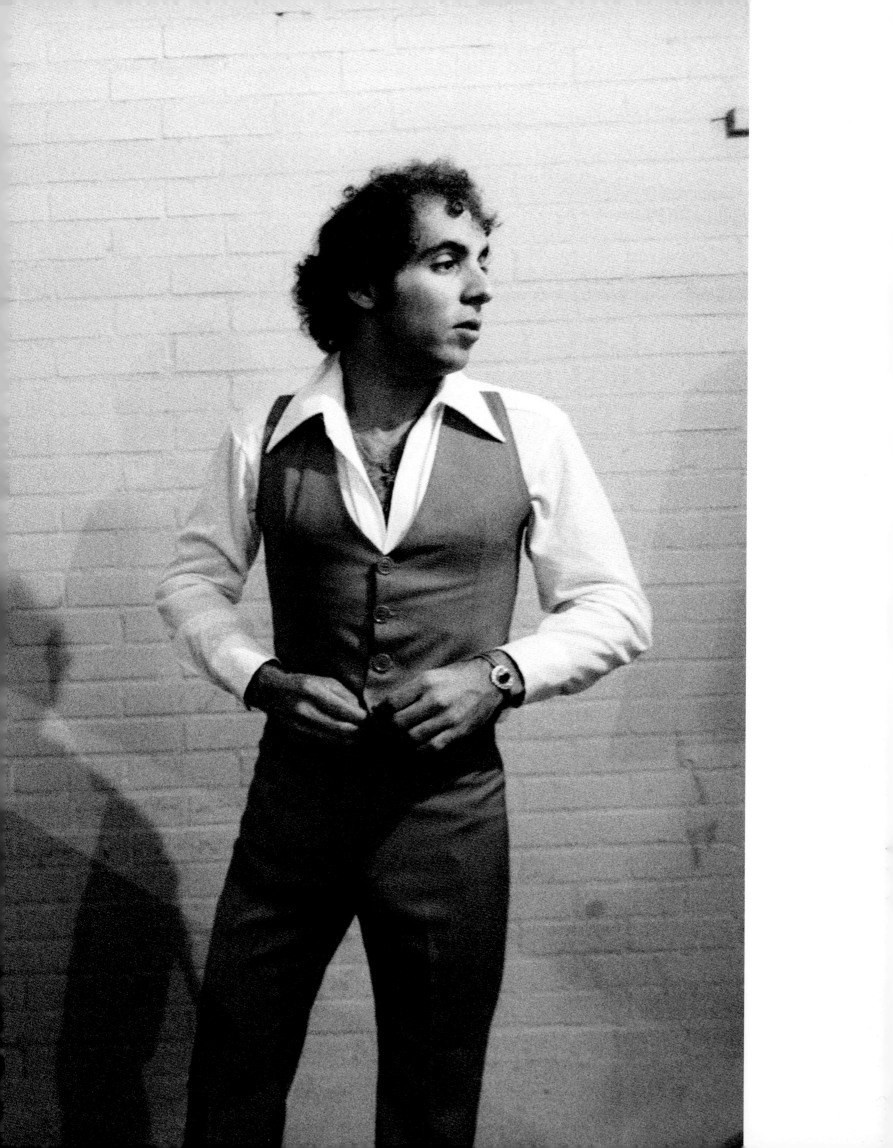

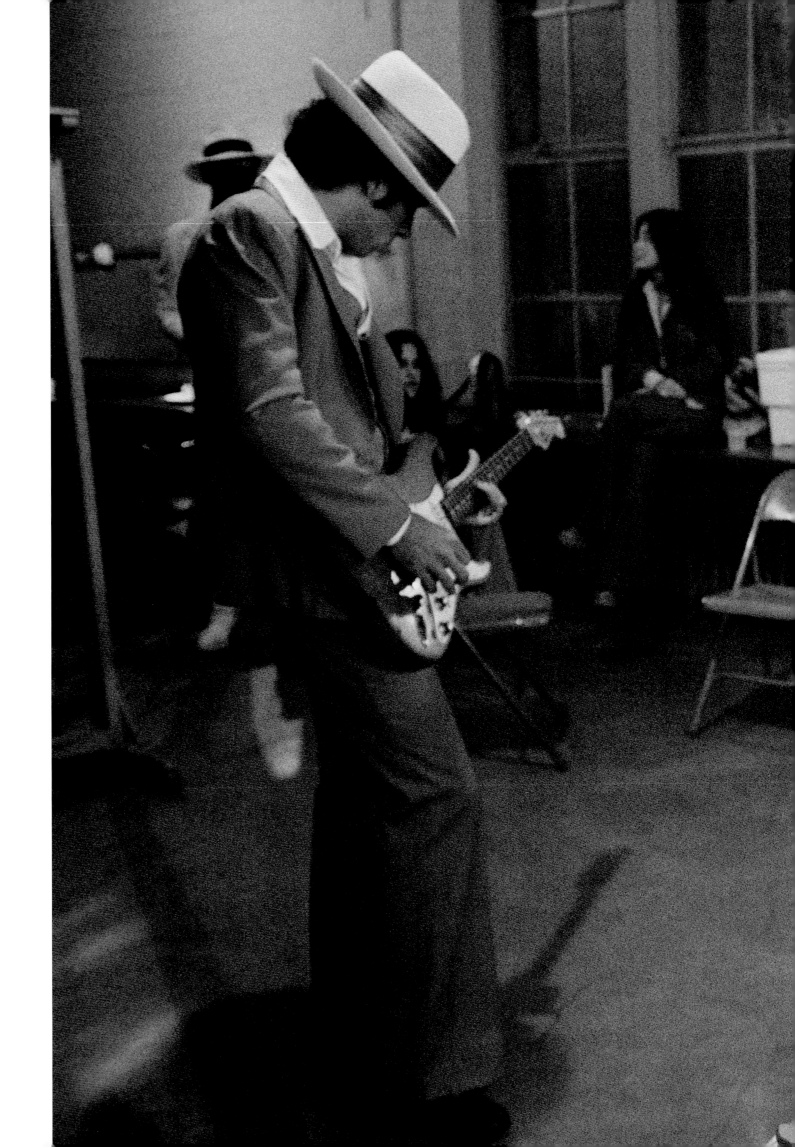

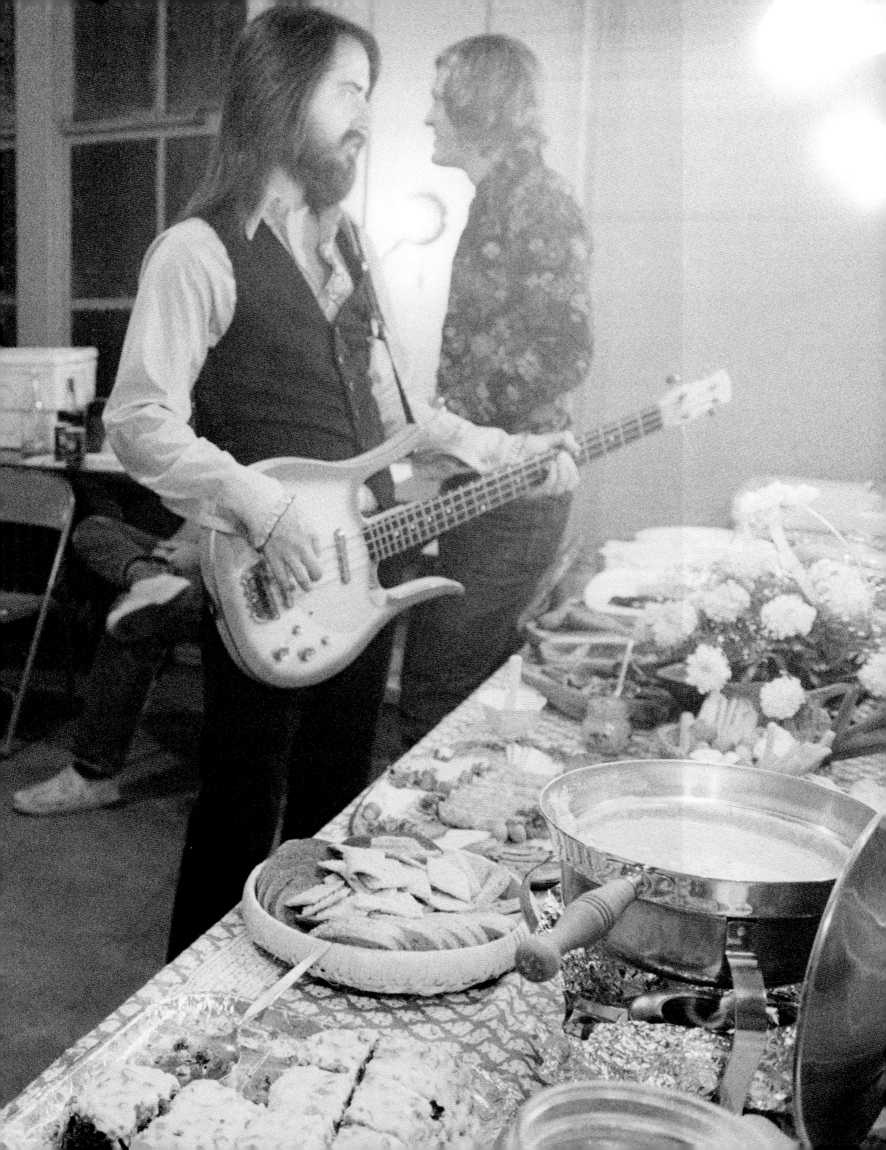

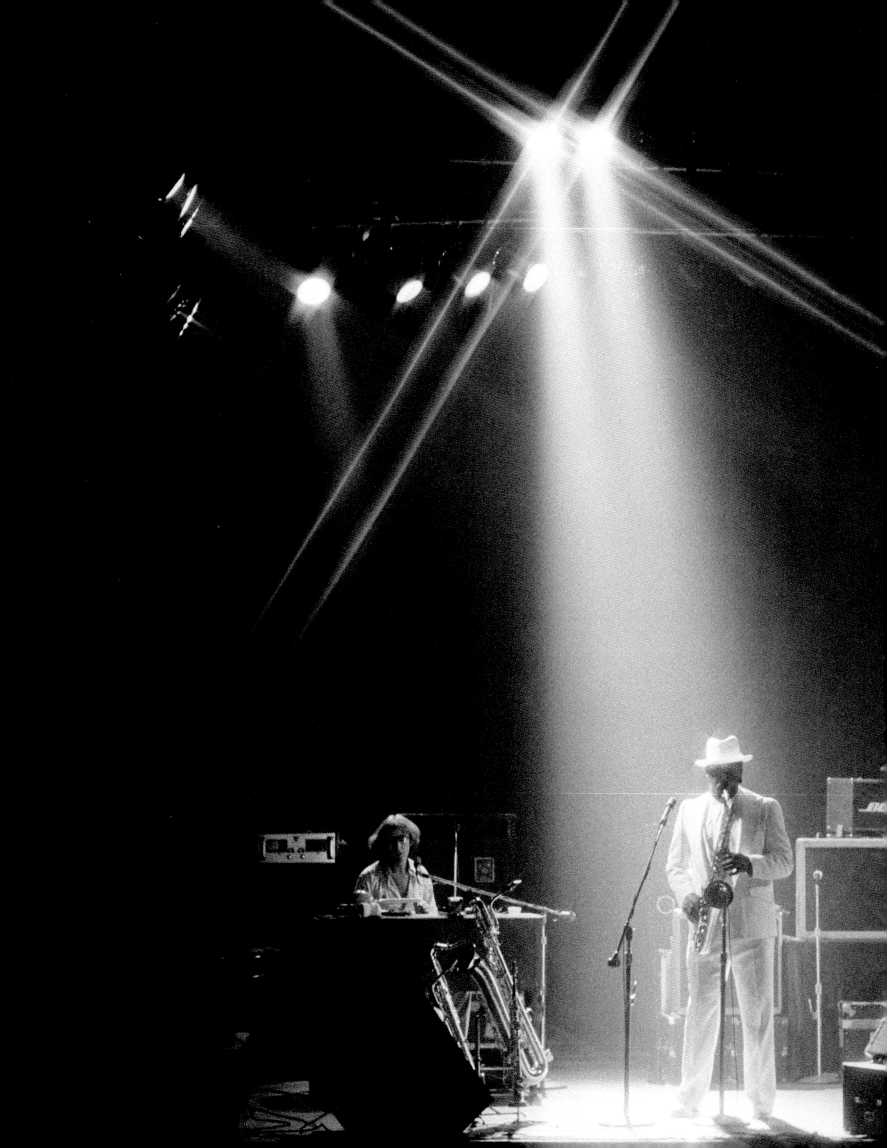

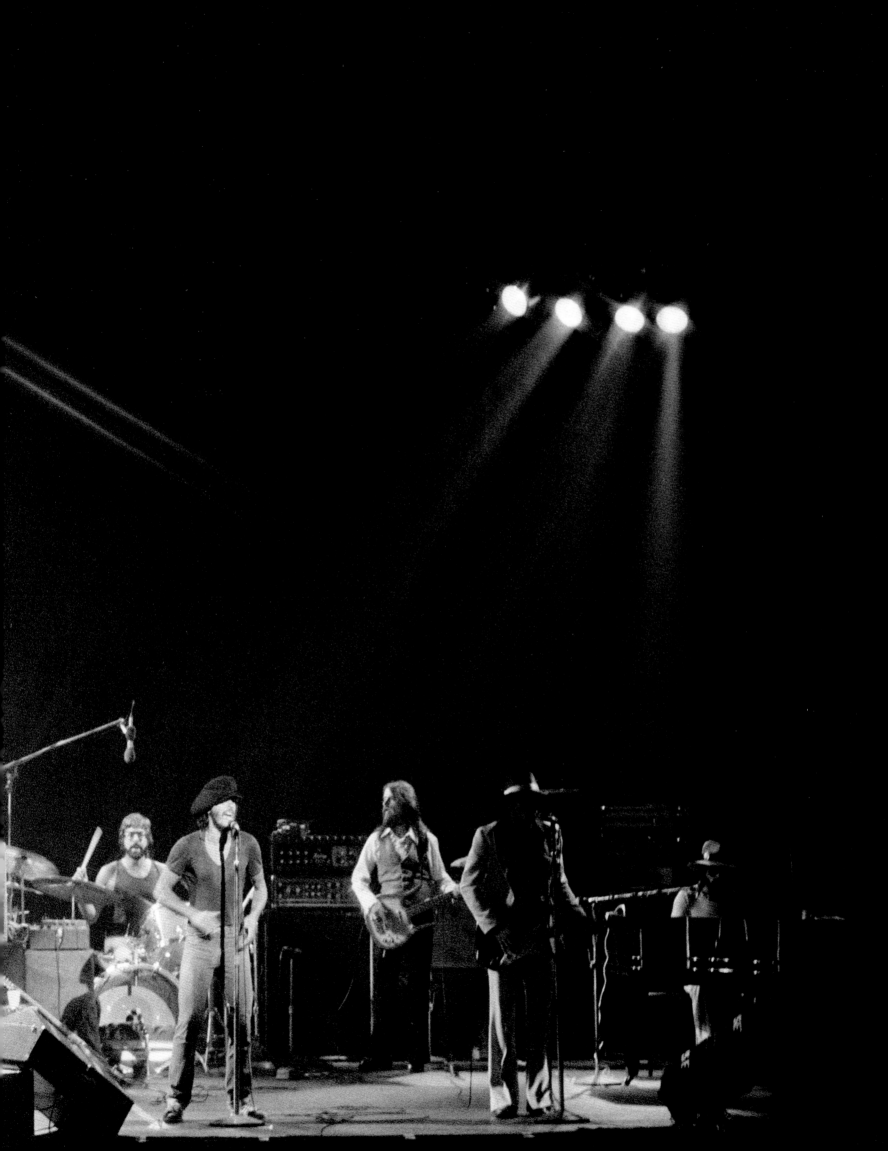

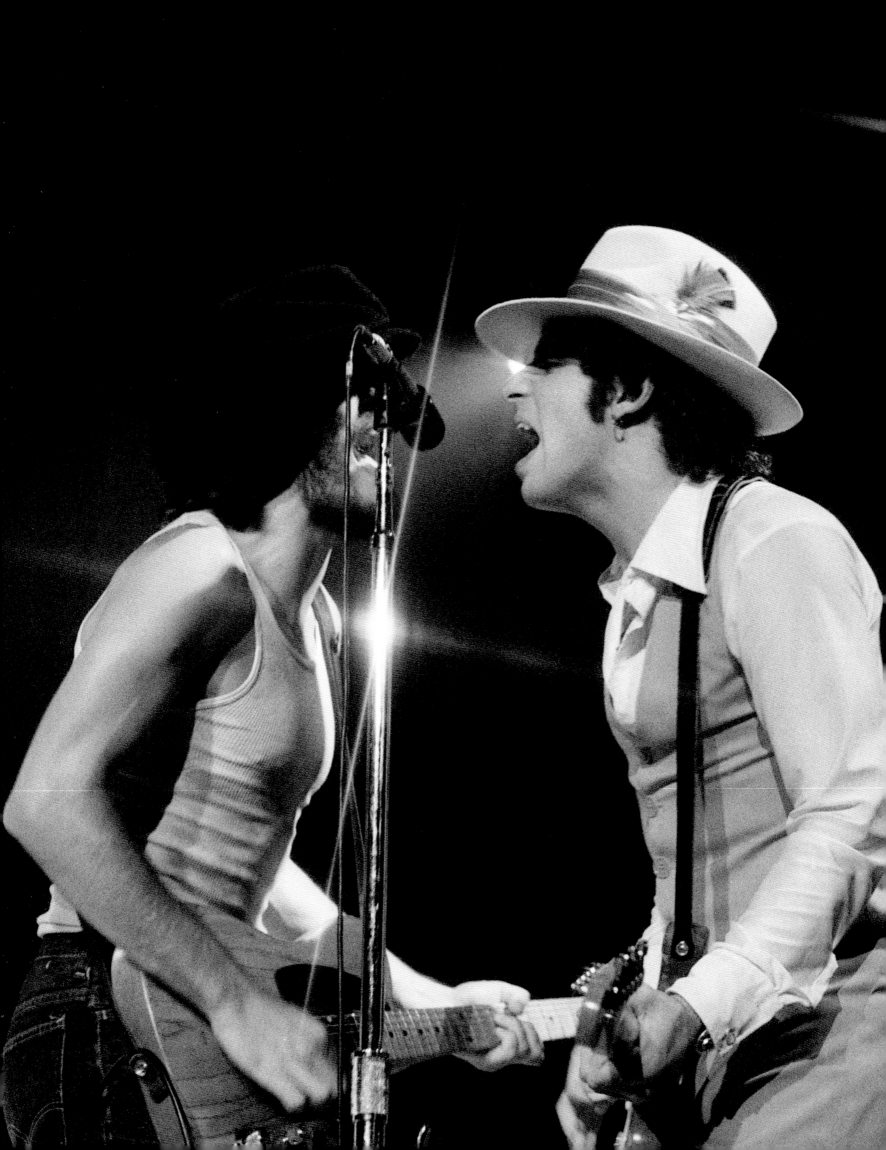

"I have a mental image of Bruce and Steve, either singing at a microphone together, or working on a part together . . . it felt like a missing member of the band had suddenly shown up. Where was he all this time?"
- Max Weinberg

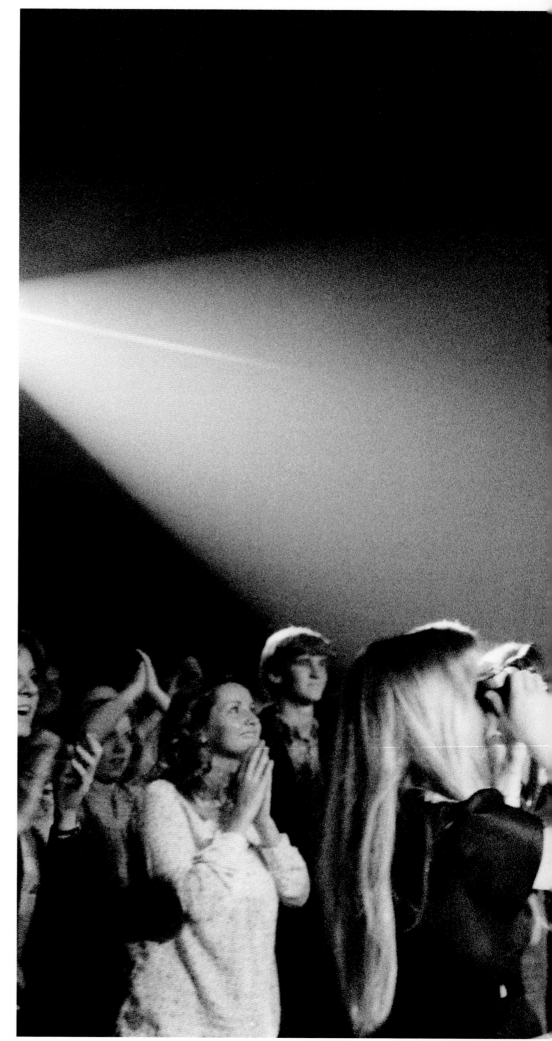

I never bought into the hype that Bruce was "the new Dylan." Bruce was nothing like Dylan. In 1975, he was raw and real, literally a fireball on stage, an explosion of energy and stamina. After every gig, he limped off the stage to standing ovations countless times. Off stage, Bruce would retreat into his private thoughts and worries.

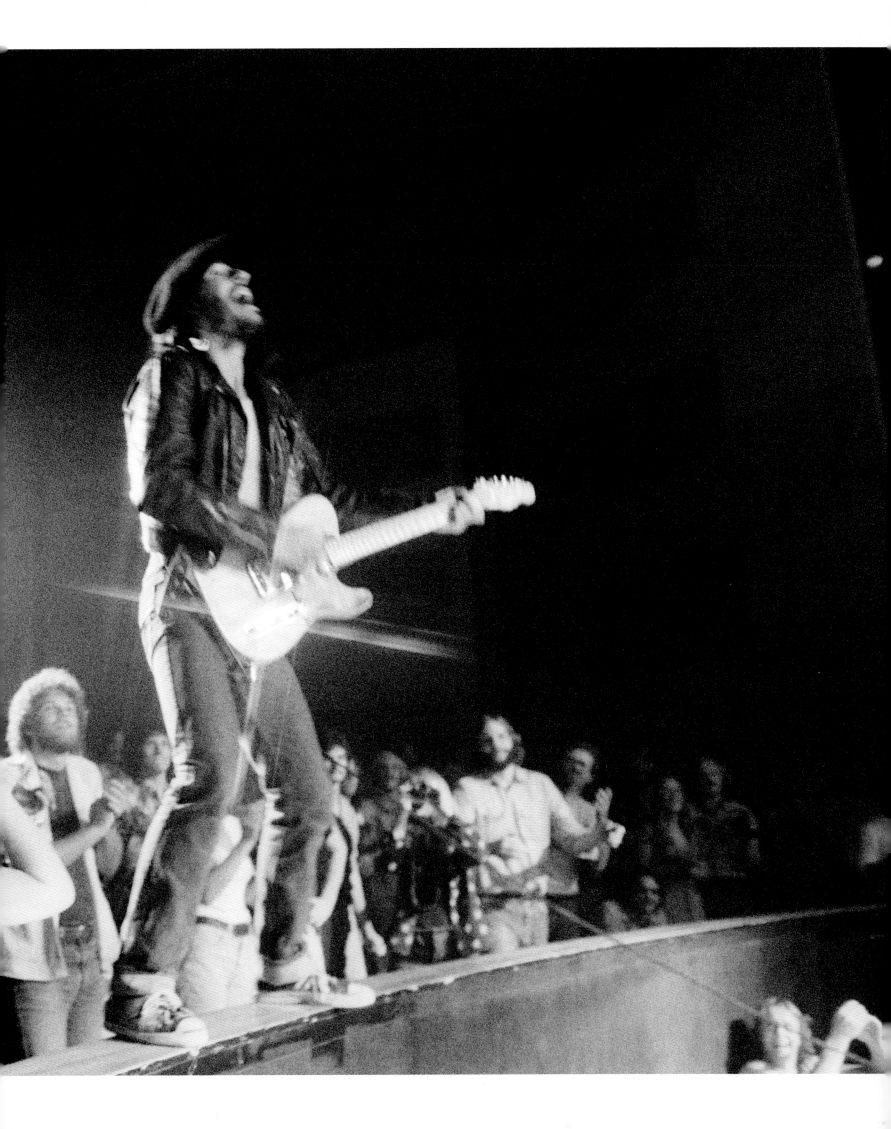

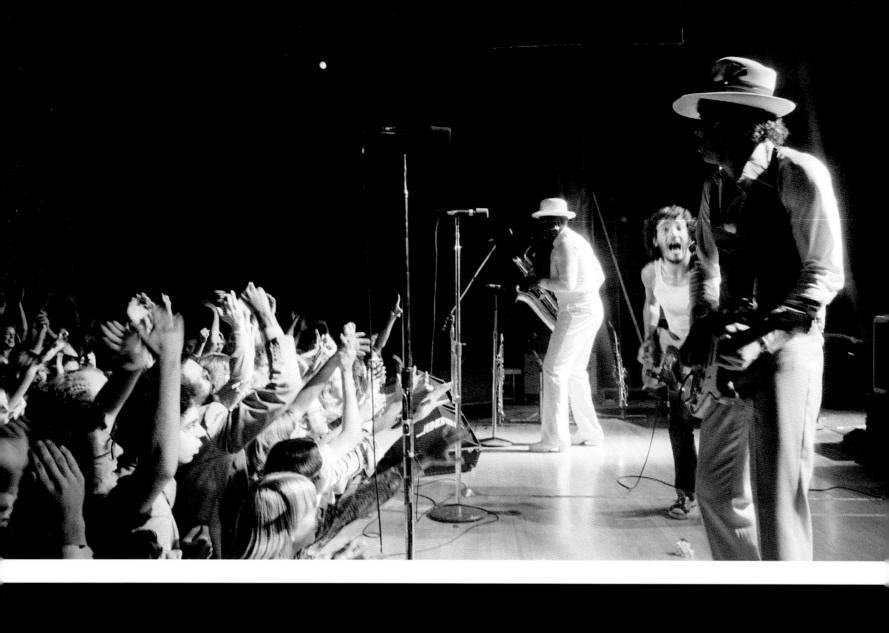
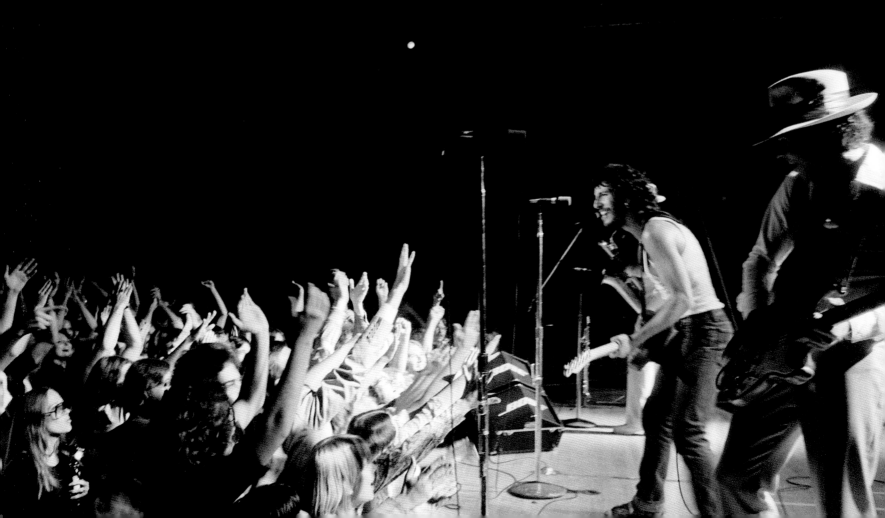

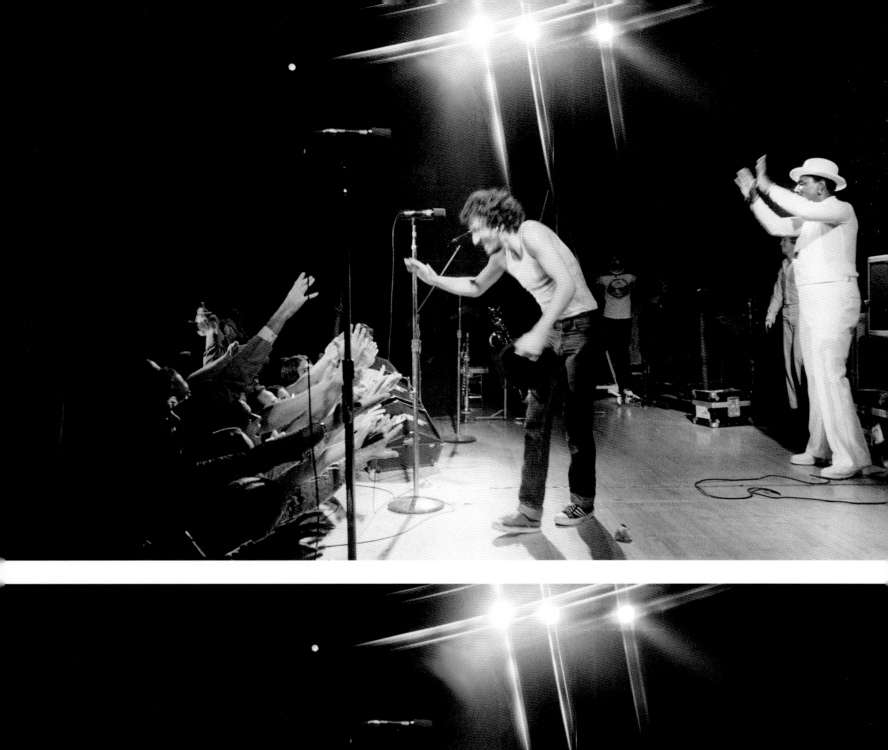
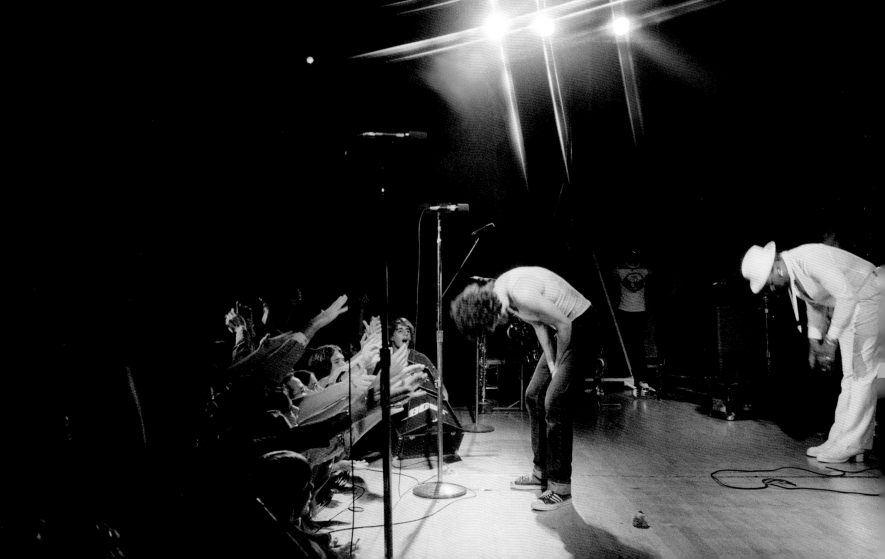

TOUR BUS

After meeting the band in New Orleans and Houston, I got on the bus. Not a showbiz bus and too tiny for sleep. They booked cheap motels. People always ask, "Why Bruce?" With Bruce it was a double, his music and his stories. His words spoke to me, as they did to all of us. Bruce describes his early lyrics as "twisted autobiographies" but he is telling our stories too. This connection explains the loyalty and longevity of his massive fan base. Though he was singing about his own life, he struck chords within us. "Long hair falling and eyes that shine like a midnight sun" is how many of my friends described me. My life was one long emergency. I was born with the power of a locomotive. When Bruce sang "your strength is devastating in the face of all these odds," his lyrics resonated with me. The six-year-old rebel who broke all the rules. My passion for sailing under a pirate flag. My sister Kitty—I wish she *could* be back in town. My time as a clown with the Chipperfield Circus in England. By the time I met Bruce, I had already been hiding in the backstreets of New Orleans for ten years. We were spirits in the night because of the ninety-degree heat. Now, I am living in Saint Lucia, winning boat races. I have shaken off the street life, the city life and am finally walking in the sun. My most upsetting connection was to Bruce's lyric about a body hitting the street "with a beautiful thud." I walked out of my studio as a limo pulled up in front of the restaurant across the street. Shots rang out. A body hit the street. I saw an assassination. It wasn't beautiful at all. I didn't see any faces. They were just shadows in the night. My favorite lyric is "Someday we will look back on this and it will all seem funny." Bruce says in his book *Songs* that it would not *be* funny but would *seem* funny. He believes it is the most useful line he ever wrote. I believe that too.

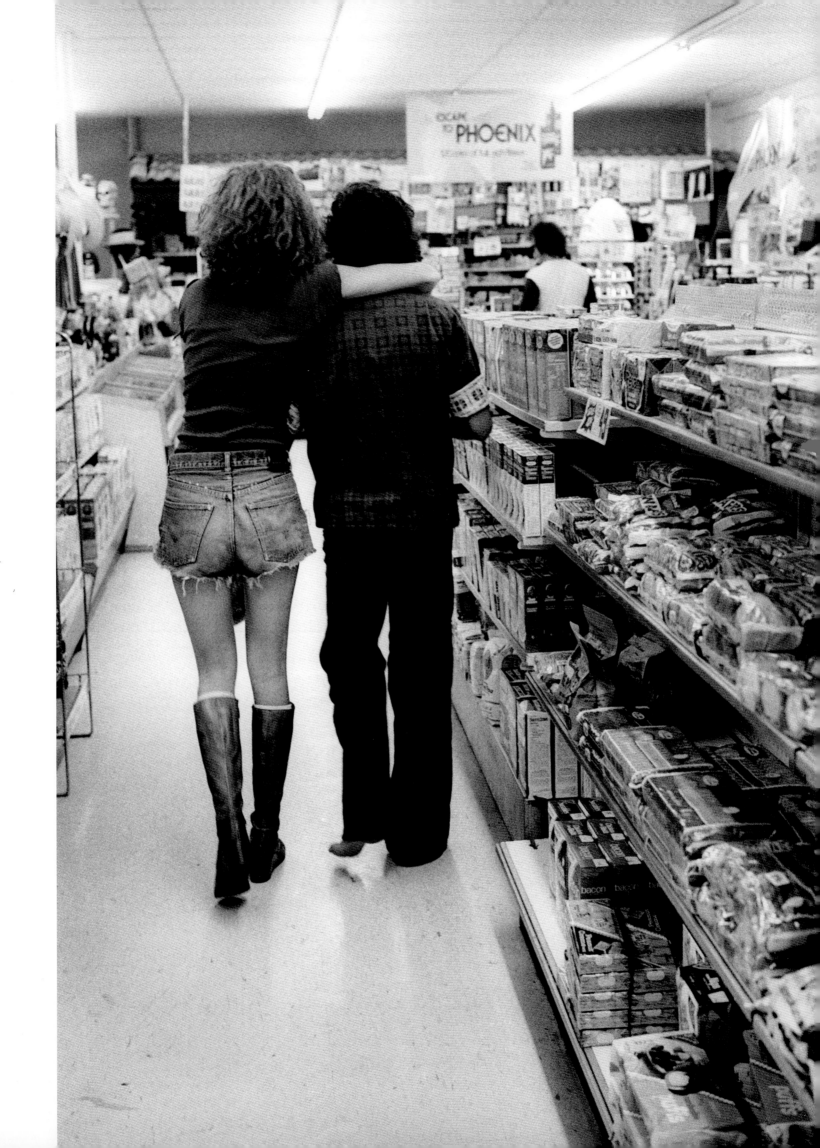

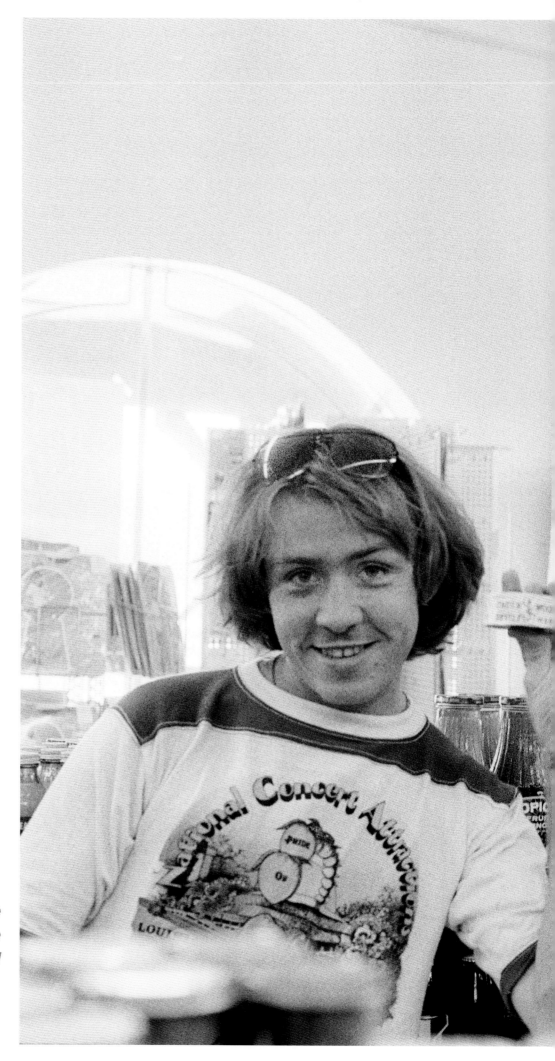

"He was the most intuitive player I've ever seen. He naturally supplied the glue that bound the band's sound together."
- Bruce Springsteen on Danny Federici

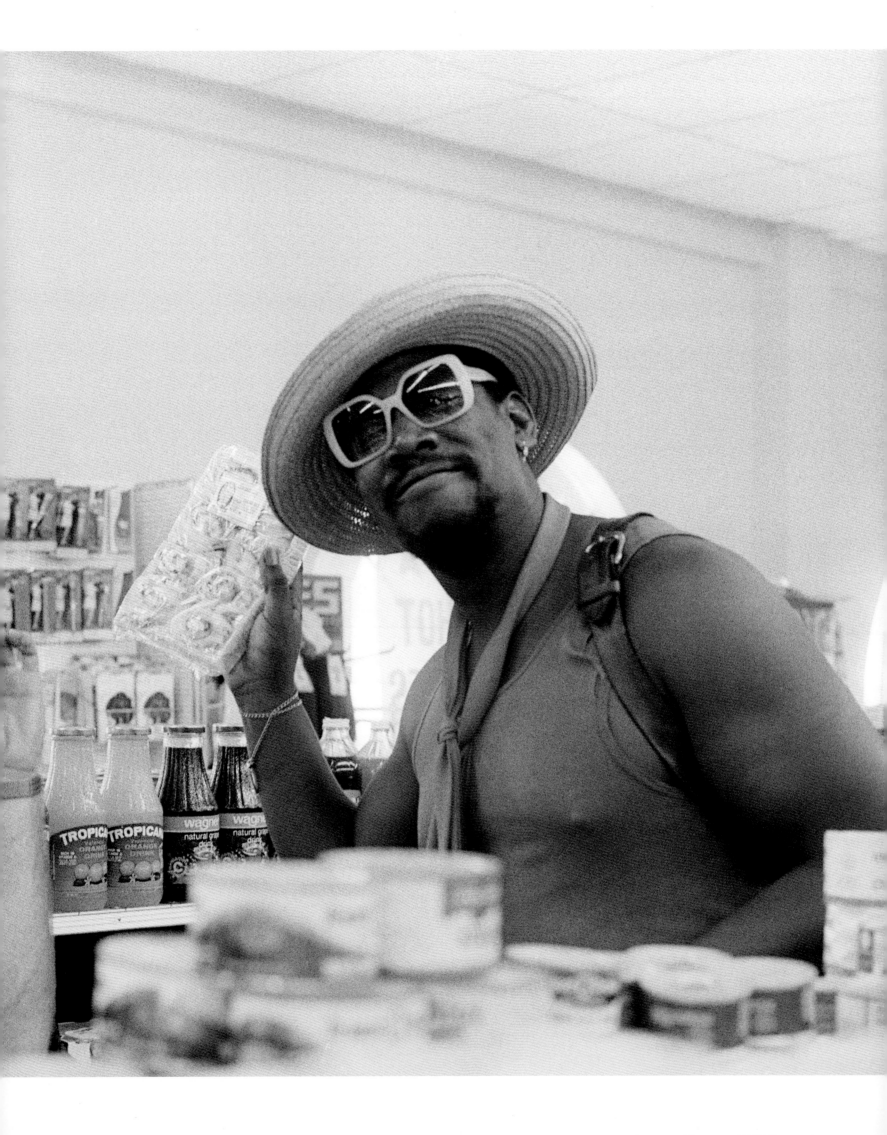

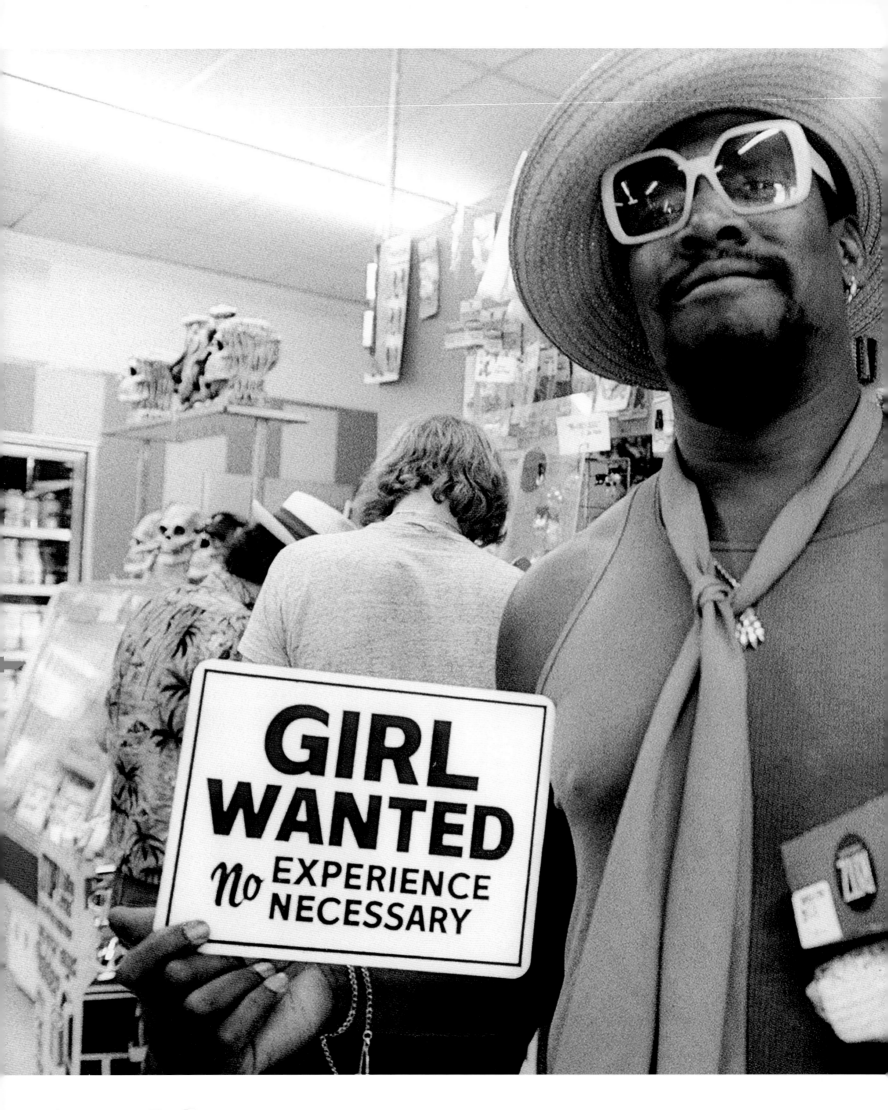

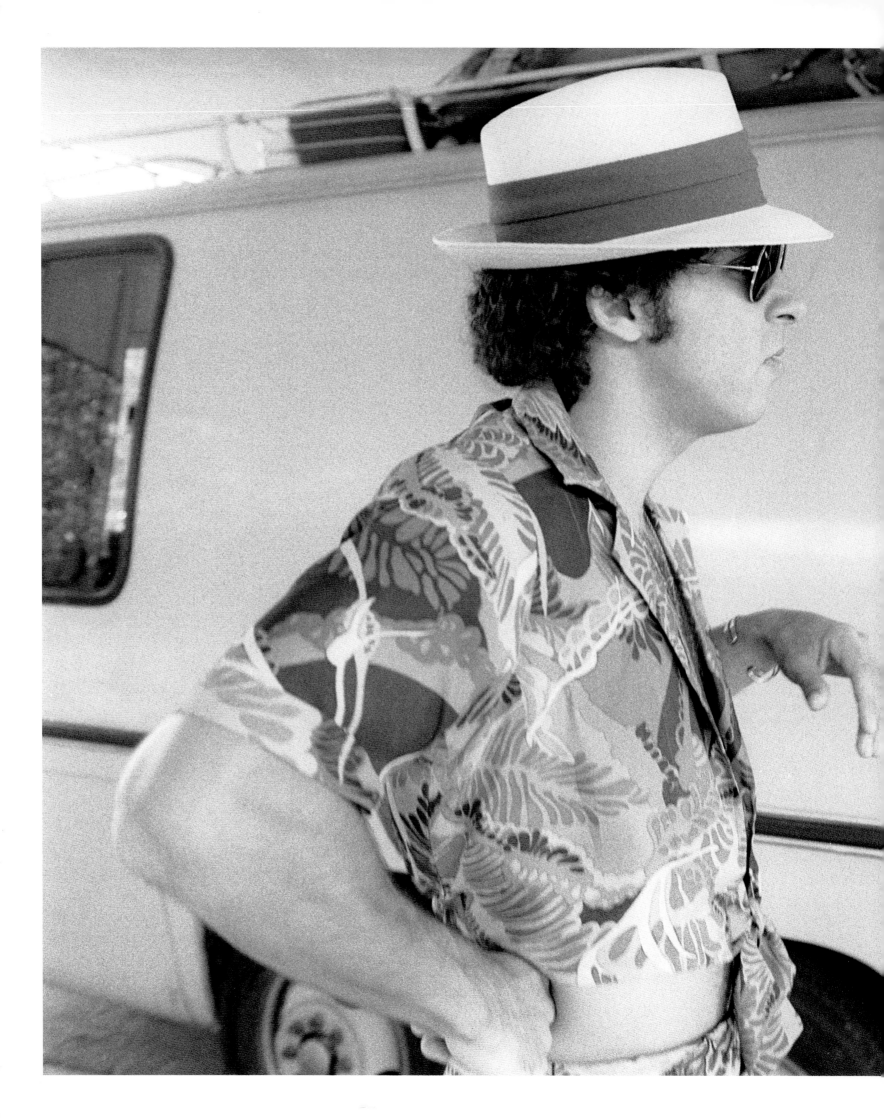

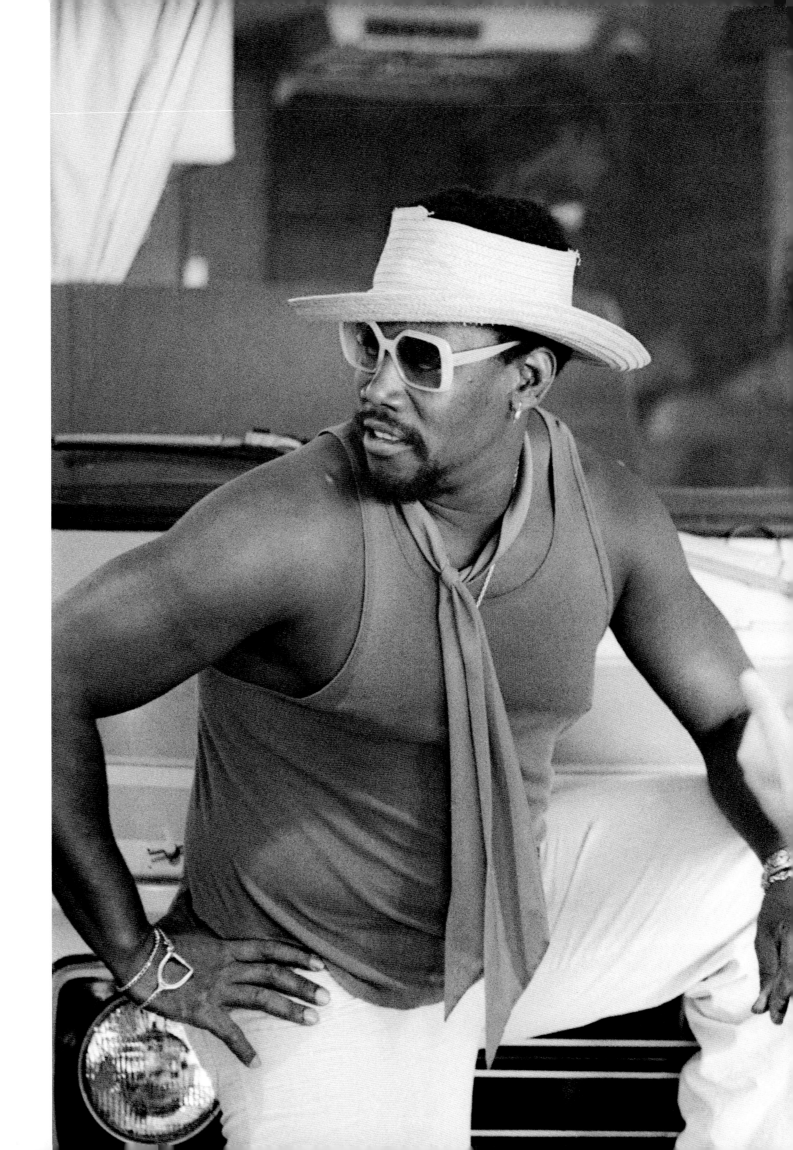

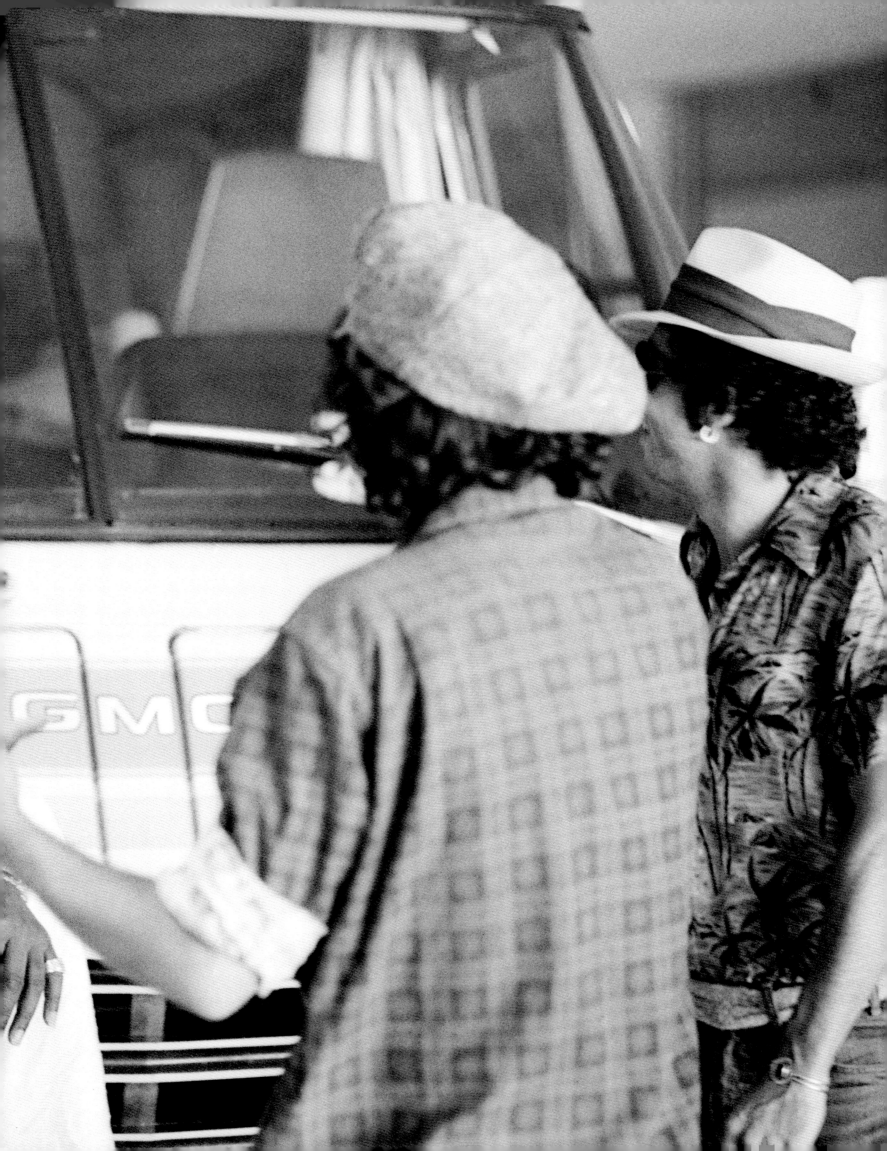

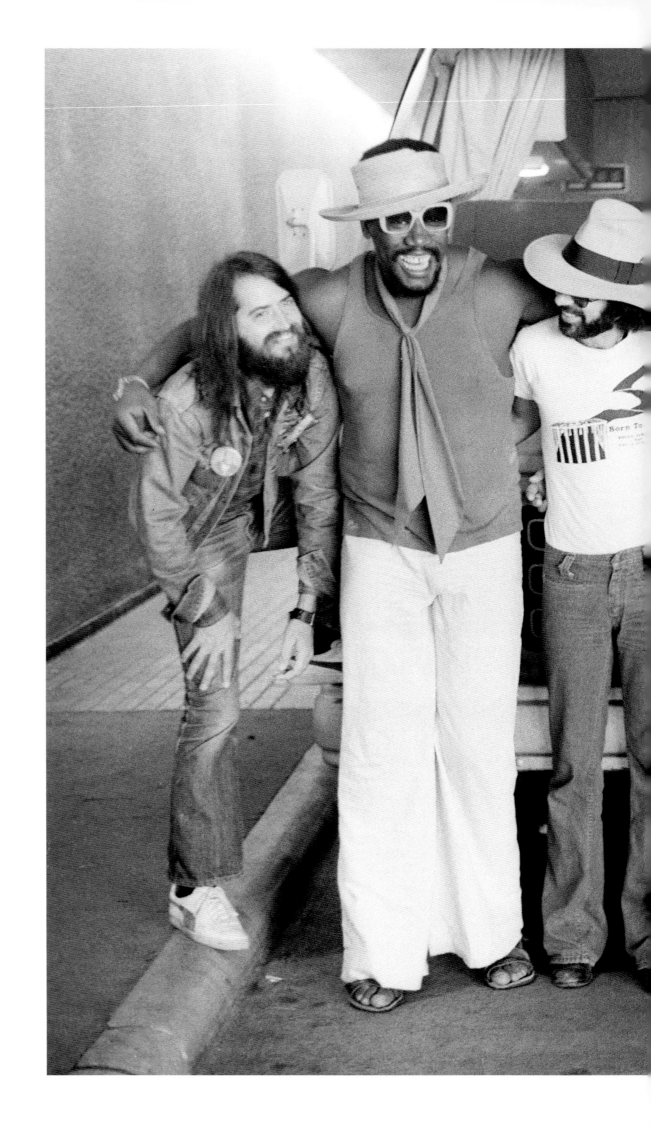

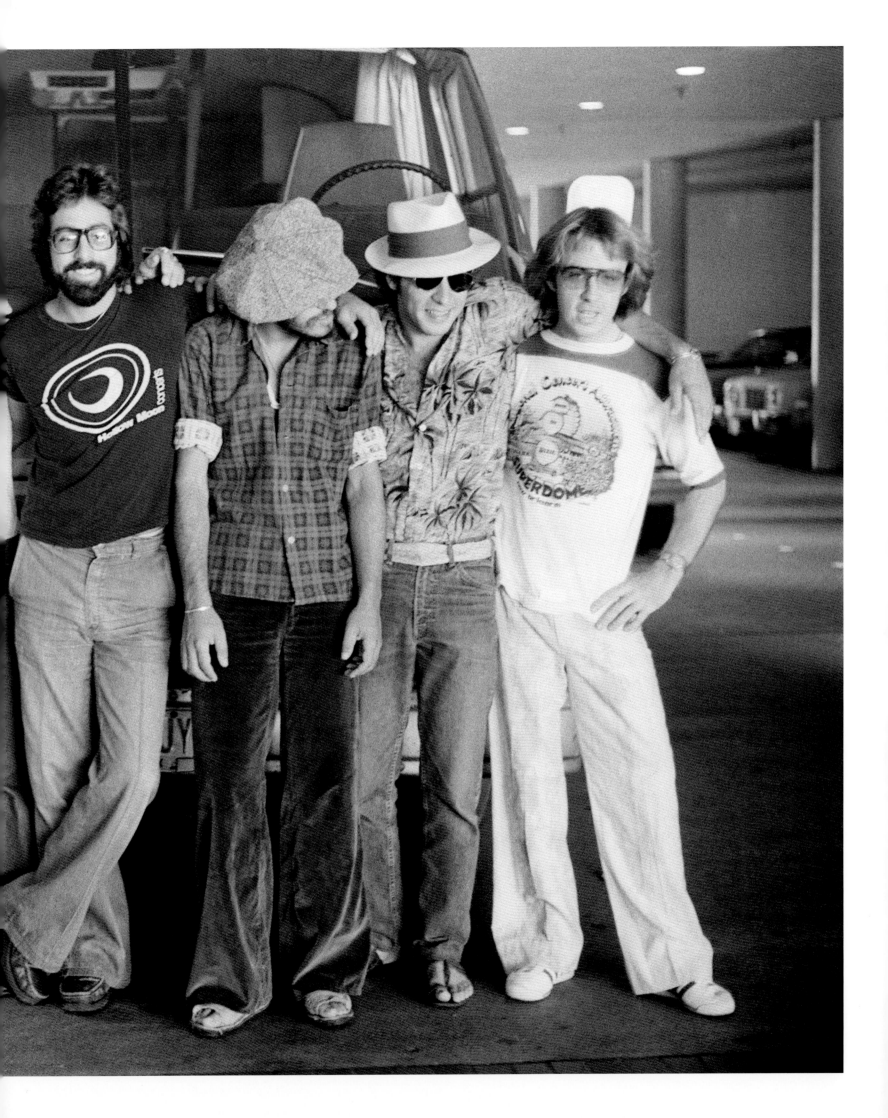

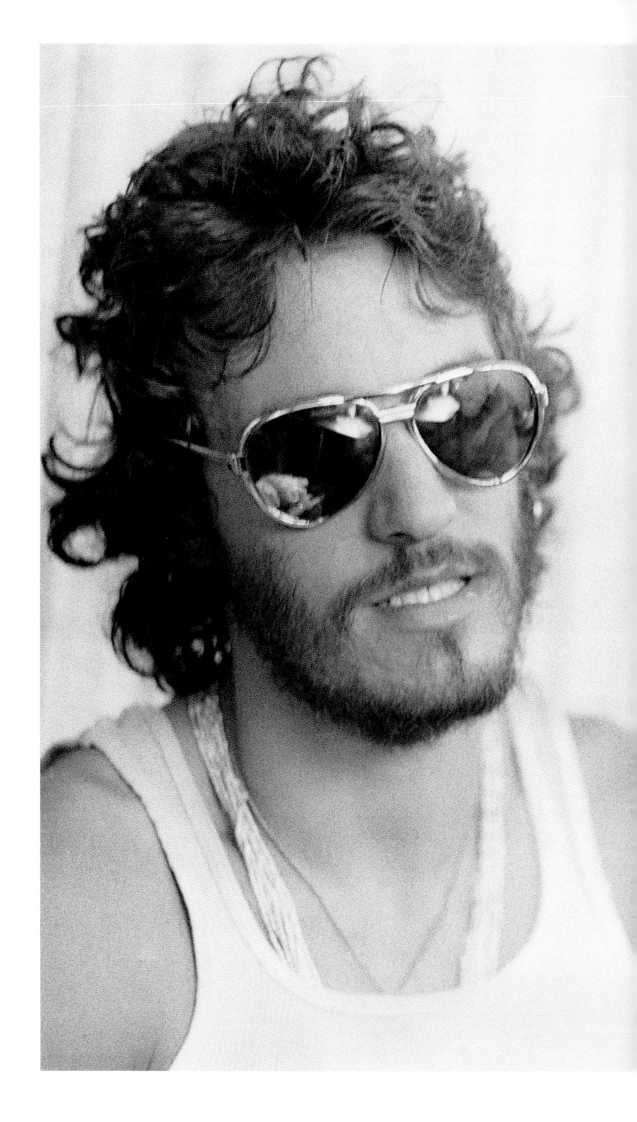

Bruce with Mike Appel.

OKLAHOMA

We were heading from Dallas to Oklahoma City. I knew that by the time we reached my hometown of Pauls Valley, Oklahoma, Bruce and the band would be hungry. I took them to Pauls Valley with the promise of a country barbecue at my parents' house. What I really wanted was to photograph them in front of the Coffee Cup Cafe on Highway 77 at Charles Street. As a kid I used to eat there with my grandfather. It was just a block away from my dad's pecan warehouse. Whenever I hear "My Hometown" I think of that hot afternoon on those wide brick streets. I'll never forget that day— Roy playing with my parents' dog, Alfie, Bruce sitting in my dad's favorite chair reading *Time* magazine, Clarence chatting with my mother, and everyone just chilling out before we left for the sound check in Oklahoma City.

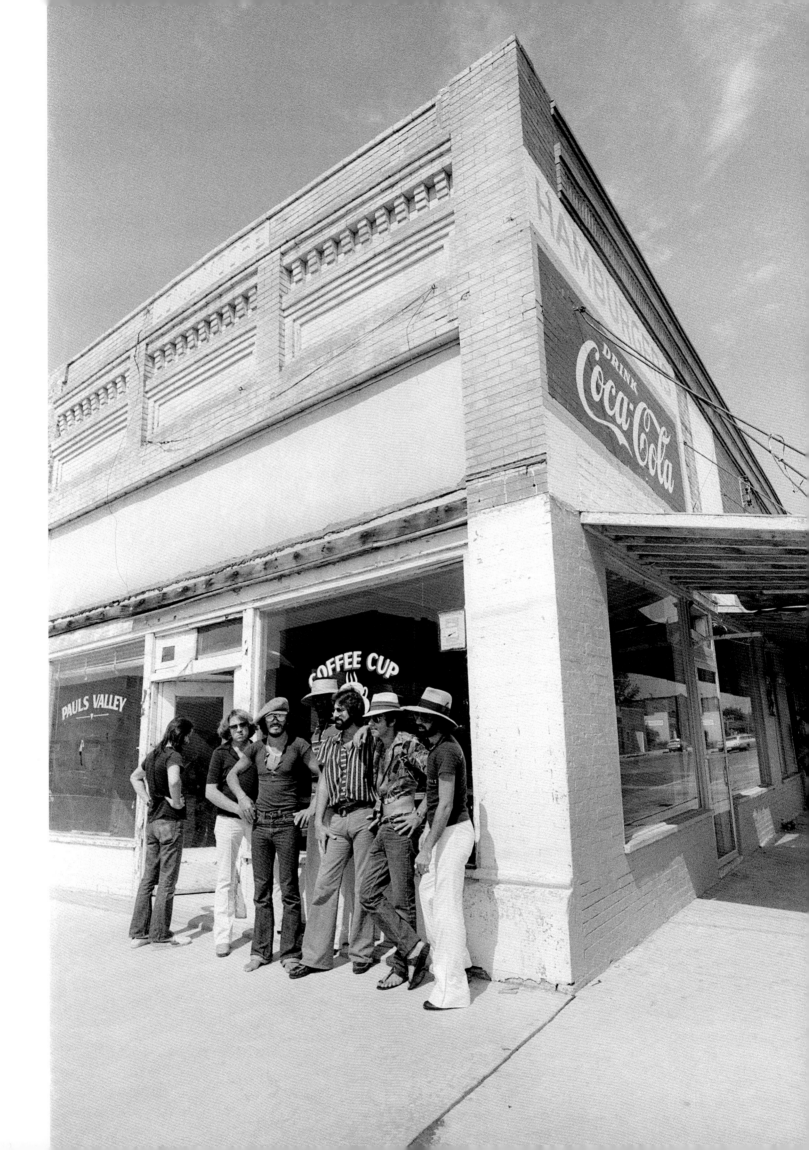

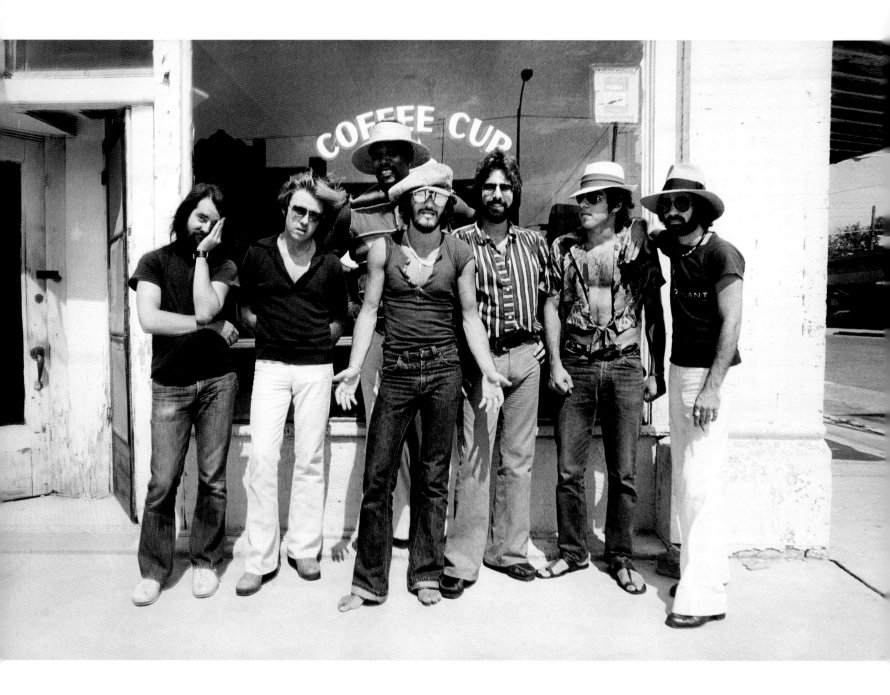

The band were accustomed to my asking them to stand together for group shots but "accustomed" does not mean "pleased." They stood there for about a New York second before Bruce said, "OK, Barbara, enough." That photo ran as part of the Time *magazine cover story, captioned "Real Roadhouse Rock."*

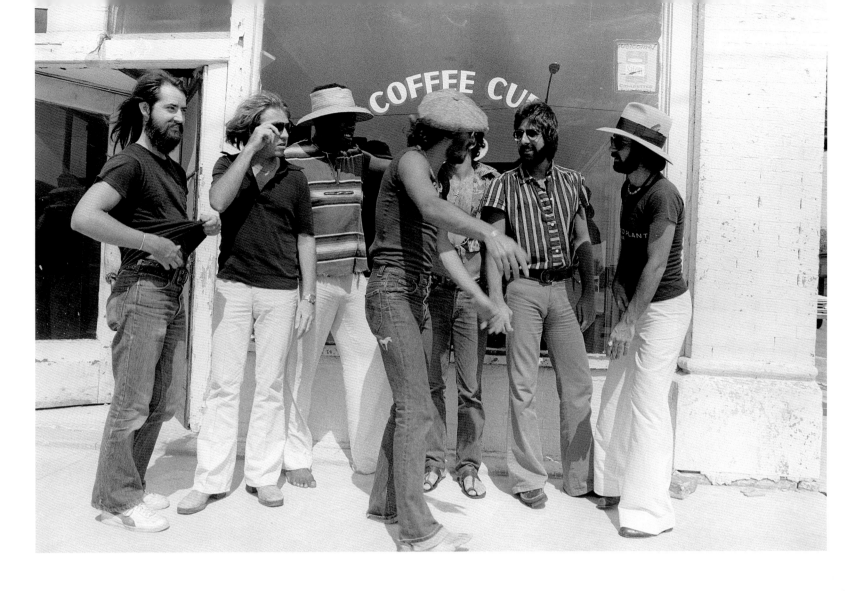

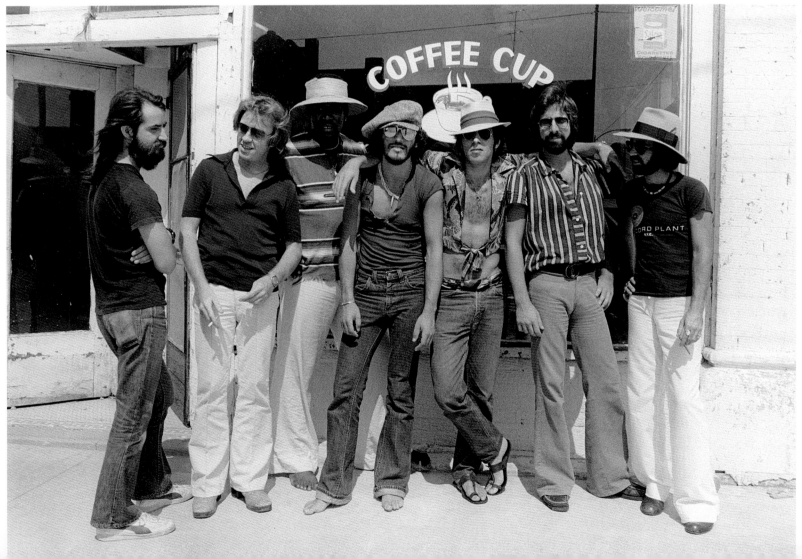

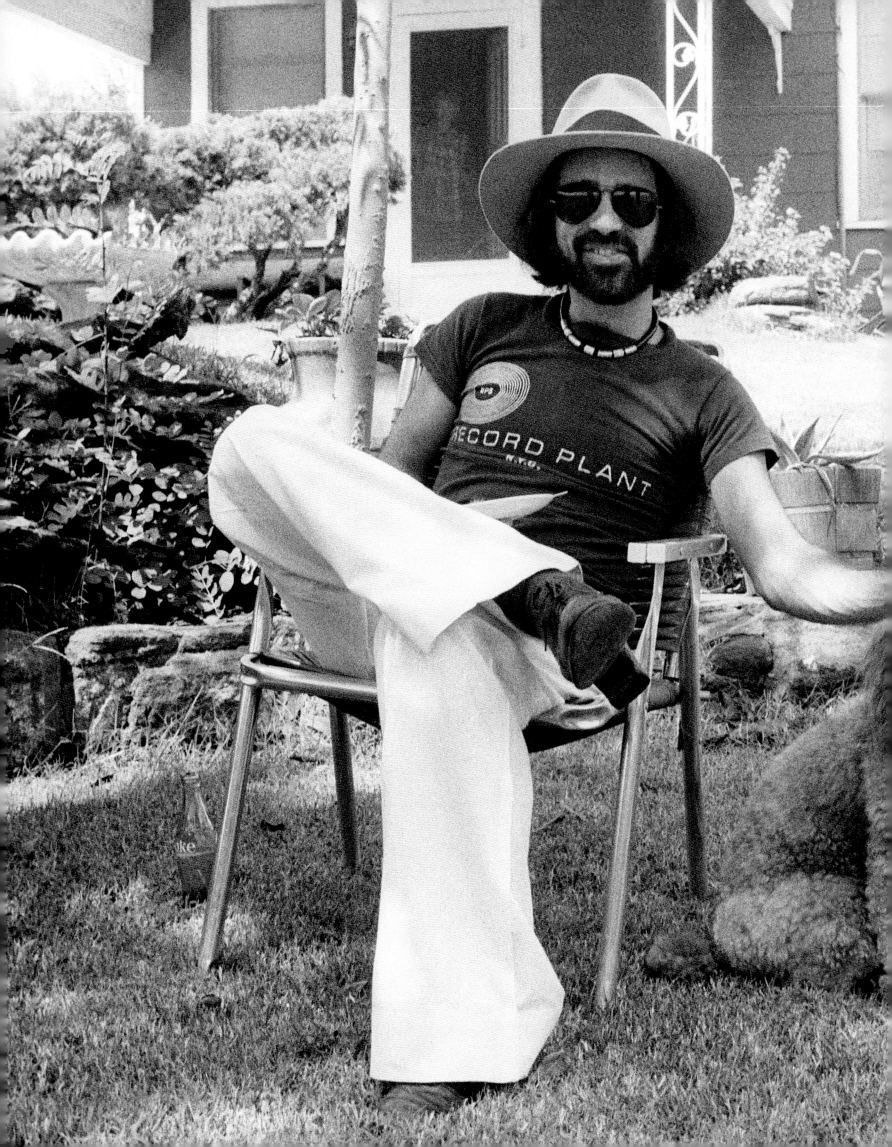

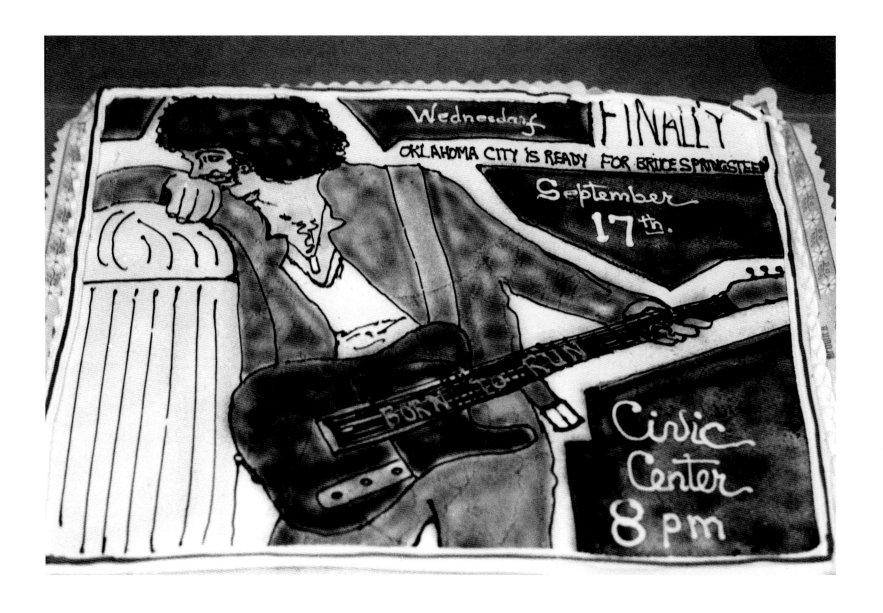

Just before his twenty-sixth birthday, Bruce was presented with a cake. He is smiling so big because Born to Run *had entered the US Top 10.*

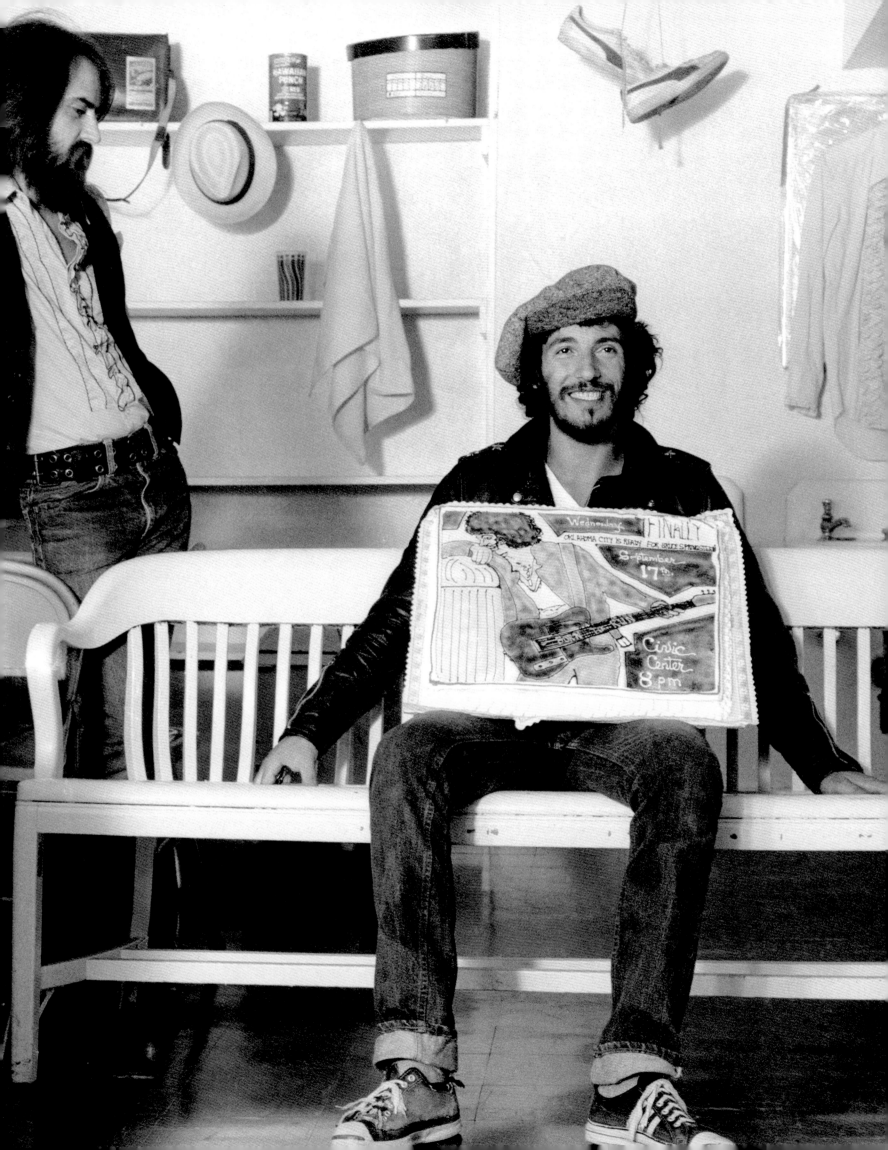

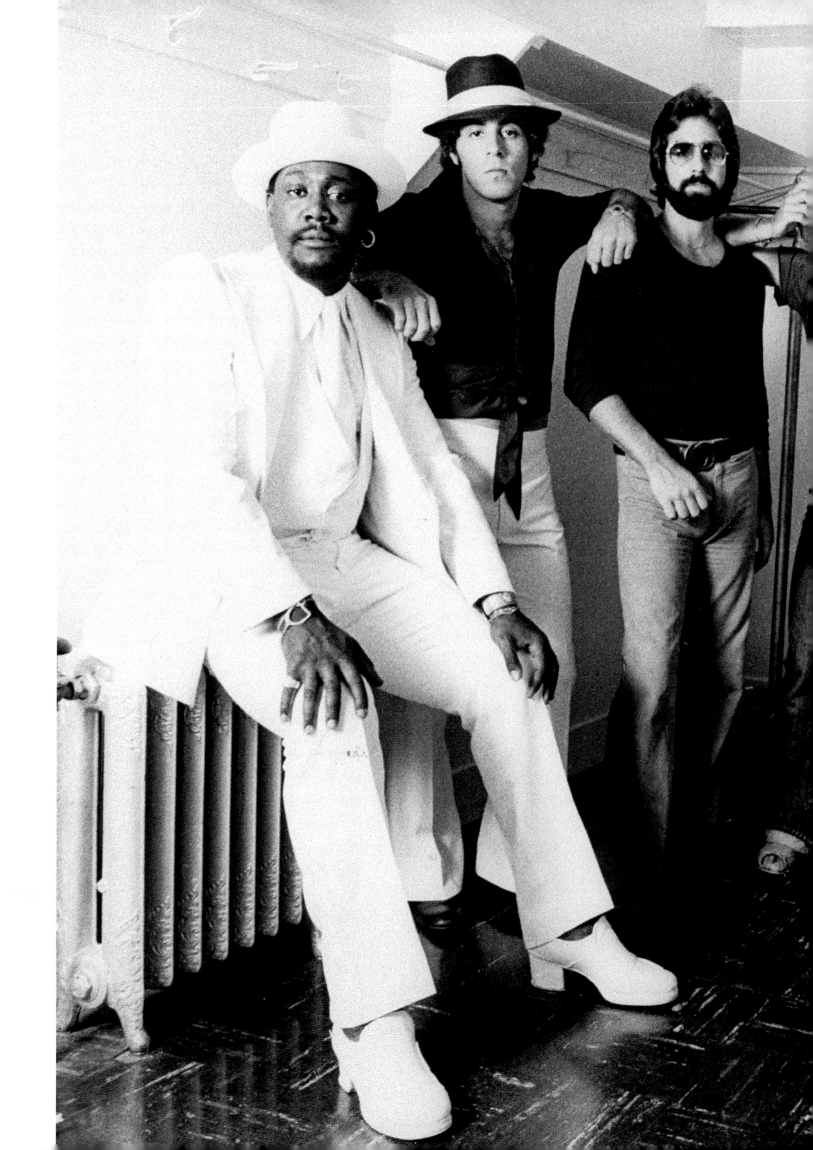

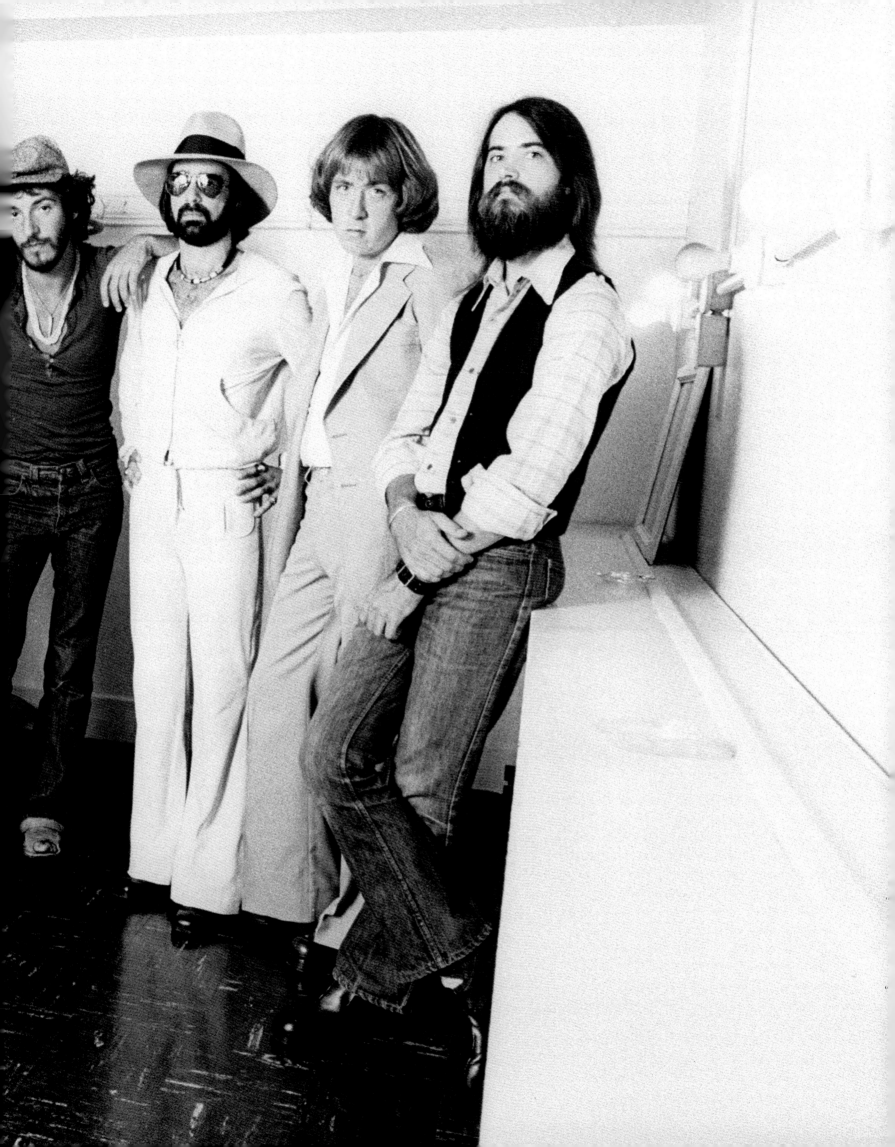

CONCERTS IN COLOR

"Marc [Brickman, lighting designer] started using a special overhead spot on Bruce which none of us had ever seen before, and much more dramatic colors. He transformed this little ratty show into something we'd never thought about before. Bruce's performance took on dramatic dimensions that raised the entire show to new visual, musical and emotional heights."
- Mike Appel

I was determined to record the visual extravaganza of Bruce's concerts. But I could barely get it in black and white with Tri-X 400 pushed to 3200. Kodachrome at 64 ASA was laughable. In those days, in my own color lab, Process Associates, I had a full C-22 color negative line, E6 Ektachrome line and could make C-prints. I tried pushing the ASA on the color negatives (C-22) but that didn't work. When I tried pushing Ektachrome I could only push it to 1000 ASA before it fell apart. Pushed Ektachrome worked for the brightly lit parts of Bruce's concerts but what I really wanted to get was the mood lighting. When Bruce sang "Sandy" in total darkness with just a pool of light shining down on him, it was magic. Every girl in the audience wanted to be that Sandy with an aurora rising behind her. On a whim, in my attempt to capture those pools of light, I shot Ektachrome but at 8000 ASA. I knew I would get nothing processing it in E6 so I thought "What the heck? Let's process it in C-22 as a negative and see what comes out . . ." and WOW! What came out was amazing. When printed, the color was true and the grain was the size of golf balls. Looking at these old pictures now feels just like being at one of those spectacular early concerts.

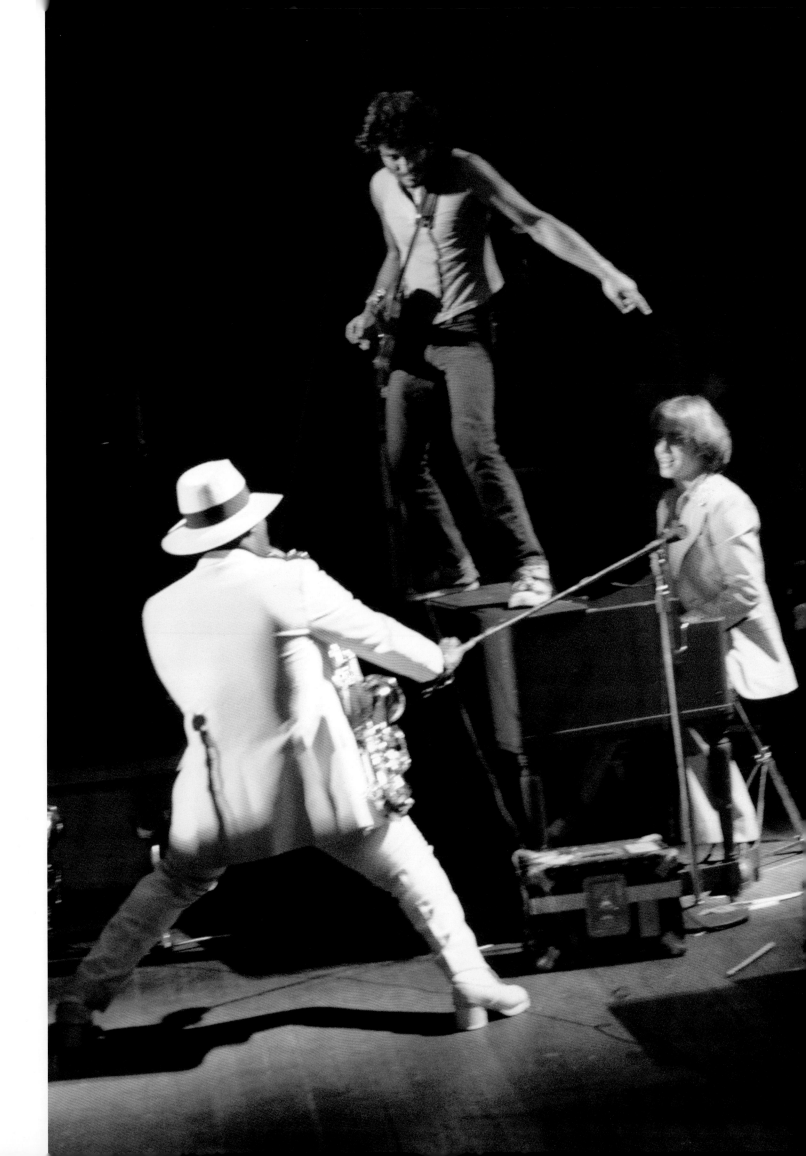

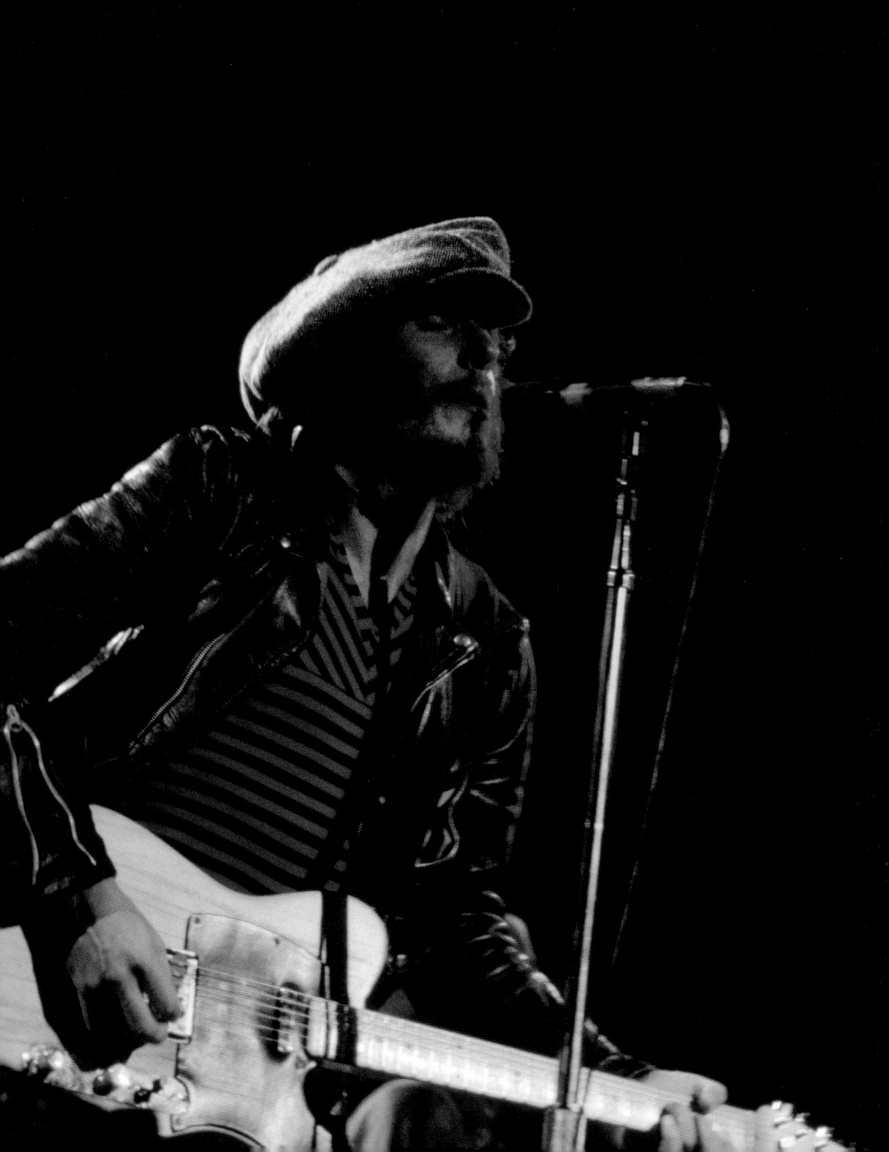

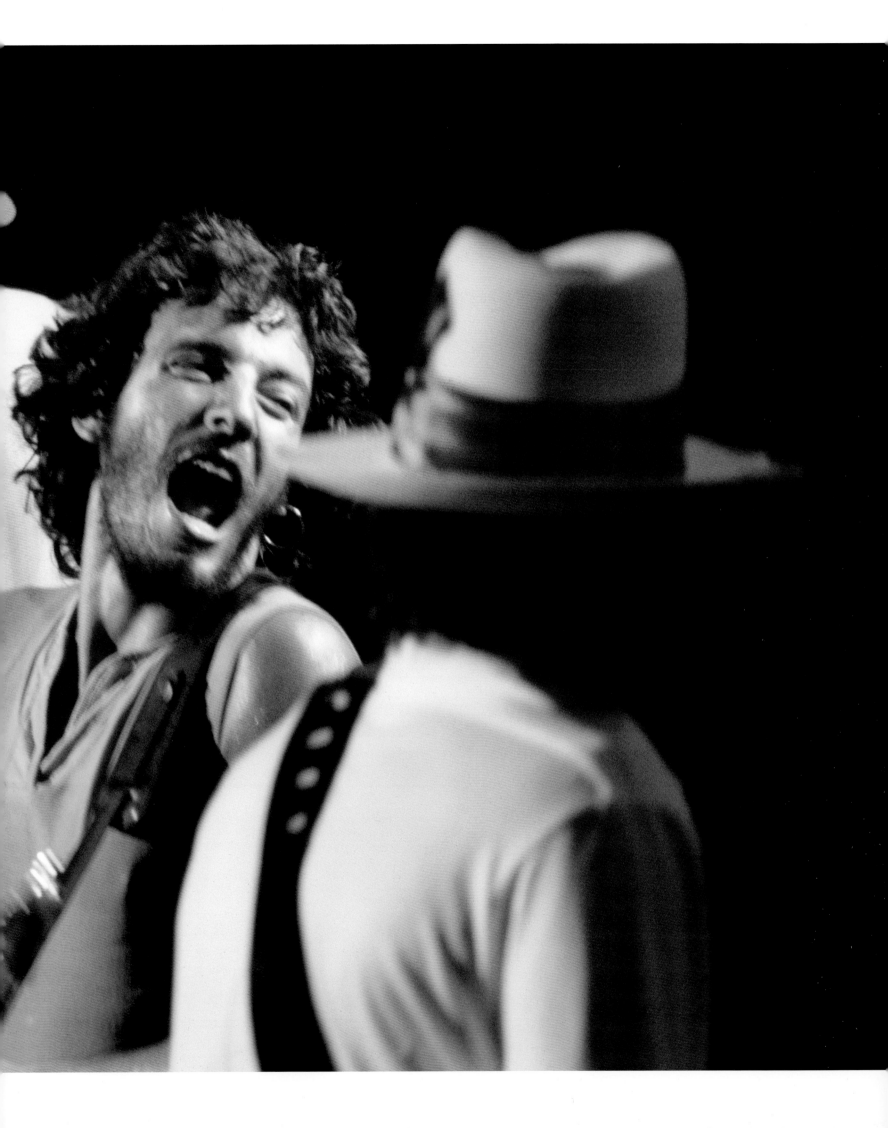

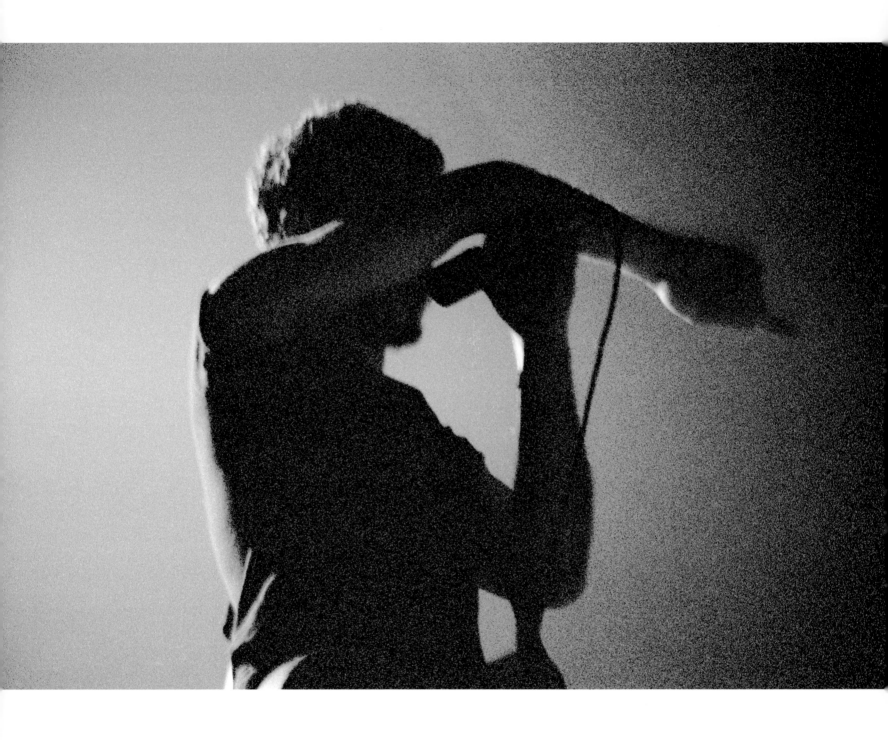

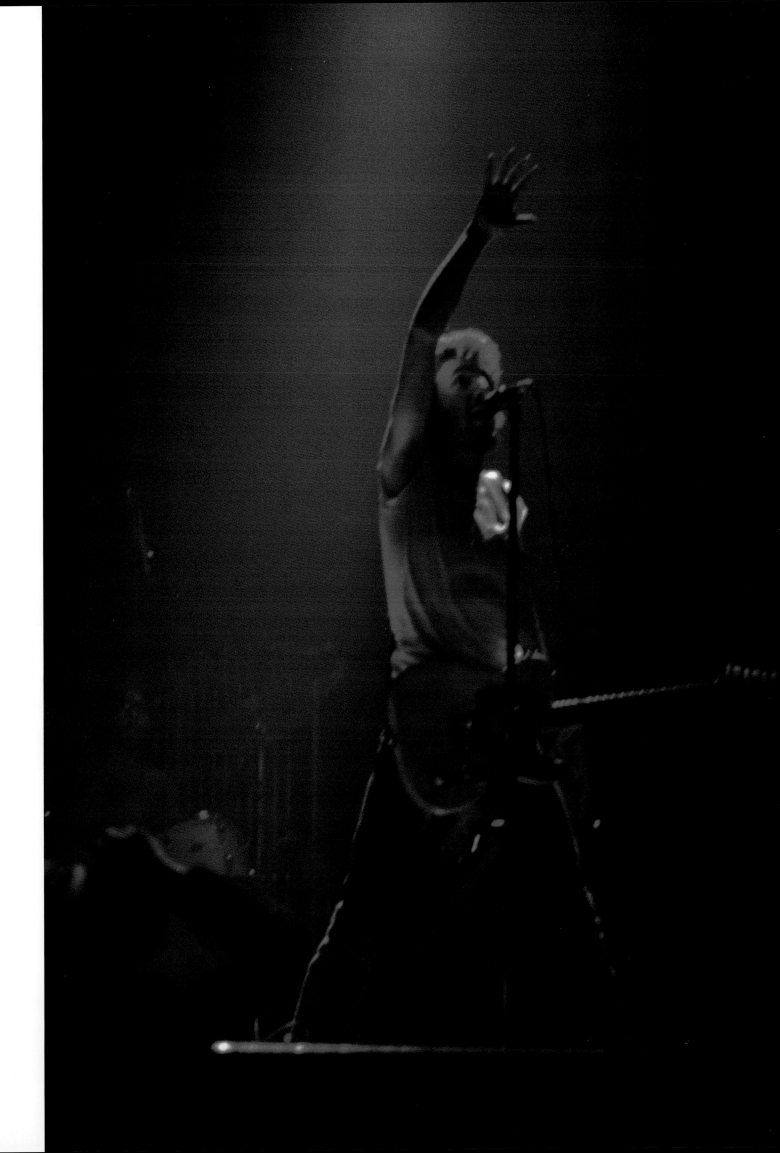

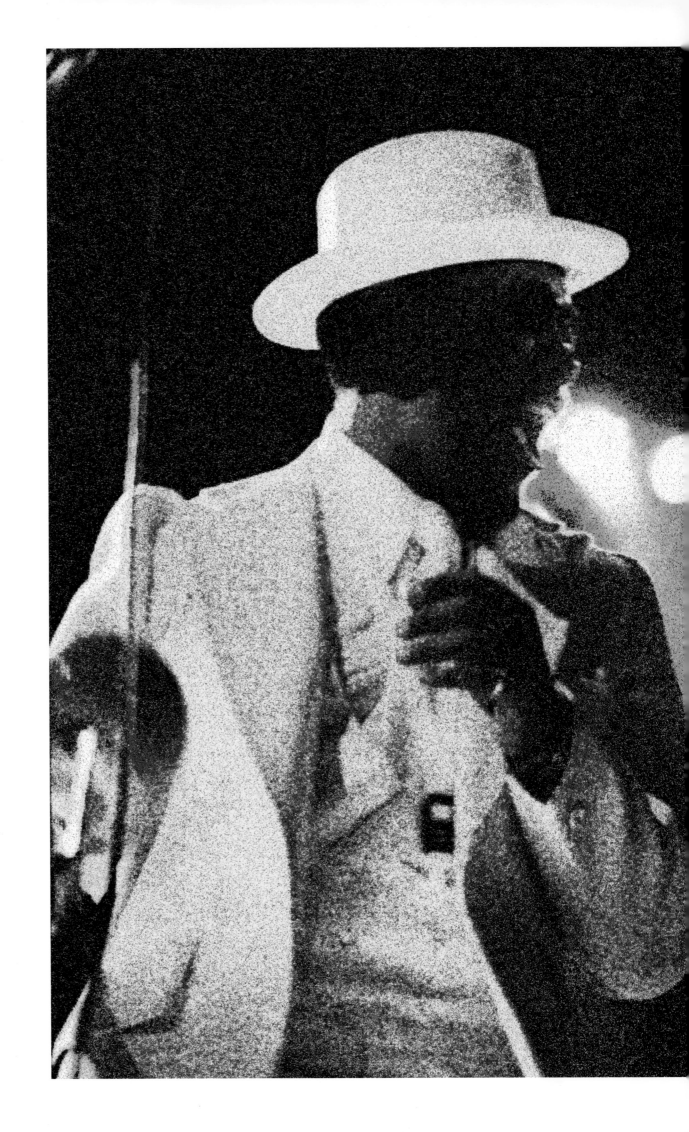

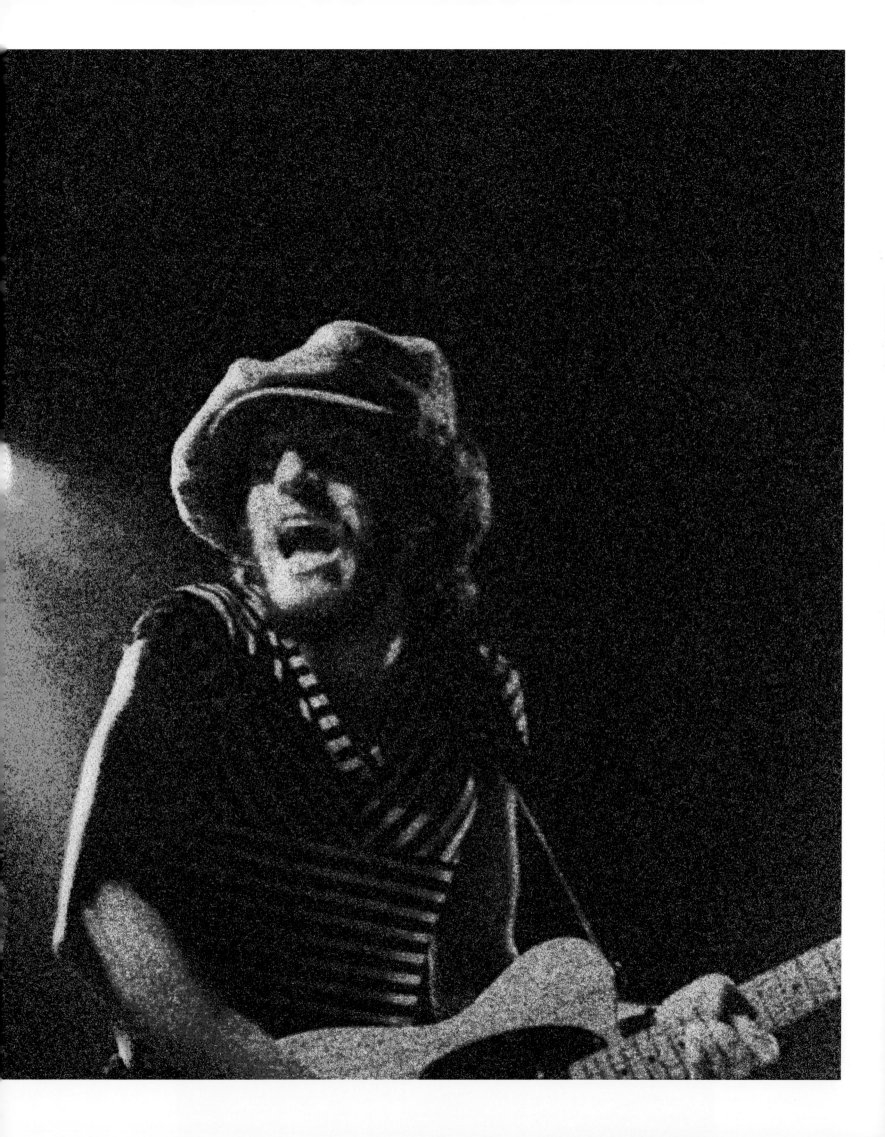

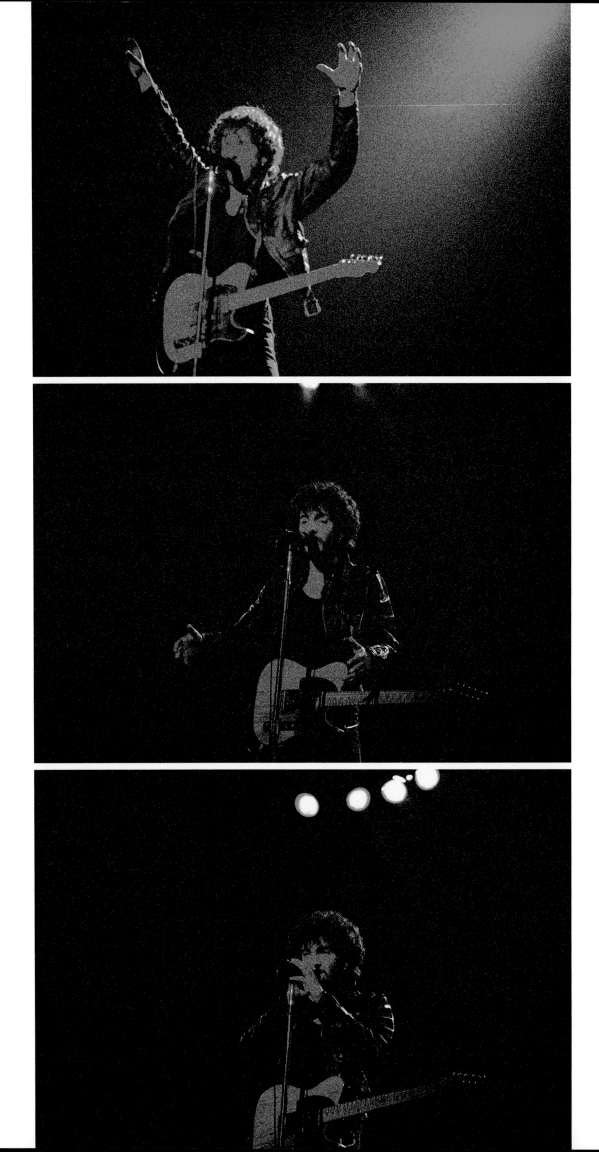

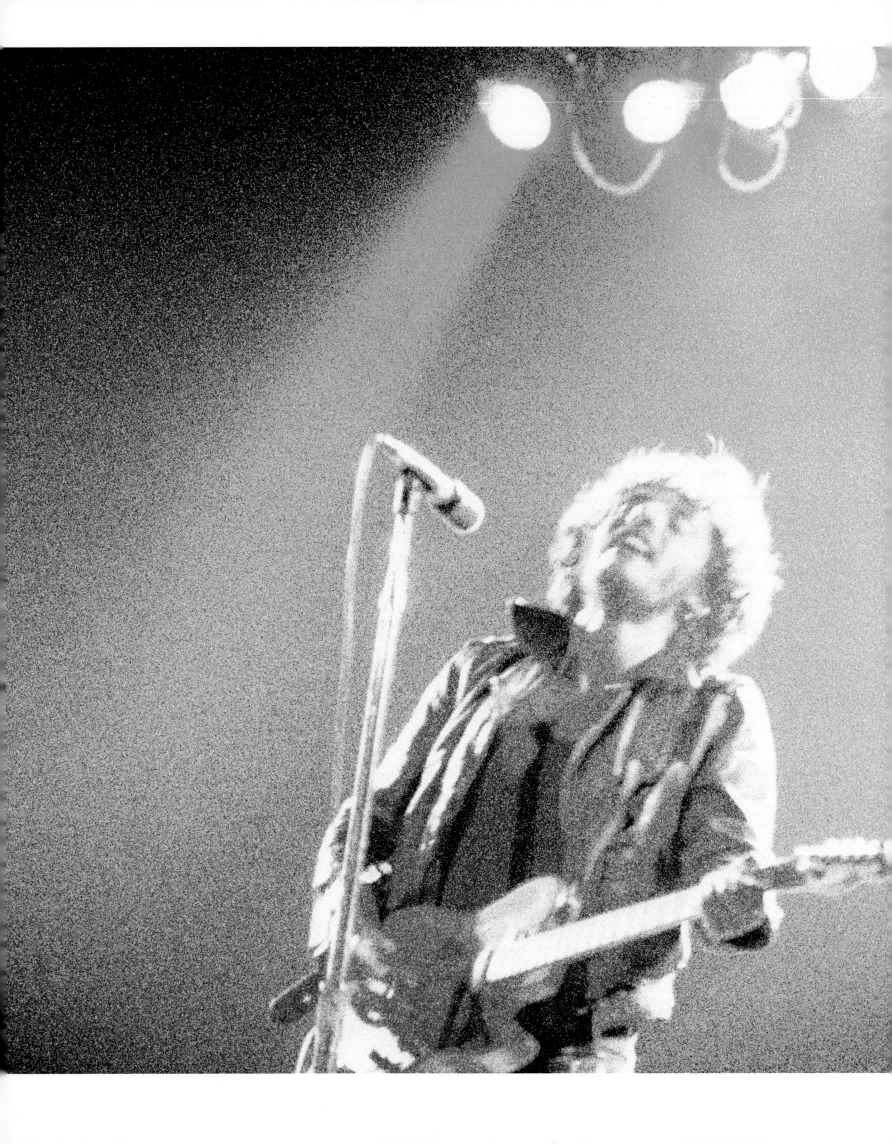

"This music is forever for me. It's the stage thing, that rush moment that you live for. It never lasts, but that's what you live for."
- Bruce Springsteen

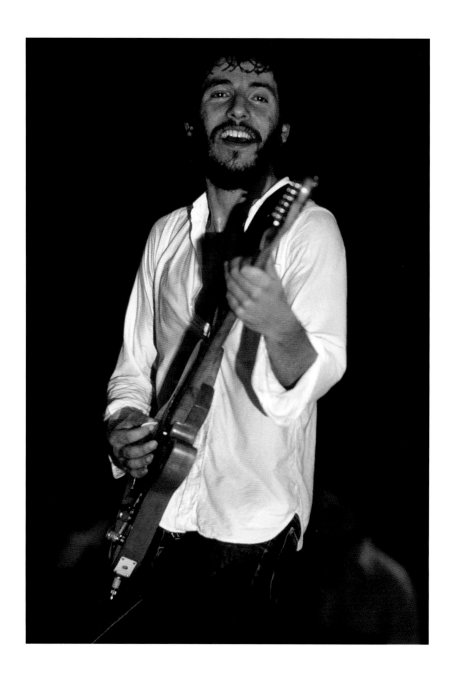

At what I thought was going to be a routine concert in Red Bank, New Jersey, I was suddenly surrounded by Newsweek *editors who wanted to buy my pictures. I would never give those pictures to* Newsweek *because I was a* Time *"stringer." Monday morning, I went to see my editors and told them that* Newsweek *was doing a cover on Bruce. It was now or never. The* Time *illustrator used my photos. That's the true story of how Bruce got the covers of* Time *and* Newsweek *in the same week.*

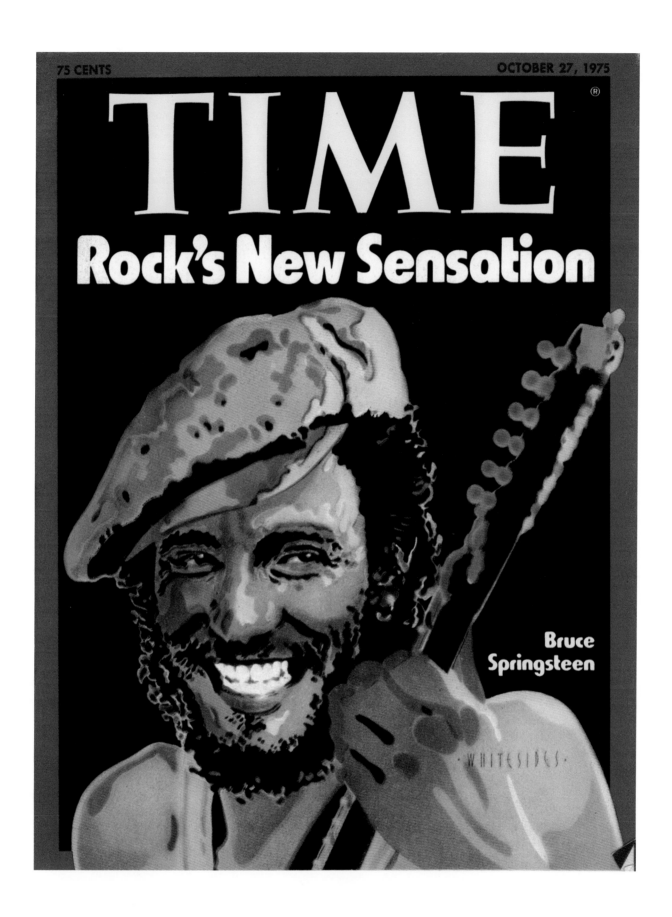

"He got extremely upset by the Time *and* Newsweek *covers and I was just laughing, this is great!"*
- Stevie Van Zandt

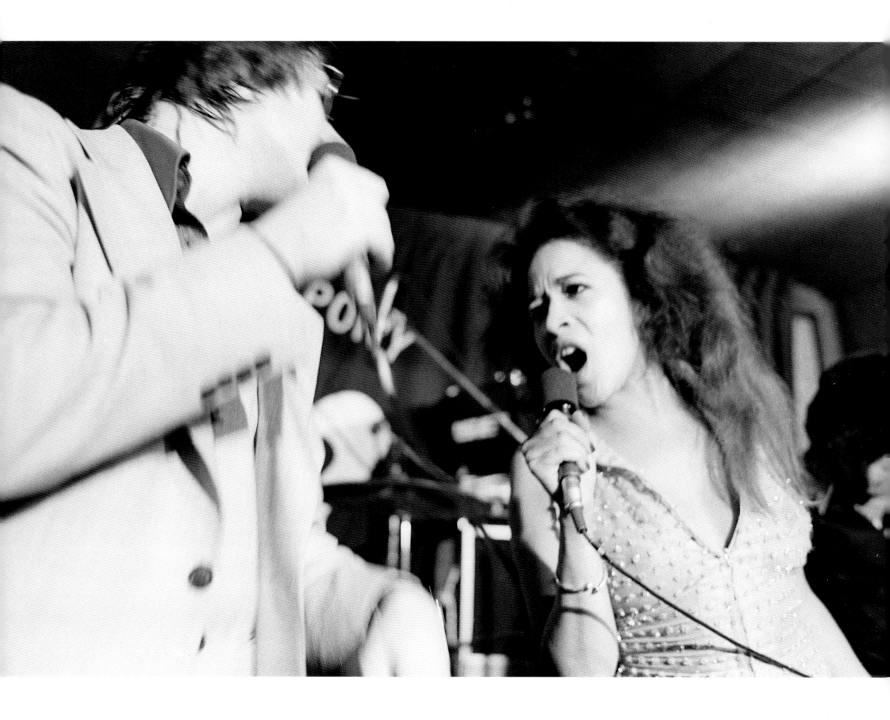

Bruce first appeared at the legendary Stone Pony club at 913 Ocean Avenue in Asbury Park during a jam session in September 1974. Nearly two years later, on May 30, 1976, he, Ronnie Spector of the Ronettes and other members of the E Street Band sat in with Southside Johnny and the Asbury Jukes to celebrate the release of Johnny's debut album.

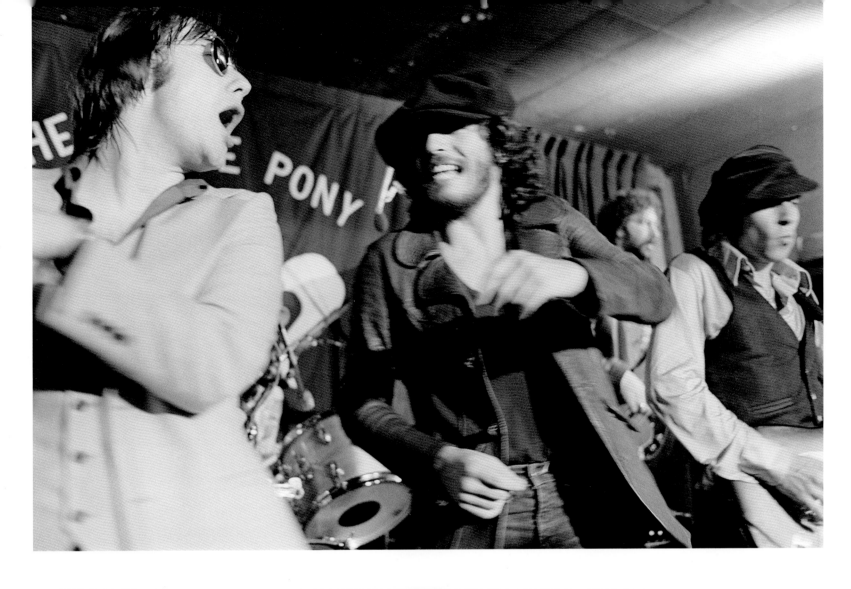
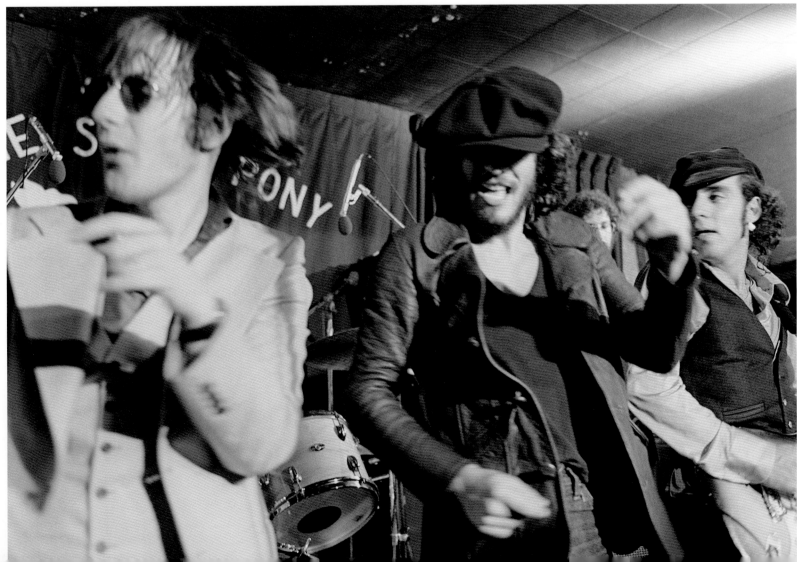

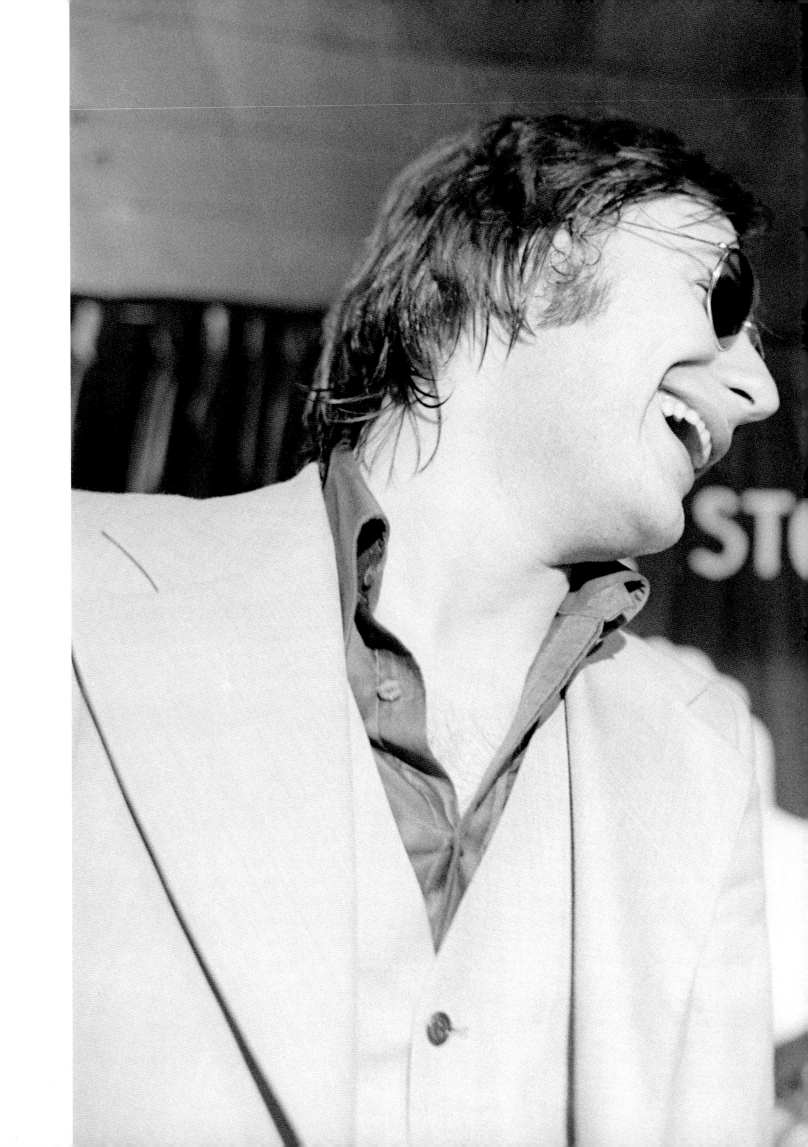

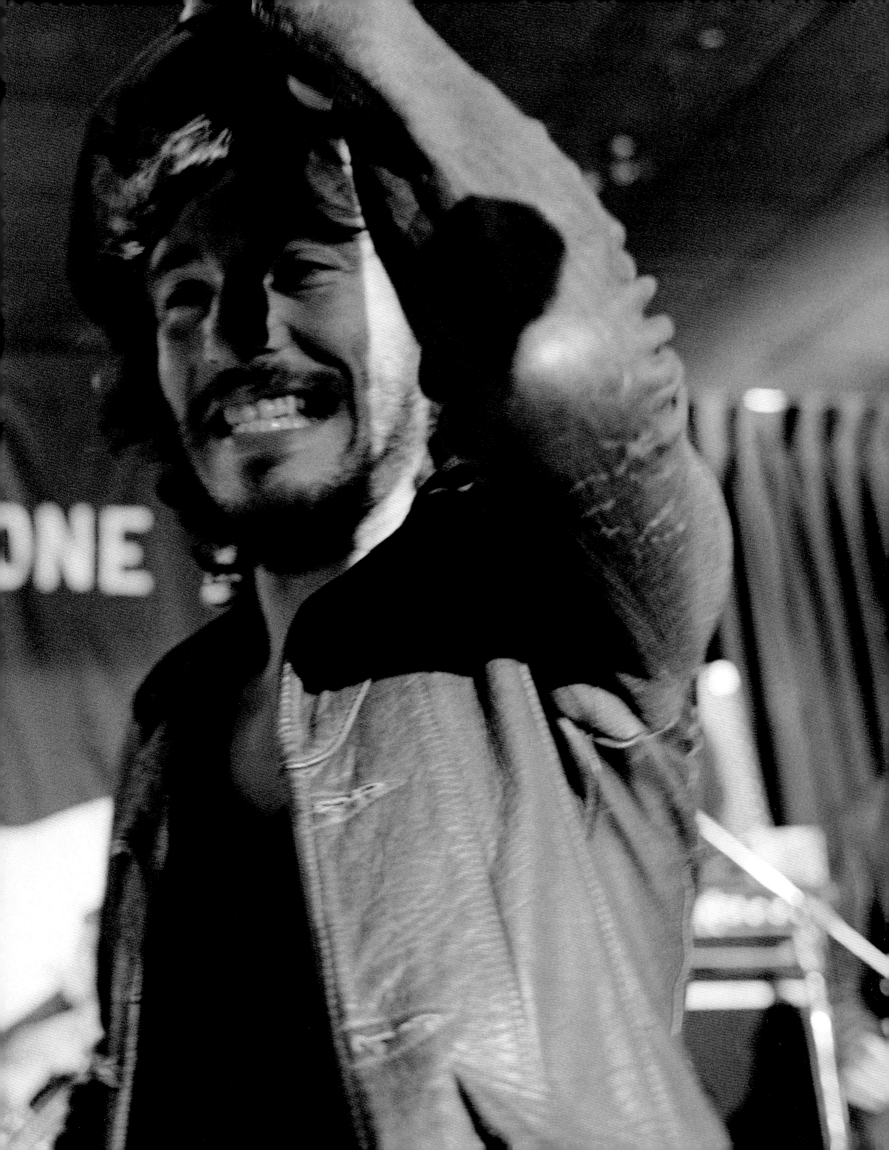

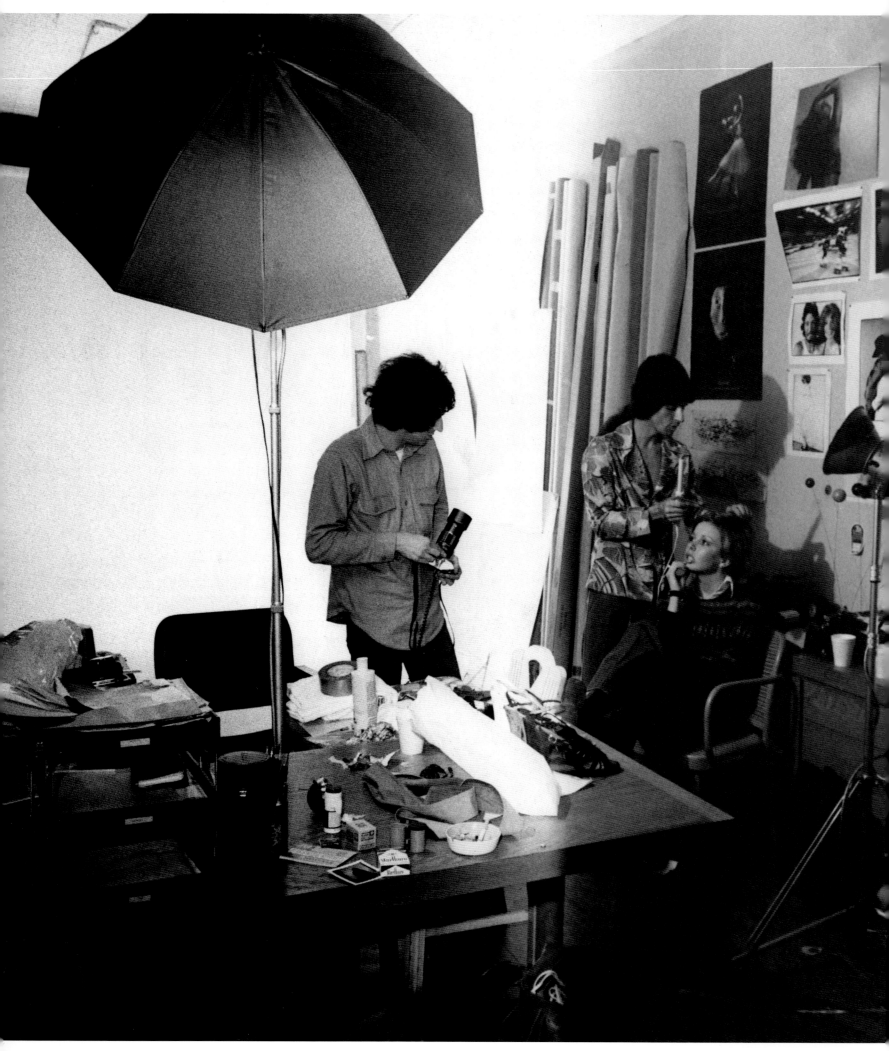

STUDIO
Passport Photos

My Seventeen Seventh Avenue South Studio is where everyone's passport pictures were shot. With me in this photo are Kamil Sukun, who later became a highly respected Turkish music impresario and Joey Badalati, my erstwhile superintendent and stylist. The band was preparing to leave for their first international tour and they still didn't have their passport photos. As their "official unofficial photographer" I got the job. They straggled into my studio over a week or so, one by one. It was great fun. The shots of Bruce making faces really cracked me up.

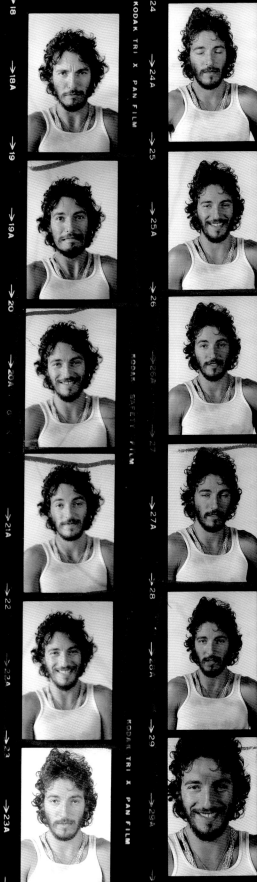

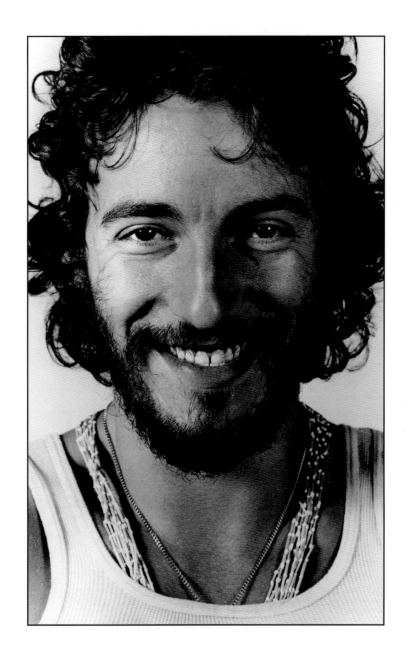

BRUCE SPRINGSTEEN

Guitar/keyboards/harmonica/vocals
Born: Long Branch NJ, September 23, 1949
First documented live show with the Castiles, August 1965

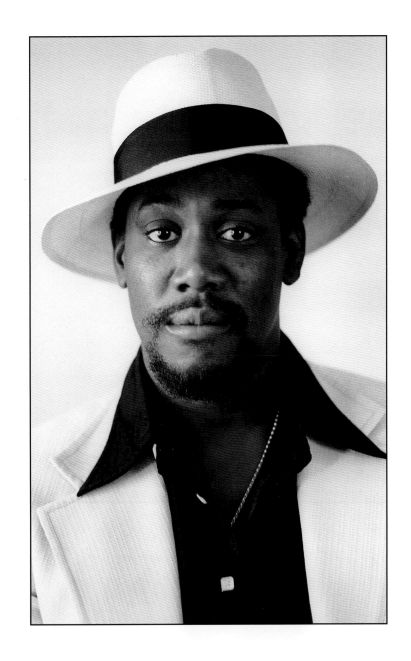

CLARENCE CLEMONS

Saxophone/vocals
Born: Norfolk County VA, January 11, 1942
Died: June 18, 2011
First joined Bruce's band: October 1972
Founding member of the E Street Band

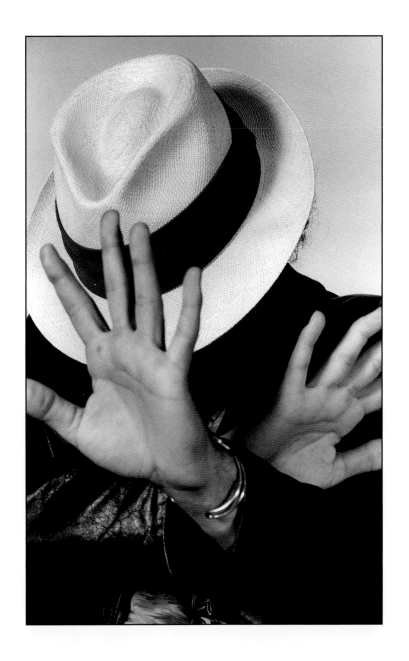

'MIAMI' STEVE VAN ZANDT

Guitar/bass/vocals
Born: Boston MA, November 22, 1950
First joined Bruce's band (Steel Mill): March 1970
Joined the E Street Band: June 1975

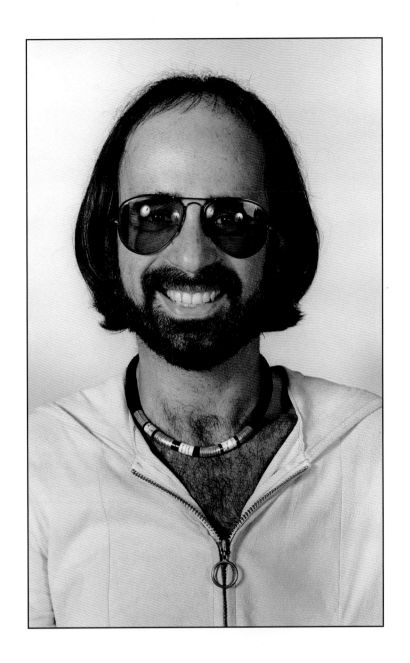

ROY BITTAN

Keyboards
Born: Rockaway Beach NY, July 2, 1949
Joined the E Street Band: August 1974

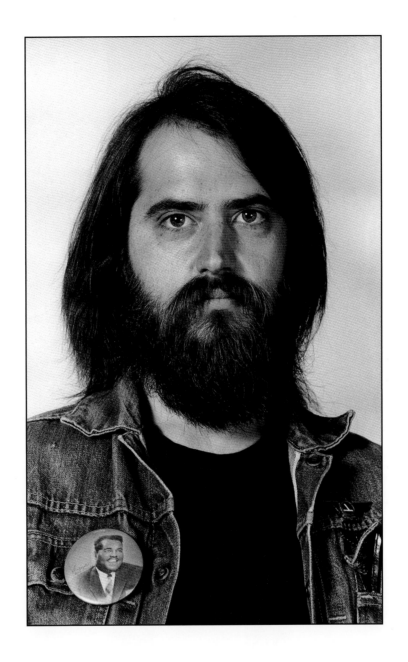

GARRY TALLENT

Bass/tuba/vocals
Born: Detroit MI, October 27, 1949
First joined Bruce's band (Friendly Enemies): March 1971
Founding member of the E Street Band

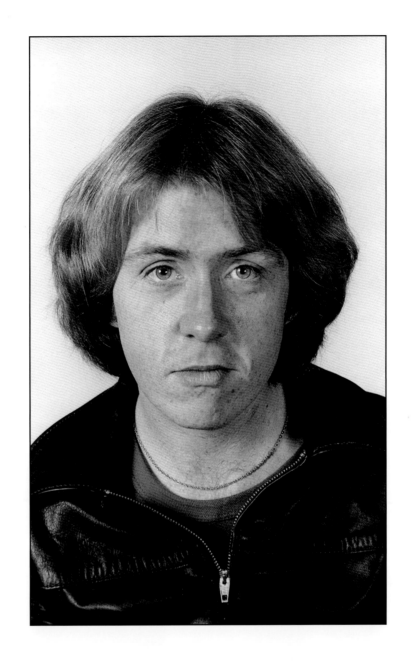

DANNY FEDERICI

Accordion/bass/keyboards
Born: Flemington NJ, January 23, 1950
Died: April 17, 2008
First joined Bruce's band (Child): February 1974
Founding member of the E Street Band

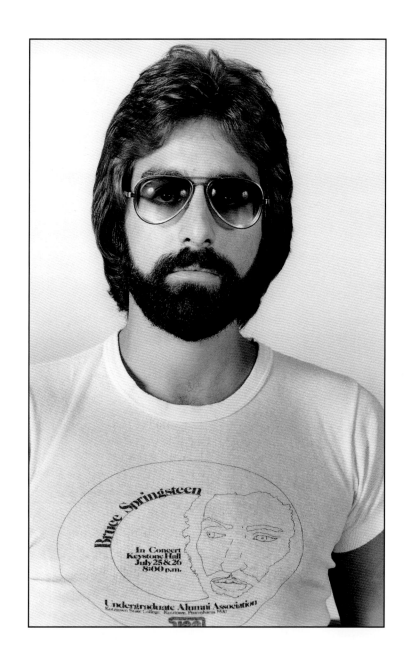

MAX WEINBERG

Drums/percussion
Born: Newark NJ, April 13, 1951
Joined the E Street Band: August 1974

THE SAGA OF THE NEGATIVES

The tortured life of these negatives is a long tale. If it were not for all the test prints and contact sheets I made in 1975 this book couldn't exist, and neither would the photographic story of Bruce and the E Street Band's hard climb to superstardom. Shooting the photos was only the beginning. Preserving them for posterity turned out to be much more difficult. While filming for the United Nations in China, my meticulously organized filing cabinets were thrown into liquor boxes in the boiler room. The humidity caused many of the glassine sleeves of negatives to stick together and scratch. All of my work, not only with Bruce and the band, but also for NBC News, *Playboy*, Rolex, *Time,* the 1980 America's Cup and my personal archive were in dire condition. They were truly "lost in the flood" and it took decades to save them.

But the story gets worse. My work heading up the Turner Environmental Policy Division, producing 113 episodes of *Captain Planet and the Planeteers* and over sixty documentary films did not leave me much time to pay attention to my historic film library. Negatives would go out but never come back, requests would come in from this book or that book and I would simply send off the original negatives, never to see them again. Many runs were made at my Springsteen archive and the extent of the loss of the original negatives did not become apparent until my publisher, Tony, and I spent days trying to match up contact sheets with negatives. It was a heart-wrenching exercise.

To whoever still has my negatives, you know who you are. You can keep them. Just let me make high resolution scans for gallery prints. Tony and I were lucky to find some boxes of the 8x10 proof prints from 1975, intended for reference only, and some 4x5s that Robert Pledge of Contact Press Images printed during an attempt to mark the twenty-fifth anniversary. Most photographers wouldn't have printed so many proofs back in 1975, but I wanted to see the photos for myself and print them for the band. If it were not for the excessive printing, you would not be holding this book in your hands today.

SOURCES

p.13 Springsteen quotes from Phillips, Christopher, and Louis P. Masur, eds. *Talk About a Dream: The Essential Interviews of Bruce Springsteen* (Bloomsbury Press, 2013) and "The Riches of a Rocker Fella," *Sarasota Herald-Tribune*, Oct 26, 1980; p.14 Springsteen quotes from Springsteen, Bruce, *Songs* (Harper Collins, 2003); p.40 Heylin, Clinton, *E Street Shuffle: The Glory Days of Bruce Springsteen and the E Street Band* (Constable, 2013); p.42 38:00: Springsteen, *Wings for Wheels: The Making of "Born to Run,"* Directed by Thom Zimny, Thrill Hill Productions, 2005, DVD; p.51 Clarence Clemons uncredited quote; p.58 Heylin, Clinton, *E Street Shuffle*; p.59 Jon Landau uncredited quote; p.61 Fricke, David, "Jimmy Iovine: the Man With the Magic Ears," *Rolling Stone*, April 2012; p.63 Phillips, Christopher, and Louis P. Masur, eds. *Talk About a Dream*; p.98: Sutcliffe, Phil, "Interview with Springsteen," *Mojo* magazine, Sept. 1971; p.99 & p.117 Phillips, Christopher, and Louis P. Masur, eds. *Talk About a Dream*; p.122 Bruce Springsteen uncredited quote; p.139 57:00: Max Weinberg, *Wings for Wheels* DVD; p.156 Springsteen, Bruce, "Farewell to Danny," *Rolling Stone*, April 25, 2008, Accessed September 2, 2015: http://www.rollingstone.com/music/news/bruce-springsteen-pens-touching-eulogy-to-danny-federici-20080425; p.182 Heylin, Clinton, *E Street Shuffle*; p.195 *Time* magazine, 27 October 1975. p.197 Carlin, Peter Ames, *Bruce* (Simon & Schuster 2012).

THANKS

I would like to thank the following people for their help and support along the journey of making this book:

In New York:
Gianluca De Gennaro, Dzemal "John" Cobovic, Rukija Cobovic, Jim Rocco, Hal Schwartz and Doris Cadoux

In Atlanta:
Howard Warner, Jay Antzakas, Kristi Poltrack and Andy Velcoff

In St. Lucia:
Kirk Elliott, Dee Lundy-Charles, Denyse Elliott, Alvin Richard and Winston Pamphile

In New England:
Jeannie "Queen Jean" Sullivan, Gail and Rob Stephens and Family

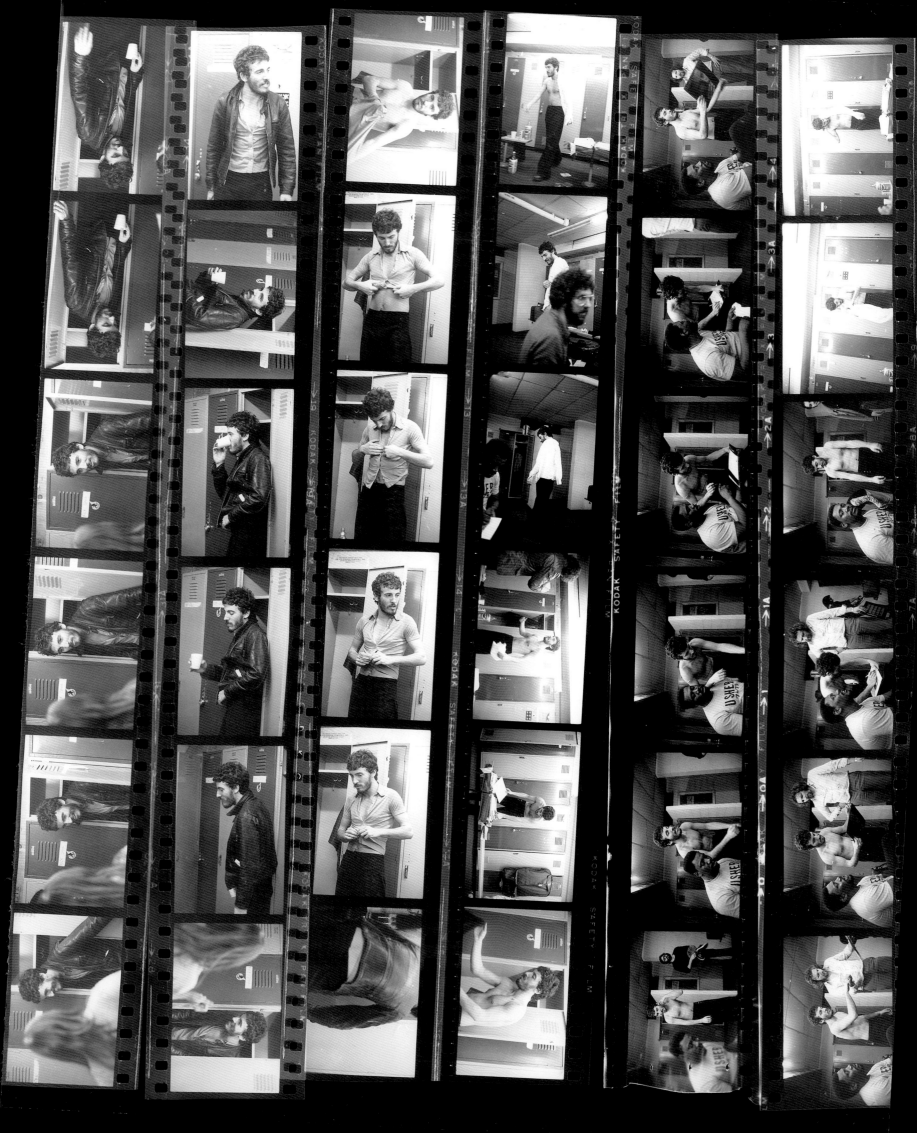

BRUCE SPRINGSTEEN & THE E STREET BAND

1975

Edited by Barbara Pyle, Tony Nourmand and Dagon James
Art Direction and Design by Dagon James

Concept and Layouts by Barbara Pyle
Introduction by Peter Doggett
'Breakfast with Barbara Pyle' by Dave Brolan
'Out in the Streets' by Eric Meola

Project Co-Ordination by Alison Elangasinghe
Production Assistants: Howard Warner and Rory Bruton
Scans Provided by Henry Davis
Pre-Press by HR Digital Solutions

First published 2015 by Reel Art Press, an imprint of Rare Art Press Ltd, London, UK
www.reelartpress.com

First Edition
10 9 8 7 6 5 4 3 2 1

ISBN Regular Edition: 978-1-909526-34-1
ISBN Limited Vintage Deluxe Edition: 978-1-909526-38-9

Copyright © Rare Art Press Ltd, 2015.
All rights reserved.

Copyright © Photographs: Barbara Pyle
Copyright © Introduction Text: Peter Doggett
Copyright © 'Breakfast With Barbara' Text: Dave Brolan
Copyright © 'Out in the Streets' Text: Eric Meola
Copyright © p.197: Time Inc. Cover painting by Kim Whitesides
Copyright © Dust Jacket Biography Portrait: Peter Jay Philbin
Copyright © All text in format: Rare Art Press Ltd, 2015

No part of this publication may be reproduced, stored in a retrieval system, or transmitted in any form or by any means, electronic, mechanical, photocopying, recording or otherwise, without written permission of the publisher. Any person who does any unauthorized act in relation to this publication may be liable to criminal prosecution and civil claims for damages. Every effort has been made to seek permission to reproduce those images whose copyright does not reside with Rare Art Press Ltd., and we are grateful to the individuals and institutions who have assisted in this task. Any omissions are entirely unintentional, and the details should be addressed to Rare Art Press Ltd.

Printed by Graphius, Gent.

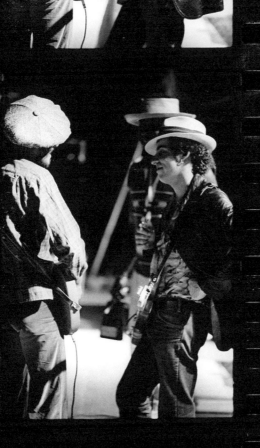
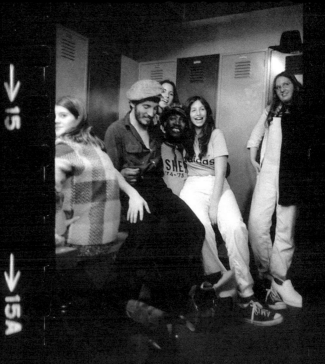
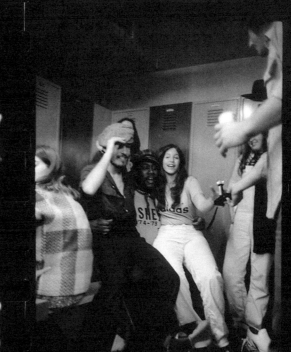
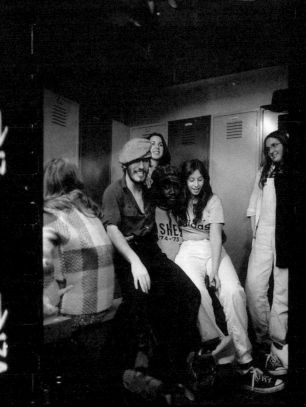

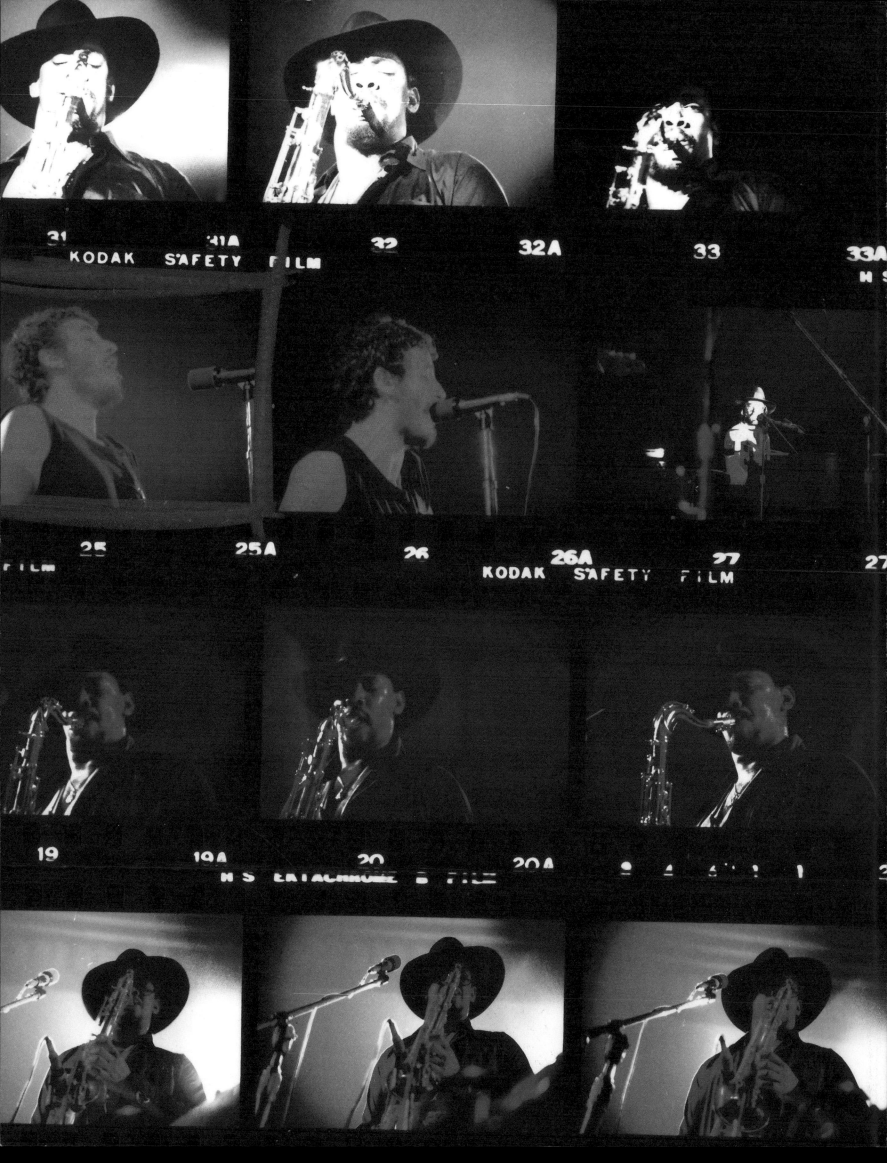

KODAK SAFETY FILM

31 31A 32 32A 33 33A

KODAK SAFETY FILM

25 25A 26 26A 27 27

19 19A 20 20A